THE
HARD
WAY

BY THE SAME AUTHOR

Home Front Posters of the Second World War
1950s Modern: British Style and Design
The Life of Stuff: A memoir about the mess we leave behind

THE HARD WAY

Discovering the Women Who Walked Before Us

SUSANNAH WALKER

unbound

First published in 2024

Unbound
c/o TC Group, 6th Floor King's House, 9-10 Haymarket, London sw1y 4bp
www.unbound.com
All rights reserved

Author photograph by Andrew Ziminski

Typeset by Jouve (UK), Milton Keynes

A CIP record for this book is available from the British Library

isbn 978-1-80018-345-2 (hardback)
isbn 978-1-80018-346-9 (ebook)

Printed in Great Britain by Clays Ltd, Elcograf S.p.A.

1 3 5 7 9 8 6 4 2

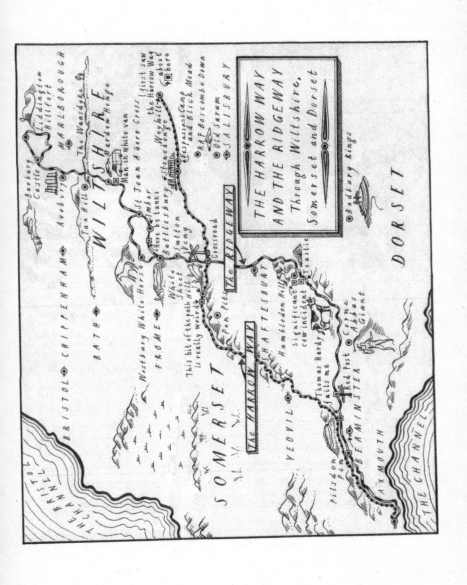

'Do you not realise you are a woman
and cannot go just anywhere?'

Abba Arsenius, 400 CE

Prologue

In an ideal world, this prologue would not exist. Or it would be excellently short, saying nothing more than this is a book about walking along the oldest roads in England and pointing out some odd remainders of history along the way. Perhaps that by the end of it you might look at the southern English countryside with slightly different eyes, in terms of what it is rather than what we imagine it to be.

Unfortunately we are not yet in utopia, which means I need to explain why I set out on this journey and what I intended to achieve, so here goes.

The best-case scenario – at least as defined by the publishing industry – is that I would have set out on a walk in order to find out something about myself or because I wanted to change my life and, at the end of the book, I would have become a different and preferably better person as a result of the healing powers of nature. Or the hope of this happening would be the hook which keeps us all going until the end.

This insistence annoys me. When a man goes for a walk and then writes a book about it, as so many of them do, they rarely present any justification for what they have done. These authors simply want to follow old tracks, or

to investigate where a Roman road or highway goes or trace a line up the centre of the country and then tell you about it. Sometimes they want to swim. But they are not asked why they are doing this, or what their personal journey might be. It's fine for a man to go out walking.

Women, though, must have a reason, to serve them as a passport, the chit which permits them to leave home. They should be coming to terms with grief, or trying to right a wrong, or perhaps they have lost everything and have no choice in the matter but to walk. Whatever the circumstances, the crucial thing is that there must be one. Unlike men, women must justify what they are doing: simply wanting to walk isn't a good enough excuse. And it's certainly no grounds for writing.

The fact that I have to explain this is the reason that this book needs to be written. Because this requirement doesn't just tell us about publishing and the kind of books we expect to see in a bookshop. Underlying it is a far more substantial assumption. Men can set out at any time. It's in their nature to walk out and seek the wild unknown. But not women. They are meant to stay at home, in the domestic sphere.

Pshaw you say: women are no longer tied to the home like Victorian wives; they can work and go wherever they want. And in theory this is true. But the reality — as almost every woman knows — is that a lot of difficulties are strewn along the way. It's still very hard for a woman with children to walk away from domestic responsibilities, away from the mother load of appointments and time and washing and other people's needs.

Even if they manage to do this, will they be safe? It's not only demands that keep women at home but also the fear of men and what they might do. Just a few men, to be

sure, but that's more than enough to lodge in the back of your mind and stop you from going out alone, hold you back from setting out into the countryside and being an independent person, one who sees things just for themselves, for the pleasure of being there. And if the abstract fear isn't enough to keep you in, the other men might be, the ones who yell at walkers from their vans, who shout at women cyclists and follow runners into the woods just for the fun of the chase. Any woman who does go out is reminded on an almost daily basis that she should not really be there. The wide expanse of the land is not ours and we do not belong in it as men do.

None of this should come as a surprise to me because my day job is all about how young women are excluded from the public realm. I'm co-founder of a charity called Make Space for Girls, which campaigns for parks and other public spaces to be as welcoming for teenage girls as they are to teenage boys. Councils and developers spend quite a lot of money on providing for 'teenagers', but in reality the BMX tracks, the skate parks and fenced pitches they provide are almost entirely used by boys. This contradicts the rights of children and sex equality; it's barely legal and has big health impacts on teenage girls (somehow the authorities manage to castigate these girls for being inactive but never notice that they have been given nothing to be active on).

But the key thing that girls themselves take from this is that they feel they do not belong outside. They have been to the park and seen that there is nothing there for them, and if they hang around people stare so they return home, shut out of pretty much the only autonomous place that teenagers have, but also out of community and belonging and civic society – all the things which public space represents.

It's easy to place this in a wider context too: one in which women have been kept to the home by religious rules or custom or social pressure. Because all of these things still apply. Girls from some parts of London tell stories of having to carry a shopping bag when they go out otherwise their brothers and peers call them 'hoes'. That bag is their legitimacy, their reason and excuse; girls have no right to go out just because they want to. No accident that the phrase is 'her indoors'.

It's not a huge stretch to see the absence of women from the countryside as part of the same pattern. So in this book I am setting out to see what the landscape looks like when you start to think of it as a place where men and women experience it differently. To see if it really is a place where men belong and where women are not meant to be. And to discover whether women who have walked out into it before now have been written out of the prevailing stories.

Despite myself, there are also elements of personal discovery in here too, because it's only through the pattern of my own life that I have really understood – the hard way – how women end up confined.

If this sounds a bit much, the book is also about old roads and what we know about them, about the meanings and uses of high places both now and in the past, and why people have always needed to get together in one place throughout all of history. So if that appeals more, do just come along for the ride.

All this explanation, however, is very much making sense of what happened after the event, because when I set off, I had no idea that I was embarking on any kind of journey. All I wanted to do was go for a walk.

Three walks on the Ridgeway between Avebury and Gore Cross
Twelve miles, ten miles and fourteen miles

Early on a Thursday morning, before anyone else is awake, I leave the house and set out to walk. That's such an easy phrase to write and other people begin books like this all the time. The door slams behind them and they are gone, adventuring off into the early morning with only a rucksack on their backs and half a plan. As a rule these books are the ones written by men.

I didn't find leaving the house quite so straightforward, and I was just going out for a day. The practical difficulties – of childcare, who would eat what and when, and how I might travel – could be sorted with a bit of effort. The other problem was more difficult to overcome. I was reluctant to walk because I had become afraid.

This hadn't always been so. Twenty years ago, when I was single and younger, I discovered that I loved walking, and that more than anything else I loved doing this on the billowing chalk lands of southern England. I loved their green, simple hills with white trackways scored into their flanks which demanded to be followed. I walked for miles

on my own and with other people, and eventually came to live on the downs for a while, exploring every part of the territory until I knew the landscape as though it were the palm of my own hand. Back then I was happy to set out on my own, without even telling anyone where I was going or when I would be back.

One reason I am setting out now is to reclaim that past self: competent, sufficient, unafraid. This is why I am now driving away from home, heading toward the Vale of Pewsey, where I am going to walk a stretch of the Ridge-way, a path which may be the oldest road in Britain.

I have several rules about what makes a proper walk. Firstly, it should go from one place to another. I don't like ending up where I started; it feels much better to find myself somewhere different to where I began. What's the point of travelling otherwise? Although sometimes – like today – the ragged state of public transport in this country means that I have no choice.

I'd also rather walk a new way if I can. I want to be somewhere I do not know, to see different views and vis-tas, encounter an unfamiliar atmosphere and different thoughts.

But the single thing I want most is to be following an old road. Modern footpaths are so often disappointing; thin, un-kept, marginal in every sense of the word. I hate being squeezed between hedgerows and crop, scrabbling up a tussocky hill skidding on each lump, pushing my way between long grass and overhanging brambles, each one coating me with the damp of last night's rain. These tracks are not welcoming when I have to assert my right to be present against every branch I pass.

In comparison, if I call up an old road in my head, I see a wide track with grass growing down the middle, hedged each side with oak and hawthorn, the way unfurling ahead of me without question or obstacle. Because they so often follow the ridgeline, these paths ride the hill like a sailing ship on the waves. Either side, the fields spread out for miles. Up here, I am monarch of the road; the path's unerring sense of direction tells me that I am in the right place and can keep going for ever.

All of which is why I am heading for the Ridgeway. I've walked some of its length before, from Tring across the Thames all the way to Overton on the hills above the Avebury stone circle. There it gave up on me, but now I know it goes further, south and west all the way to the coast. And this is where I am going to walk today, following its trail along the high ground above the Vale of Pewsey.

The road brings me in through the valley, which is hedged and productive, the space in which modern life takes place. The railway, the canal and the road now all run through this easy passage, but rising up on each side is the chalk, sleek and green and impersonal.

The Ridgeway lives on these slopes, a place so remote and unvisited by either modern roads or tourists that I have no choice but to make a circular walk. It's not ideal, but there is no other way and I have a car and a plan and a footpath and no excuse not to get on with it.

I've chosen my day by the weather, and the sky is blue with thin scribbles of high cloud, the sun already warm on my back. Even so, the walk does not start well. I park up in a small hamlet. It's spring and the hawthorn and cow parsley are edging each track in white, as clear as a spray-paint outline. All I need to do is head two fields over and I will

be on the right path. Except this is not as straightforward as it should be. Ahead on the road, a man sits in a parked white van, checking his phone. I wait for a few minutes and then he stays longer and my instincts start to kick in. My fear. I don't want to demonstrate to him that I am here, on my own, and setting out into an empty landscape.

Like every woman, I've been making these calculations ever since I started leaving the house on my own. What I've only recently discovered is that there's a term for them: safety work. This is a satisfyingly unplacatory phrase. Because safety work doesn't just describe the workarounds – the keys in the hand, the pretend phone call on a dark path, the not going out in the first place – that women do all the time. It also contains the fact that, even though attacks on women outdoors are rare, this doesn't mean that spaces are safe; instead it shows how much effort women put in to avoid potential danger. The phrase notices that this consumes energy and headspace which saps women's joy and imagination and ability to appreciate the world around us; that it's women who take responsibility for avoiding violence while men are asked nothing at all.

I like safety work; it answers back. It's only one step away from the idea that the best way to make women's lives safer would be for men to stay at home. But of course they don't do that, and this means that right now I have a problem to solve.

The map tells me I can cut across on a footpath and take the next road up. This is fine for the first few hundred metres, until the next stile brings me up against a field of cows. I am scared of cows, all of them, but the warnings are most of all about the dangers of mothers with young calves, and this field is full of them, their flanks dark like

polished wood, each adult with its child, watching me. The path cuts straight through and I don't want to risk it, so I walk down the edge of the fence, thinking I might be able to cross at the other end of the field. But the barbed wire is too tight and new to duck under, and I can't get over at the corner either, although I rip a hole in my trouser leg in trying. Even this is enough for the cows to decide that I am a problem, and all the way back they run alongside me, mobbing and lowing right by the fence, proving me right. So I go back the way I came, and the man has gone and finally I can take the path up to the Ridgeway and start heading where I want to go. What I don't realise as yet is that the morning has barely begun but I have already faced up to the two causes of my fear, the two biggest enemies of my walking. With the benefit of hindsight, the man and the cows are portents of what I would come to understand about women and the countryside, and how it is domestication which confines us at home. But all of this was contained in the journey to come.

As I head for the Ridgeway I am content enough with the fact that I have set out on old roads once more. What I am hoping for is to begin again, to reclaim my old self, and if I have any agenda at all it is to prove that the roads I love so much are as ancient as I believe them to be. What has kept me away from the hills for so long is a thought for much further along.

The way up is enclosed by high hedges, but the ground is chalky and dry, and where it has been worn away at the sides bleached tree roots look like unearthed bones. These holloways are a readable mark of travel, worn into a gulley in the hillside by hundreds or thousands of years of

travellers going from place to place. Like the lorries, only more slowly.

At the top, the path forks right and I am on the Ridgeway. This may be the oldest road in the country, dating back to the time of Stonehenge and Avebury. Or it may not.

For most of English history, the existence of ancient tracks was a matter of fact and their story straightforward. It went like this. The first paths were created by migrating animals, and humans followed these where they found them, ready-made. The oldest routes in England ran along ridges of high ground, following the crests of both chalk and limestone. These were natural highways, avoiding river crossings and marshes and the densely forested low-lands, and some are still in use today. This was how people travelled until the Romans arrived two thousand years ago to build their roads out of packed stone and straight lines, shooting them across the landscape like arrows, regardless of gradients or rivers or any other obstructions. The received wisdom was set out by the *Spectator* in 1913:

Our roads, indeed, are one of our most distinctive national possessions; they are a national heritage, and they have the romance of a heritage. They belong to and connect the very beginnings of our national civilisation . . . The journeying tribesmen chose the lines of the hills because only on the high ground could they see where they were going and could keep free from the swamps and impenetrable forests of the valleys. They followed broad and natural rules of travel: they liked to go dry and warm, and so they chose for preference the sunny side of the hill.

Of all these ancient tracks, the Ridgeway was the greatest, crossing the country diagonally from the Wash in the east to Axminster in Devon in the west. The line of monuments scattering its length, the graves and hill forts and chalk figures as well as the vast stone circle of Avebury, the way it keeps apart from modern towns,* all spoke of how important and ancient this road was. Even as late as the 1950s, prehistoric sites were being discussed in terms of their access to these first highways.

Nowadays archaeologists don't have much time for this story. The big argument is that ancient people never needed to travel that far; the revolution of farming and domestication meant that lives changed. No longer did groups roam around, following the herds and the seasons in search of food, because as farmers they were now tethered, bound to the land and its relentless demands. Any paths would only be local, running from one settlement to the next. Perhaps the ridgeways only join up by accident, or arose much later and are not ancient at all.

The problem with the idea of prehistoric roads is the absence of proof. Archaeologists like solid remains, evidence, but all that travel does to a road is wear the surface away, leaving only a negative trace. And because archaeologists want to be seen as scientific, analysing observable phenomena, this absence upsets them. Only when the Roman engineers arrive to put down hardcore can anything

* More modern towns develop in the river valleys in Saxon times, so one interpretation is that a road which doesn't join up existing towns is likely to be older than Saxon. Why the roads and the towns moved is a question with no certain answer; I would argue that one reason might be bridge technology, which totally changes what the easiest route might be. And a crossing then becomes a very good place to put a town. . .

certain be said. Older roads are dangerous, causing prehistorians to waver from the path of sensible proof. One archaeologist describes tracks as 'the haunt of the romantic, the irrational and the obsessional.' Sounds fun; count me in.

Mute and unknowable, ancient roads have fallen out of favour and out of sight. I can present as many arguments as I like about why roads might have been needed (and boy, I am going to) but in the end the Ridgeway and its fellows have become a matter of faith. Do we want to believe that these tracks persisted from the beginning of our history? Or, if nothing can be proved, shall we dismiss them as an agreeable fantasy which makes us feel better? Roads, it seems, are a lot like God.

In this case at least, I am a believer. For whatever reasons, be they national or historical or personal, I like the idea of continuity. I want to think that I am following the same path that has been taken by generation after generation before me, all their journeys laid one on top of each other by time, and so wherever I go, I search for the signs that the road I am travelling has always been there.

But I also like these paths because they are a sign that the countryside is not natural, but man-made. I am not out here to commune with anything wild and inhuman but with people. History lies just under the surface on these high old landscapes, a visible presence under the thin grass like the shape of a person sleeping under a blanket, and this is what I am here to see.

As soon as I reach the path, I know I am in the right place. Up here I can see right across the vale, where a line of monuments – a hill fort, a high barrow, an enclosure – signal

through time across the valley. Ahead of me, the path goes on, unhedged here but wide, white and certain, showing me where to go. Splashes of poppies colour the green wheat alongside.

Soon this becomes a gravelled access road, heading off like a painted line as far as the eye can see. Alongside this runs a narrow track and I walk first on one then the other. The ruts are deep, while the potholes in the road are treacherous, but I prefer the feel of grass underfoot. More natural, I find myself thinking, but of course this is non-sense. The whole expanse is the way and every part of it is the proper path. And so I carry on, the Ridgeway unrolling mile after mile towards a horizon made from oak and beech trees which I never seem to reach. I don't mind; I am happy enough to be walking again. And I have seen no one else at all while I am up here. This pleases me too.

I don't want to stop, but before it is even lunchtime I have gone as far as I intended. It's a relief to step out of the sun and into the shelter of another deep holloway heading back into the valley. The trees bend over me in welcome. Because it is Monday the pub in Urchfont that I had ear-marked is shut, so I buy a tuna and onion sandwich instead, only this is so unpleasant that I feed it to a hedge and sur-vive the afternoon on Wotsits. The two staff in the village shop appear to be the only living beings here, and the rest of the village is deserted, as though the Rapture has come and only the few ungodly remain.

I trudge over dusty fields, cross a busy road and then come with relief to small lanes which take me round the back of the villages, and so to the car. I've only been out for a few hours but even so, I am ecstatic. I have returned

to walking, and the high places I love most, all over again. I have been on my own and I have survived. Now the only thing I want to do is carry on.

I know why I stopped walking; that's an easy story to tell. It happened when I became a mother. Admitting this feels awkward, like some kind of failure. As a feminist I should surely just have picked up my baby and carried on. Only that's not the way it happened at all.

Pregnant, I kept going, even if this was on city streets rather than climbing the wild and empty hills. But the moment E was born I stopped. At first even forty paces seemed like a miracle to my battered body, but once that recovered, I still didn't walk. My mind had altered beyond all recognition.

Two months after she was born, we took E into Bristol. A small city like this should have been no trouble after two decades in London, but it terrified me. The unthinking traffic roared past too close to the pram and so fast that even standing on the edge of the pavement made me feel vulnerable and exposed. We didn't return for a long time and instead E and I went around the town in Shepton Mallet and then to shopping centres where I could push her pram around on flat tiled floors with no cars nearby, while pretending I still belonged in the wider world.

E began to seem more solid, as though she might survive, so we began to go a bit further. I loved her and had made this choice; I did not want to complain. But the one place which seemed unreachable was the countryside. The pram was an impossibility, but the sling wasn't much better. What if I met someone bad down a long lane far from anywhere? This question had never troubled me

when I walked out before, but now it loomed like rain blurring the edge of a dark cloud. No longer could I stride down a road into an open and empty landscape. I mattered to E now, and she mattered to me so much that I dared not do anything which might risk her.

On bad days, confined to the house and always interrupted, I raged from the loss of walking. I couldn't tell what I missed the most, setting out on my own with no restrictions or the simple idea of a chalk path leading me forward to something new. Although I'd taken up these chains without knowing their full weight, I could not go back. I was inextricably tied to another soul and this could not be undone. I had been domesticated.

I do not mean this in the way of *The Taming of the Shrew*, or some Hallmark Channel movie in which a feisty and ambitious television producer finally sees the errors of her ways and dons a floral pinny. Like any woman with a child, I have been domesticated in the same way as the cows and the sheep. I am hefted to one place, fenced in, required for breeding and so my freedom has been revoked. No longer am I a wild thing.

Oddly, I understood this very soon after E was born. In the dawn hours when I woke up to feed her, a very specific image would arrive in my mind. I was sitting on top of a high hill, cross-legged at the entrance of a thatched roundhouse in the grey-lemon light before sunrise. That me was also feeding a baby, watching from within the banks of the hill fort as light spread over the green fields ghosted with tatters of mist. One sentence ran through my head as I sat there, over and over: 'I am as alike as to the sheep and the kyne.' It's pseudo-historical doggerel, made up out of scraps. Kyne are cattle, just as swine are

pigs. But the words didn't matter. I had seen that now I was a mother, I had become little more than livestock and my fate was inescapable.

Despite my achievement in setting out, the fear has not entirely departed. Before the next journey, I lie awake in the darkness, worrying. Not that I will be shot or hurt; these fears are much more nebulous and vague. Dark shapes lurk in copses, the undergrowth rustles with menace, threats hover but never form. The thoughts jostle in the dark and I cannot tell if they are cows or men, but I am not going to give in. Fear is what would imprison me at home; it's what keeps so many women domesticated while their men set out on long adventures. I should not be afraid. The rustling in the undergrowth is almost always a bird.

The trick is not to stop. A week later, I climb back up to the chalk on the same narrow holloway which took me down last time. From here I emerge into a triangle of high grasses and wide sky, passed by the white road. Up here are also booms, which echo against the clouds and the grass and the air. Down in the valley the sound is less intense, like someone slamming a garage door shut, but up here it rumbles around the hills. I know it isn't thunder because it stops for lunch – well that and the fact that the path now is taking me towards the Salisbury Plain Training Ground where the army are practising for war.

Almost all my walks are undertaken to the sound of guns, and I have a lot of fun on social media juxtaposing seemingly peaceful images of growing wheat, wild flowers and rolling hills against a listing of the particular day's

gunfire, whether that's machine guns, shelling or helicopter fire. Where the artillery is not, there are clay-pigeon shooters, rattling out their cartridges in the lee of another hill, or bird-scarers frightening rooks. We like to believe that the countryside is quiet, but when we listen this may not be true. People are almost always out here shooting at things; usually the ones doing it are men.

The next landmark is a clearing of grey metal shed and baled hay, tatty and uninspiring, enclosed with hedges and dark trees. But I am learning to read the inky emphatic strokes of the Scots pines, the tallest and darkest green around, as a sign, a word to those in the know.

Before the railways and the diesel cattle trucks, drovers used old roads like the Ridgeway to walk sheep and cattle from the grazing fields of the west to market in the cities. The story is that a drover would carry a handful of pine cones in their pocket. When they found a good place to rest and water their charges, they would bury a cone or two, which would eventually turn into a marker for those who took the journey after them. The pines stood out over the native trees, a signal which could be read for miles. This triangular space must have been one of their halting places.

I've been testing this theory for a bit now, and it seems to work. On a recent walk nearer to home, I noticed a clump of pines outside a farmyard and thought it odd, because there was no wide road there that I knew. Then, when I got closer and looked, on the other side of a wooden gate was the perfect trackway, hedged on each side and dense with buttercups and good grass. No one used this stretch now, but once it must have been important.

Not all tall trees can be read this way though. The early

railway companies borrowed the trick, planting clumps of pines at their more remote stations so that a traveller arriving on foot didn't get lost. Gardens around Victorian villas can also provide false positives.

Droving is one of the reasons that the Ridgeway and other old roads survive. Huge herds went across the country, hundreds of cattle at a time, thousands of sheep, going to market in London or to be sold at one of the great fairs along the way, or heading to Portsmouth or Plymouth to provision the navy. It's far easier to drive a flock of sheep or a herd of cows on soft ground, away from carts and horses, and being in the way, and, later, out of the reach of tolls too. Up here there are wide spaces and grass as fodder.

The drovers themselves were not mere agricultural labourers. Not only did they know the routes and the fairs, they had to be as reliable as a bank. Farmers trusted them with the animals, which represented a year's profit, and had to be certain that the drover would not only sell them for the best price he could get, but would also return with the money.

The heyday of droving was the eighteenth century, when each year a hundred thousand cattle and three quarters of a million sheep arrived at Smithfield Market alone. This hoofed traffic kept the old ways alive, and the journeys live on not only in the tall pines but also in innumerable ancient lanes called The Drove, or the Welsh Road, because so many of the drovers came from Wales. There are Welsh Houses too, and inns called The Drover, as well as strange, isolated pubs on high hills which must have got much of their trade from these travellers. One, in Hampshire, is now a house but still has a painted slogan under its eaves.

GWAIR-TYMHERUS-PORFA-FLASUS-CWRW-
DA-A-GWAL-CYCURUS, it reads, which translates as
Season's Hay – Rich Grass – Good Ale – Sound Sleep.

All too soon I have done my day's walking and the path
begins to drop down an easy slope, bordered by wheat
fields which shimmer like pale green satin in the breeze.
But before I go back to the car, I have one last detour to
make, to a place which is now almost entirely invisible.
Deep in the green flatness of the Vale of Pewsey sits Marden
Henge, one of the unknown monuments of England. Situ-
ated almost exactly in the midpoint between Avebury and
Stonehenge, it was once a place of great significance. The
enclosure of ditches and banks was the largest in the coun-
try, and encircled a giant man-made hill called Hatfield
Barrow, which used to be two hundred feet across and
thirty feet high, but has now been dug and ploughed into
nothingness. These days, bungalows squat on its fringes
and the space is bisected by a road. All that remains is the
slight rise of a curving bank in a field and a dark green sign
at the gate, put up by English Heritage. There's hardly
even the place to park one car.

What's not an accident is that Marden is close to the
Ridgeway, and may even mark the point where the road
crossed the River Avon. And the trackway was an import-
ant part of why it was here. In recent years it has become
clear that people travelled vast distances to come to these
monuments, and the newest clues to this have come from
the bones of pigs.

We don't know why people visited monuments like
Marden or Stonehenge – to worship or dance or study or
sacrifice or something else altogether – but one thing they

definitely did was feast. These gatherings were so immense and left so many bones that they can tell us a few stories. To start with, the etiquette was very much Bring Your Own Pig. We know this because it's now possible to find out where these animals were reared. Pigs, like humans, collect chemical signatures in their bones and teeth as they develop, and these vary from place to place. The porcine remains at Marden come from as far as west Wales, the Lake District and possibly even Scotland. And as all the parts of the pig are present, they seem to have been brought here alive.

One of the many arguments as to why the Ridgeway only really dates back a few hundred years is that Neolithic people didn't need to travel far, and when they did they went by boat. The pigs of Marden chew up that idea entirely. Would you rather wrestle a pig or three into a small craft made from logs and cowhide, and take them along the northern coast of England, or round the tip of Cornwall, with all the food they require, never mind the need to shovel pig shit? Or would you rather take them for a walk, feeding them as you went?

The idea of long-distance ancient travel is so unfashionable that some archaeologists have even suggested that the results must be a mistake, because you can't transport pigs like that. You can. Just because it's difficult, that doesn't mean that it can't be done. In the eighteenth and nineteenth centuries, pigs, along with geese and turkeys, were driven along the same routes as the cattle and the sheep.

The other day we happened to be among a set of spectators who could not help stopping to admire

the patience and address with which a pig-driver
huddled and cherished onward his drove of unac-
commodating élèves. He was a born genius for a
manœuvre. Had he originated in a higher sphere he
would have been a general, or a stage-manager, or, at
least, the head of a set of monks.

Leigh Hunt, in 1828, was so tickled by the sight of a pig-
drover that he wrote an entire essay about the skill involved.
Who knows, perhaps the pigs were brought to Marden
precisely because it was a difficult thing to do. I rather like
that thought. But we'll never know what these pigs and
their journeys meant back then. All we know is that they
arrived.*

Unlike the ancients, I have no destination in mind, so all I
can do is keep going. For my next assault on the Ridgeway,
I go back to the other side of the Vale of Pewsey, where I
have already seen the monuments lining the horizon, to
walk from the Marlborough Downs into the valley again.

The track takes me across the Wansdyke, a great ditch
which runs along this ridge for more than twenty miles,
between Savernake Forest near Marlborough, all the way,
perhaps, to the Severn Estuary. No one knows quite when
it was built – perhaps just after the Romans left – or what
it was meant to do. One of its functions might have been
to control the Ridgeway and who could pass down it, like
some kind of customs barrier. But here the Ridgeway
won, because where the road crosses the Wansdyke, its

* They also stayed. The enclosure of the henge was being used as a piggery as
late as the 1930s.

ditches and banks are worn down and the route passes through almost unimpeded.

From here the path takes me down a shallow valley, almost a pass, with a steep hill rising either side, and each of these summits carries a monument. On my left is Adam's Grave, a long barrow holding the collective dead of the early Neolithic, while on the right are the ditches and ridges of Knap Hill, a causewayed enclosure. These places are the first marks made on the land by people, dug more than five thousand years ago. Scattered across southern England, they consist of a ring of ditches, sometimes more than one, but these circuits are never complete; instead they are divided into sections, each part separated by narrow causeways, from which they get their name of causewayed enclosures. And no one really knows what they were for, only that they seem to have been very important. Knap Hill is particularly notable because back in 1909 it was the first causewayed enclosure ever to be identified and understood, and this was done by a woman archaeologist, Maud Cunnington.

Maud Pegge had the good fortune for a Victorian girl to have been sent to an academic school, and was originally interested in church architecture, but at the age of twenty she married Ben Cunnington, whose family had already been active in Wiltshire archaeology for generations. She took their antiquarian interests and transformed them into something new, exploring ditches and earthworks as well as graves and treasures. No one else had done this before, and Maud was the first archaeologist to recognise that timber monuments had existed alongside those of stone. She discovered the Sanctuary near the Ridgeway at Avebury, along with the similar monument at Woodhenge, near

Stonehenge. What's more, she and her husband bought both these monuments and gave them to the nation.

At Knap Hill, what she excavated was a chain of seven ditches set around the summit of the hill, each one separated from the next by a small bank of earth, like a chain of sausages. She understood that the site was very old, wondering whether it was a kind of fortification, but perhaps unfinished, hence the gaps. Her report on the excavation is measured and analytical, making no wild claims and reporting in detail the bones and fragments of flint they found. Researchers working today can still use what she wrote.

Yet later archaeologists rarely speak well of her; she is seen as inept and old-fashioned in her methods, which is a bit like criticising a Victorian for wearing a crinoline. She worked as well as any other archaeologist of her time and in some ways better, with her careful interest in discovering new kinds of sites. One of the problems is that she and her husband were among the very last of the amateur antiquarians. They were often able to excavate a site because they had bought the land, and were not paid for what they did. It's the old British gentlemen vs players class war, but in archaeology the players took over and they can still sometimes get chippy about their status.

The real difficulty with Maud Cunnington was that she was a woman in charge of men. It was understood that she was the driving force in the partnership and she knew as much as any male archaeologist of the time and quite probably more. She could be bossy and blunt but then she'd never have got anywhere had she not been. When asked for advice by another woman wanting to get on in archaeology she simply said, 'Don't. It's far too

difficult.' Archaeology can often be less a neutral science, and rather another way of men walking around the landscape. They are not always keen when a woman decides to do the same.

Historians can't seem to get their heads around her either, often suggesting that she only became interested in the subject because she wanted to share in her son's enthusiasm – a prime example of the kind of sexism which says that women only exist in terms of their relationships with men. Maud didn't seem to get involved to be a helpmeet; she was very much the leader of the excavations, deciding what would be dug and what it meant. More sadly, her most productive period came after the First World War, when her son Edward, their only child, had been killed in France. Maybe she dug to bury her sorrow, or perhaps she simply worked because she was very good at it.

Maud identified the odd segmented ditches of Knap Hill very well. Now we are able to date them to the very start of the Neolithic, five and a half thousand years ago, and are pretty sure that they were not defensive, as she had thought them to be. What they were dug for is still uncertain.

One interpretation is that the causewayed camps were neutral gathering places for the groups of early people scattered across the landscape. Every so often they would come together here to meet, and each tribe or family would dig its own symbolic ditch, both an individual thing and part of a larger whole. So the camps like Knap Hill – and seventy more have been discovered since Maud Cunnington first investigated here – were the precursors of the great gathering places like Marden and then of every fair or festival which has happened since then. Human beings need

to get together every so often to meet and celebrate, and that story is another which is written all over the landscape, should we choose to look.

Knowing exactly when the ditches on Knap Hill were dug does not in theory make the Ridgeway any more datable. But it's hard not to walk between these two ancient markers of Adam's Grave and Knap Hill, the grave of the ancestors and the gathering place of the living, without seeing them as sentinels on the road, keeping watch on the travellers coming down from the high lands, signalling the way to go.

As I come through the gateway, the track shifts into modern tarmac. Here the difference between the downland and the valley is clearest. Above me and to each side, the landscape is stripped back to the barest minimum: green turf, some fence posts, and the ditches, shadows and banks which are the remains of long past intentions. Below me is the ordinary modern world, criss-crossed with roads and hedges, electricity wires and white vans, all compressed into this lowland space. The canal and railway run down the length of the vale, taking people and their stuff through and out and back again at a pace that would have been unimaginable to the people who built Knap Hill.

The rest of my journey is along the towpath of the Kennet and Avon Canal to Pewsey. Here I can see almost nothing, just the water and the green of weed, hedge and field. This feels benign in its simplicity, despite the anarchy which lurks in places along the waterside. Boats have washing out to dry or bicycles on the roof, others are covered in mannequins and street signs and plants potted into plastic clogs. A few are run down, with tatty net curtains behind dirty

windows. Here and there weather-beaten men sit and chat on deckchairs outside.

They are not alone in hiding by the canal. The towpath takes me up and over every bridge and on each one I find thick concrete cylinders, two thirds my height, set each side of the roadway. Short and squat, they guard the entrances like trolls. Some are disappearing into ivy and hedge while one pair have been repurposed as gateposts. When I look over the hedges, every second field holds a pillbox of concrete or red brick, low and patient, their single square eye still scanning for the invader.

These stark, almost abstract structures are the visible remains of something which never happened. Straight after Dunkirk, England was at its most vulnerable: the Nazis stood just twenty miles away across the Channel and far too much of the army's equipment had been left in France. Invasion seemed inevitable, and soon. Within just twelve weeks, the southern counties had been crossed with fifty defensive lines, each one intended to delay an advancing German army. They incorporated any existing features which would help, and GHQ Stop Line Blue, the most important and strongly armed of all, runs for some of its length along this canal. As well as the pillboxes and concrete obstacles, the bridges would have been studded with mines and metal spikes, manned by members of the Home Guard equipped with rifles and flamethrowers. The big guns would have fired down as well from the high ridge of the chalk above. Even so, all this armoury was only intended to slow the German advance down. No one really believed that the Blitzkrieg could be halted.

These defences echo back in time to the great ditch of

the Wansdyke on the hill above. Archaeologists say that the Wansdyke is too long to be defended, but Stop Line Blue stretches for sixty miles, from Bradford on Avon in the west all the way to Reading, and the British army believed they could defend it all.

These brick and concrete remains are portals into an alternative reality, solid manifestations of a world which could have gone a very different way. They unpick the neat story we now tell about the Second World War. With hindsight, the result seems inevitable: the country stood strong, right triumphed, but at the time nothing was so certain.

As I stand on the towpath, one present is layered on top of another. The Victorians pushed this canal through the marshy valley, then thirty years later the railway followed the same route. A century after that, the bollards and pill-boxes were added. But if I look up, Adam's Grave and Knap Hill still overlook the valley, just as they did when none of this future had been imagined at all.

I'm not a naturalist, but nor am I a historian. The past isn't interesting for its own sake. What I like most of all are places, like this, where the past and present exist in the same space, knitting up time and looping it. And it turns out that there is a word for this, although I only discovered this recently. I am a topophile.

The term was coined by the poet W. H. Auden in an introduction to the collected works of John Betjeman. These were being published in America, so he had a lot of explaining to do. The literal meaning of topophile is someone who loves places, but for Auden this attachment is to history and culture as much as to landscape. It's a very English state of mind.

Wild or unhumanised nature holds no charms for the average topophile because it is lacking in history . . . At the same time, though history manifested by objects is essential, the quantity of the history and the quality of the object are irrelevant; a branch railroad is as valuable as a Roman wall, a neo-Tudor teashop as interesting as a Gothic cathedral.

He catches my feelings exactly. The brick boxes and concrete shapes have as much claim on the landscape here as the ancient ditches and banks and I am interested in them all.

Yet this place is not entirely comfortable; the potential for something malign lies under the smooth skin of the chalk. I am used to the graves here: the long barrows on ridges, the humps of Bronze Age tumuli pocking the valley edges. These seem like fine places to be buried, with the white soil under the grass like bones beneath the flesh. The concrete holds a different story. Had there been guns behind the steep scarp of the slope, the fields around me would have held a massacre: the tanks and troop carriers pressed up at the bridges, the mines, the raking shells form over the edge. Bodies and torn flesh everywhere. I do not want to imagine that amongst this placid green.

'A great many must be walking over England for the primary object of writing books; it has not been decided whether this is a worthy object.'

Edward Thomas

The Ridgeway, a loop around
Barbury Castle
Thirteen miles

Like the past, my stories layer one on top of another. I know why I have stopped walking, but I have also not started again by accident. Each walk is part of a very particular quest, filling in stretches of the Ridgeway which I have not encountered before. And I am doing this because the Ridgeway and I have history, big time. That's what I am going to revisit on today's walk.

A small piece of its track towards Avebury remains undone and so I need to fill it in. Up here on the Wiltshire Downs, the main route of the Ridgeway National Trail diverts where a piece of the ancient track has become a metalled road. Last time I took the footpath, but now I want to follow the original route of the old way, regardless of how it has been remade. To do this, I am tracing a circuit between two hill forts on the Ridgeway, through Liddington Castle and Barbury, going out on the footpath and coming back on the old road. I begin high up on the ridge and from here I can see as far as Salisbury Plain, where great inky wipes of clouds are fraying at the edges with rain.

In front of me the way is obvious. The track sets out,

unhedged and with fine waving grasses each side, its path made up only of custom and walking but as visible as a map, following the crests of the hills in front of me. It's almost impossible to get lost where the way is shown so clearly, but even so I have signs to help me. At each turning is a wooden fingerpost with RIDGEWAY carved into its face, along with the shape of an acorn. All the way from the Chilterns to Avebury the old path has been turned into an approved route, mandated by the authorities. Although that sounds dreary, I am in favour. It shows that the Ridgeway is important enough to be part of our national culture.

This Ridgeway path came into being as part of the democratisation of the countryside which happened either side of the Second World War. It began in the 1920s and 30s, when getting out of the city to hike became a popular pastime. This happened all across Europe, but in Britain, inevitably, it got tangled up with questions of class. Specifically, aristocrats got upset about oiks, or indeed anyone, having access to their land.

Hiking became a form of class warfare. The conflict reached its height in the Kinder Scout Mass Trespass of 1932, in which four hundred or so hikers defied the Duke of Devonshire's gamekeepers and walked across his Peak District estate, an event which has become as hallowed in British rural history as the departure of the Pilgrim Fathers for America. Both men and women took part, but the women were kept to the back to save them from being thumped. The pictures, as a result, show entirely men.

After the war, it was seen as essential that the countryside should be opened up for everyone to use. This wasn't just the result of the trespassers; there was also a sense that

people had been fighting for an ideal Britain represented by the land itself and so it was a common good. In 1949, the National Parks were created, setting aside tens of thousands of acres to be opened up for general use. What always gets overlooked in this is that the same Act of Parliament also created the National Trails. Access didn't just mean day-tripping for the views, it also included the right to roam for a very long way. The first was the Pennine Way, but it took until 1973 for the Ridgeway to be formalised.

The Ridgeway National Trail now runs from Ivinghoe Beacon near Tring to West Overton by Avebury, but this ties down a route which until then had not been so set. In places the path was known as the Rudgeway or the Rudge, while for most of its length it runs parallel with, and sometimes becomes, Icknield Street, which old maps mark as a Roman road. Old paths were never meant to be neat and mappable, but the civil servants managed to agree a route and this more orderly and legislated path has now become part of my rights as a citizen.

Whatever it is called, and however it is signposted, the Ridgeway still takes the course it always has done, along the knife edge of the chalk, surfing above the plains of Oxfordshire and Wiltshire from on high, carrying us along with it as it goes.

Because this section is a path I have already travelled, I cut a corner to take the road across to Ogbourne St George. All through the village, a steep ledge of downland rises behind the brick and thatch like a wave about to break over the houses. This means the road out of the village is steep. I swear and sweat my way up. Without my noticing

the day has shifted and the sky above is now bright blue. White clouds bubble up at the edges of the horizon, as clean and fresh as spring water.

At the top I rejoin the Ridgeway. A few paces along I am confused to see the metal of cats' eyes glinting in the grey tarmac, not in a neat line down the middle but scattered across the surface and tilted at all angles. I keep looking down and further on I see fragments of yellow as well, and then I understand. A load of rubble has been dumped on the track to stop it getting muddy, but it is smashed-up old tarmac, and these are the pieces I am seeing beneath my feet. The ancient track is made up of broken new road and time itself has been reassembled in the form of the path, past and present running as one towards the brow of the hill.

Perhaps this is what time looks like anyway. The French historian Michel Serres imagines it as a handkerchief. Laid flat and ironed, history works as we expect it; the most recent happenings are near and the distant past much further away. Now crumple up the handkerchief in your pocket: moments which were far apart are now set against one another, related and kin. Should the fabric have a tear then times which were once close might now be separated, unbridgeable.

Here on the downs, history is wrinkled and complex, and the broken and remade road is just one reminder of this. When I follow the path, I am always walking through multiple times together where the world wars are close neighbours to the old stones and barrows, staring down at farmers and railways and electricity from their high simple ridges.

On the old roads, I am also walking through my own

crumpled time, trying to catch up with the fearless person I once was. I understood these places so much better then, or at least I thought I did. But I also thought that I was somehow exempt from the pressures of society and biology which operated on other people, and that turned out not to be true. I might never reach the person I used to be before, however far I walk.

The track turns to follow a new ridge, past woodlands and out onto the open downs where the wheat is now rising high and green, bending in the breeze. Paths go off to the left and right, but I am carrying on towards the folded edges of Liddington hill fort. Whatever these banks and ditches may have meant in the past, the place is now a temple to nature writing. More specifically, it is the spiritual home of Men Who Talk About The Downs. Two writers in particular, Richard Jefferies and Alfred Williams, are commemorated in this place by a cast-iron plaque set into the hill's concrete trig point marker. The monument is not as old as the memory, though, as it had to be replaced when bored soldiers used it for target practice during World War Two.

Born in Coate, just below Liddington Hill, Richard Jefferies was a prolific writer of novels, articles, essays and children's books in the late Victorian era, but is now best known for his writings about rural life and nature. He is the first to observe the Ridgeway and what sets it apart from other tracks.

A broad green track runs for many a long mile across the downs . . . It is distinct from the wagon tracks which cross it here and there, for these are local only

and, if traced up, land the wayfarer presently in a maze of fields, or end abruptly on the rickyard of a lone farmhouse. It is distinct from the hard roads of modern construction which also at wide intervals cross its course, dusty and glaringly white in the sunshine. It is not a farm track – you may walk for twenty miles along it over the hills; neither is it the king's highway.

Although he is renowned for his description of the pre-industrial countryside, there is more to Jefferies' work than simple observation. In his dense and ecstatic short memoir, *The Story of My Heart*, he finds a transcendence on the downland, very specifically on Liddington Hill.

Moving up the sweet short turf, at every step my heart seemed to obtain a wider horizon of feeling; with every inhalation of rich pure air, a deeper desire. The very light of the sun was whiter and more brilliant here. By the time I had reached the summit I had entirely forgotten the petty circumstances and the annoyances of existence. I felt myself, myself.

Alfred Williams, remembered on the same stone, is less well known outside Swindon. A generation younger than Jefferies, he worked for twenty-three years as a hammer operator in the town's immense railway workshops, writing poetry and collecting folk songs in his spare time. He too wrote about Liddington Hill, but his fondness for an exact metre, all too often studded with Thou and Ere and O, makes his work less appealing to the modern ear.

A loop around Barbury Castle

The friendship of a hill I know
 Above the rising down,
Where the balmy souther breezes blow
 But a mile or two from town;
The budded broom and heather
 Are wedded on its breast,
And I love to wander thither
 When the sun is in the west.

I can live without this, but then I have a problem with quite a lot of nature writing. What Jefferies and Williams want to see in the shrubs and birds and what they like to refer to as 'timid conies' is something immortal and unchanging. I find this hard to believe in. Very little nature exists in England unaltered by humans. We are not living in tropical rainforests, treading along tracks made by animals. Even if this was the origin of the Ridgeway, quite a lot has happened since then. When Jefferies glimpsed infinity on the top of Liddington Hill in the 1860s, he lay within the ditches of a hill fort built by people, on grass grazed short by flocks of domesticated sheep. Ahead of him lay Swindon, no longer a small market town but already spreading out in red brick thanks to the railways. By the time Williams climbed the same hill, the huge industrial sheds in which he worked were sending engines and carriages out across the country, along the railway lines which still run below the fort.

When I look in the same direction, I see the terraces of railway houses and the train tracks, but also the car factories with their white roofs, the sleek high-rise box of the new Swindon Hospital and, in the cutting just below, the incessant thrum of the M4. Of course there are grass and

trees and hedges too, but none of them are growing freely; each has been contained and placed by the wishes of humans. The countryside is something we have constructed, not that we have found.

The railways and their industry were why Jefferies and Williams wrote. Anxious about modernity and change, they wanted to disappear into a timeless England, populated only by stalwart country folk, crops and tradition. Things aren't much different nowadays. Whenever we are afraid about our future, we get the urge to dive into the countryside. But these days – unlike the ramblers of the 1930s, trying to walk away from war – very few of us actually go out into it. Instead we read nature writers for the same reason that we watch cookery programmes and read recipe books in order to live the fantasy about what we might cook if only we had the time. Books about nature and walking assuage our guilt about what we don't do rather than inspiring us to set out.

A later writer also loved the view from these downland heights, but he is missing from this memorial. Edward Thomas grew up in London but spent his holidays with an aunt in Swindon and so learned to love the green hills swelling beyond the dirty railway town. Thomas was a great admirer of Jefferies, even writing his biography, and he in turn is seen as the father of most modern nature writing. The baton is handed on from man to man.

In theory, I should love Edward Thomas. He is a careful admirer of the ordinary, who sees the unregarded parts of the English countryside: its verges, wildflowers and paths. His is a democratising vision, teaching people to appreciate the pleasures of their native land rather than poetically

preaching that true beauty can only be found in the Alps or the glittering light of Southern France. More than that, he is interested in tradition and maps and the old roads, and he cared very deeply for the same downland that I love. He even wrote a book, *The Icknield Way*, in which he walked some of these same paths along the ridges.

Plenty of people would agree with me here, and quite a lot of them write about nature and walking: book after book quotes him as an epigraph. He goes for walks and writes about them, what could there be to dislike? The problem is that he's also the patron saint of every modern writer who sets out on an adventure without a second thought about childcare, getting tickets for the school concert or what's for dinner tonight. Plenty of creative men achieve success at the expense of their wives, but Thomas turned it, quite literally, into an artform. Every time he set out, he was always walking away from his home, his wife and his family, and his writing is born out of this separation from the domestic.

Distinguishing between the work and its creator is always a problem. Mostly, I think they can exist apart. I love the poetry of T. S. Eliot even though he makes anti-Semitic comments in his letters, because the poems themselves are open and inclusive. We adore the VW Beetle, even though it was the product of Nazi engineering and design, because it was an excellent car. However, I can't entirely separate my dislike of Thomas's behaviour from his writing, because walking away from home is at the heart of his work.

Thomas married young, before he went to university, and spent much of his life producing book after book to support his family. His wife, Helen, gets a hard time from

his supporters and biographers, who treat her as a home-obsessed drudge, an early mistake which could never be righted, a drag on his poetry and his soul who forced him to turn out hack work in order to keep his children in food. In fuzzy photographs she peers out at us from behind round spectacles, looking diffident and uncertain. He should have left her a long time ago, they say, or never married in the first place

I have big problems with this point of view, the main one being Helen herself, who was a brave, talented and individual character. When she met Thomas in 1896, she was a New Woman who believed in emancipation and freedom and had little care for conventional opinions. As part of a circle of friends who were painters and actors and craftworkers, all freethinkers and bohemians like her, she had much more to her life than just yearning after a young poet – although she did also do plenty of that.

Helen Noble loved her naked body, climbed trees barefoot and freely embraced her sexuality – which is why she defied the prevailing Victorian morality and slept with Thomas for two years, unmarried. Only then, with a heavy inevitability, she got pregnant.

Suddenly the liberated woman found herself married and confined at home with their son, while Thomas went back to his studies at Oxford, trying to ignore both his wife and the very idea of family life. Many years later, Helen recounted that she'd never seen the city of Oxford until long after her husband died. He got to have his cake and eat it, while she ended up living with his mother, holding the baby.

Helen Thomas did mind being kept indoors. Nine years after their marriage, when the family were living in

Kent – Thomas's decision – while he worked in London, she sent him furious letters, complaining that he goes to places while she is shut at home as a nurse and housekeeper and that the people that he is seeing knew her before they ever knew him. But this didn't change anything.

Later on, when her husband's writing didn't provide enough for them to live on, Helen became a teacher at the progressive co-educational school Bedales. Not that you'd ever find that out unless you read very closely between the lines. Steep, where the school is still based, is only ever associated with Edward Thomas and his fellow poets, and the school itself managed to commemorate Thomas on the centenary of his death without once mentioning Helen. How easy it is for the labours of women to disappear.

Helen herself was no saint. She could be needy and demanding, but she was also efficient and relentlessly cheerful, making friends with ease. From a modern perspective, she could have done with some therapy around self-esteem and possibly codependency as well. As a woman who was plain and, more damagingly, opinionated and clever, she never really recovered from her amazement that this talented and handsome poet had chosen her.

This sense of being honoured was what kept her going through all his bad treatment. There was plenty of it – he told her about his infatuations, left her at home and broke, wrote love poems to many women but never her – but what Thomas did most of all was walk away from home.

For there were to come dark days when his brooding melancholy shut me out in a lonely exile, and my heart waited too eagerly to be let into the light again. When those days came, with no apparent reason for

their coming, bringing to him a deep spiritual unrest and discontent, he would be silent for hours, and perhaps stride out of the house, angry and bitter and cruel, and walk and walk far into the night, and come home, worn out with deadly fatigue.

His complaints at these times are that Helen is too cheerful, or simply that his family are too present, too much there. He flails at them as though it was their fault for existing in the first place.

Thomas couldn't bear domesticity, but he needed it in order to have something to leave. Home and his wife are not just a base camp from which he can walk out unimpeded with, helpfully, his lunch fixed by someone else. More essentially, his opposition to domesticity is what defines him. In order to show that he is a man, in the world, there has to be a woman staying at home.

Her husband's final, quixotic act of walking away was to sign up in 1915 to fight in the Great War. As a married man he was not expected to volunteer but he did, in part because of an imagined slight on his manhood but also because he valued the land more than he did his own self, never mind his wife.

After he'd enlisted, his friend Eleanor Farjeon was out walking with him and asked what he was fighting for.

He stopped and picked up a pinch of earth, crumbling it between finger and thumb. 'Literally for this,' he said.

Thomas died at Arras in 1917.

Widowed, with three children, Helen Thomas wrote an autobiography which is more about him than her. Their daughter felt it was therapy, lifting her out of the depression that descended when he died. At the same time, it is

also a brave and unexpected book, which is entirely open about their sex before marriage, and which also gives a vivid description of the birth of their son as being both uplifting and a bodily mess in a way which seems surprising even today.

It's easy to be modern and sharp about her dependent drudgery, but Helen Thomas, while a rebel, was also a product of the times: a feminist while single but unable to escape many of society's pressures later on. Once pregnant, she had few choices. Had she and Thomas separated, Helen would almost certainly have had to stop her teaching job, leaving her with only her parents to rely on. Her world would have become narrower still.

It's possible that I mind so much about Helen Thomas because I feel her situation reverberating with mine. Even though I went to university and worked in a job I loved, my choices also closed in once I had a child. I also ended up at home, in a way that I still sometimes cannot quite believe has happened. Surely a woman's life does not have to be like this?

Her situation is archetypal, and how and why this happens is one of the things I need to grapple with. It is what I am both trying to walk away from and to carry with me as I go. I need to find a better way and, rationally or not, I am hoping to discover this somewhere out on the chalk downland.

But his treatment of his wife isn't the only issue; Thomas's life and works pose another problem too. If he is, as so many modern authors insist, the model for all writing about landscape, then where does that leave the women? Where do the people like me, walking out, find ourselves? We have nowhere to go, no one to follow. All that is left

to us is being at home, looking after the children and waiting for our man to return. But this is not what I want from my life, nor even from my books. For now, if I can find no companions in art, I will simply have to set out alone.

I'm heading for a small road, which may possibly be the original line of the Ridgeway. At least that's what it's called on the maps, which is enough for me. Where this crosses the A-road leading to Marlborough from the motorway, I stand and wait for ages as I am passed by vans and coaches and lorries with containers labelled Yang Ming, goods passing me on their journey across half the known world.

It's hard work treading along the paved lane in the sun. I pass a farm with a shepherd's hut outside, hung all over with walking boots as though they have been bagging hikers as trophies. Then the road turns into a dirt track, shaded by trees, as much of a relief as the sun after rain. Within five minutes I have entered a more comfortable walk, down a dappled way with leaves shifting in a slight breeze, fields of wheat sunning themselves on either side.

The path begins to climb towards Barbury Castle, slowly rising above the fields which are still luminous with new life, the grass scattered with the yellow froth of buttercups. Beyond this is a glittering spread of solar panels, and behind that the curved and faded shapes of aircraft hangars, grey and dark green on the edge of the hills. These mark the site of Wroughton Airfield, built as a maintenance depot, hospital and aircraft factory for the RAF in 1940.

The building of the airfields was even more of an endeavour than the creation of the Stop Lines. Almost four hundred and fifty were constructed from scratch between

1935 and 1943, the biggest engineering project in British history. The concrete alone could have made a road nine thousand miles long, and at the peak of the works in 1942, one new station was coming into service every three days.

At Wroughton planes arrived from distant factories to have specialist weapons and equipment fitted, before being sent out to squadrons across the country. Some of these delivery pilots were women, the only flying duties they were permitted during the war. Other aircraft would be boxed up here in wooden cases to be sent to operations abroad. Later on, Wroughton also housed its own factory producing Hurricanes for the Battle of Britain, then planes and wooden gliders for the invasion of Europe.

Up on Barbury Castle, earthworks still show where guns were stationed to protect the airfield, and there are craters where German bombs landed. The ancient banks at one entrance were also reconfigured by an American regiment with bulldozers who wanted to improve the access.

Just as on the road, history here is complicated and folded over on itself. We like to think, looking at a hill fort like Barbury, that this is the work of many centuries ago, miraculously surviving. But not all the marks on the earth are ancient, and many of them have been changed by time. Equally, the marks of the much more recent war are scattered all over England, yet we all seem to have agreed to ignore them, never to mention what we can see before us on the land.

After the war was over, Wroughton stayed in use longer than many of the new airfields, only being given to the navy in 1972 and then closed for good in 1978. Since then, several of the huge hangars have been used by the Science Museum as storage for their Large Object Collection,

which includes hovercraft, MRI scanners, combine harvesters and nuclear missiles, along with nineteen aircraft. It's the ultimate shed. While outside, Jeremy Clarkson and his fellow presenters race around the old runways filming their Amazon show, *The Grand Tour*.

I don't like symbolism to be this obvious. The landscape is no fun when it can be this easily read. But I can't deny what's in front of me. Wroughton is a place where men have made their mark, over and over again. Maybe that's true of the countryside everywhere, it's just that the signs poke through the earth more clearly in some places than others.

From here I walk over the edge into the vast grassy bowl of Barbury Castle itself. There's another monument to Richard Jefferies and Alfred Williams up here somewhere, but I can't be bothered to find it because by now my feet really hurt. And anyway, nothing in the books will have changed since this morning.

At the entrance to the fort are old information panels. Worn and weather-beaten, these have been encroached on by lichen until their words have been eroded almost away but the pictures remain. In one the men are centre stage, forging metal, walking purposefully across the yard and doing something indeterminate to a vat of vegetables with a spade, while in the background a woman works on her loom. In the other a family sit inside their round-house, eating a meal which one woman is serving while at the door another woman minds a child, unnervingly close to a large boiling pot. Outside a man is loading a cart.

I imagine this is meant to be an expression of continuity: women and men, doing the same thing they've always done

over the centuries. The men are wearing check shirts and Magnum PI moustaches, making them the direct ancestors of their 1980s counterparts who were working in the vast white Honda factory below. The women are a bit more Iron Age, with plaits and plaid skirts. Meanwhile the words which remain talk of defence and warring tribes and battles conducted over the edges of the fort, attackers hurling spears and arrows and stones.

All of this is the product of imagination alone. We have no idea what really happened at Barbury or any other hill fort that exists. Maybe no families ever lived here; perhaps it wasn't meant for fighting at all. The ideas of men seep into the landscape and shape how we imagine its history. Although we call Barbury a hill fort, it was certainly not built for defence – anyone approaching from the west can see right into the fort from miles away. For all we know the women might have been in charge and it was designed as a sacred space and men were never permitted to cross its boundaries and enter. Although that might be taking things too far. The only thing I do know for certain is that most of the theories we have now tell us far more about our present life, and our fears, than they can ever reveal about the past.

I climb up onto the earthen bank of the fort, still steep and imposing despite two thousand years of wind, rain and disuse. Ahead of me is one of the most enticing views I know. From the far side of the hill fort, I can see the Ridgeway heading onwards. The track dips down into a slight combe and then up again, following a clear ridge curving off into the far distance. Scrubby hawthorn bushes and the occasional stand of trees mark its line, allowing me

to follow it all the way to the edge of the sky. I'm tired now, but still feel the urge to press on, to take that path wherever it wants to lead me, just as I did the first time I saw it. Because Barbury Castle is where I first saw the Ridgeway and knew I had to follow its ancient course.

I hadn't come here to find the path. I hadn't even meant to come here at all. I was on a day out alone in my car and Barbury was an accidental destination, the result of a random decision to turn left instead of right. I'd climbed up the banks to where I am standing now only to look at the view down into the valley. But as soon as I saw the Ridgeway, I understood with total clarity that this was the place I needed to be.

This is why I can't entirely dismiss Richard Jefferies. His ecstasy on Liddington Hill, his sense that the whole landscape – from the widest panorama to the smallest leaf of the turf – was humming with a vast but ungraspable significance, was exactly what I had felt when I arrived on this hill.

What was most surprising was that I was not surprised. These rolling ridges of downland and smooth-sloped hills were entirely new to me. I'd never been anywhere which looked like this – in truth I'd hardly walked out into the English countryside as an adult – yet I knew this to be the right place, as though I had walked into one of my dreams and felt the setting to be as familiar as my own skin. I loved every single part of what was in front of me, but above all I was hypnotised by the path as it ran off along the edge of the hill. Wherever it was going, I wanted to be travelling with it. For the first time in my rather transient and unrooted life, I had found a place where I belonged, but where at the same time I would always be in the process of

arriving, and that is perhaps the best state of all. I could never be disappointed.

That unexpected day was in April 1999 – Maundy Thursday to be specific. By the first May bank holiday just three weeks later I had organised to walk the Ridgeway from Uffington White Horse to Overton near Avebury with a friend, seventeen miles one day, fourteen on the next, as though we had been walking these high roadways for years already.

Once I'd accepted the inevitability of the path, everything else fell into place along its course. We'd set out for the weekend by train and then taxi, knowing where we would stay the night but with no thought of how we'd get back home at the end, except that there might be a bus to somewhere. But as we trudged heavily from the end of the path towards Avebury itself, following the avenue of stones, we met a close friend of mine walking the other way, here on a day trip with his girlfriend. They drove us home to London as though this meeting had always been planned.

From here on, the path led me. That summer we walked the entire official Ridgeway, and the next spring, just a year after I had first encountered this place, I had changed job and was living just a mile from the Ridgeway and its chalk, with no thought of any reason except that this was where I needed to be.

After this, I feel a bit uncomfortable about telling the story because it starts to invite words like fate and destiny and I sound like yet another wide-eyed hippy who has ended up at Avebury, which I am not. Even so, the Ridgeway led me towards a set of events which followed one

another like a story, rolling forward from its own narrative logic without any intervention from me.

The true metaphor is of course more direct. I had stepped onto a pathway, and should I choose to follow it and read the signs along the way, I knew it would lead me to the right destination.

And so it happened. I read about the Ridgeway and its landscapes and their ancient history and this got me another job working on a TV programme about archaeology. The connections I made there led me to T and I married him. Together we moved out of London, had a child. Six years after I had first seen the Ridgeway my life had changed entirely.

All I had to do was put one foot in front of the other. The path had taken me on a journey which had become my life and by the end of it I was no longer the same person who had driven up to Barbury Castle by accident. I had a family; I understood where I was on the face of the earth; I belonged.

No wonder that I believe in the old roads. No wonder I am always trying to find out what they mean.

The Ridgeway, from St Joan a Gore Cross to Westbury White Horse
Twelve miles

Back then I only walked the length of the officially marked Ridgeway, from Ivinghoe Beacon in Buckinghamshire to Overton, by the A4 near Avebury. I tried to see where the path went after that, but for reasons that I cannot now understand, it eluded me entirely. Now – with the aid of the internet and an easy supply of old maps and books – its course is relatively obvious. This is what I am following as I try to get back on track. As well as filling in gaps, I am trying to trace the course of the old road south beyond where I left it twenty years ago at Overton. These are the paths which have taken me over the Vale of Pewsey and are now heading towards Salisbury Plain. Although what's also clear is that I cannot cross straight over the plain as the Ridgeway once did. I am going to have to go round the edge because the army is in the way.

By now none of this is a surprise to me, not the game shooting nor the bangs to scare off rooks. But most of all I am used to the sounds of warfare, or at least the rehearsals for it.

Where I live now is only ten miles from the edge of the

Salisbury Plain Training Area, and so the army occupies the fringes of our minds, not often noticed but always present. We pass their camps as we drive to and from London, our progress marked out by their Nissen huts and barracks: Knook, Larkhill, Bulford, Boscombe Down. We overtake their tanks as they are brought on transporters in convoy, escorted by jeeps, all painted the deep matte green of an August oak.

Sometimes their doings reach right up to our house. At the end of one summer a few years ago we woke up to find the whole town vanishing into a pale smoke. This had drifted from the east, from fires on Salisbury Plain. I drove past a few days later and saw the column of smoke rising, as though a volcano had erupted in the middle of England. Army firing had set the parched land alight and no one could extinguish the fire because the ground around it was studded with live ammunition and so it was impossible to reach. All they could do was let it burn.

So I am not surprised when I open the car door at the start of my next walk and hear a short burst of machine-gun fire, as though the army were executing people up on the hills. T, who has dropped me off, is more taken aback. 'I thought it would be more like clay-pigeon shooting,' he says. I don't tell him that this is light relief in comparison with the booms and the bangs I have already heard up here, the low rumble when shells slam into the earth.

Today's walk is beginning in a gentle valley where the road from Devizes to Salisbury cuts across Salisbury Plain. This road meets the Ridgeway at St Joan a Gore Cross. The name has been mangled by time: gore means a triangular patch of land, but the chapel which sat in this desolate place

was originally dedicated to St John. The building has long since disappeared, buried in the grass, but its name remains, marking the crossroads and a collection of corrugated sheds and farm buildings which seem to have been thrown onto the site at random. This name is also evidence that I am not the only traveller on these roads to have been afraid.

Here, the Ridgeway is about to enter its most dangerous stretch across the riverless and empty wastes of Salisbury Plain. Up until this point, its route has been easy to follow, skirting the scarp and the watershed, sticking to the edge and the dry heights. But once the traveller has crossed this road there are no more streams or muddy valleys to avoid. The whole area is one vast upturned bowl of chalk and the way could take any route across, with no hedges, fields or landmarks to give a clue. It would be far too easy to be lost here; so the chapel existed in order that you could pray for a safe passage and to arrive at your destination.

You may also wish to pray that you do not get robbed. These unpeopled uplands made easy pickings for high-waymen and thieves, particularly in the dark. Across the road sits the Robber Stone, a tall square pillar sitting in the mown grass of the verge. It marks the spot where Mr Dean, a farmer, was robbed on his way back from Devizes market in 1839. His four assailants ran off down the hill, but Mr Dean chased them across the plain, acquiring a whole crowd of helpers along the way. One robber got away, another fell and was left where he lay, but three hours later the last two were cornered and Mr Dean had his considerable market takings – more than six thousand pounds in today's money – returned to him.

The stone marks the spot where he had his money taken, and an engraved steel plate records that three of the

highwaymen, as it calls them, were transported for fifteen years. The last line says that the monument was erected as a warning to any other thieves who thought they might escape punishment. I can't help noticing that they've spelled 'theives' wrong.

This isn't the only Robber Stone. A second — now marooned on inaccessible army land and surrounded by signs reminding tanks not to bulldoze it – marks where the second robber fell. When the constables returned the next day, they found him there dead. He was buried 'without Funeral Rights' and this plaque signs off with the biblical thought that the wicked shall not remain unpunished.

St Joan a Gore still marks where the Ridgeway gets dangerous, but for different reasons these days. Its route would take me right into the training area, a landscape of tanks and shells with live ammunition lodged in the soil. I have to detour along the edge of the chalk, on an army-sanctioned route called the Imber Range Perimeter Path, waymarked with signs carrying the logo of a large gun, just in case you manage to forget that they are shooting at things.

The sky is clear blue and I set off along an old tarmac road with no shade. Either side of me is picture-perfect farm-land with hedges, sloping fields and cows grazing. Apart from the road under my feet, I can see nothing modern. This morning could have happened at any time in the last four hundred years. As I go on, the road rises and now I can see the plain itself to my left, a wilderness of long grass and hawthorn bushes bowed low by the wind. A brick pillbox stands guard and the machine gun executions have resumed in the distance. Up above, larks fly like motes in the burning eye of the sky.

Before I began walking I believed that skylarks were something so rare and endangered that they belonged in the past, a distant place where they flew over Victorian villages in books and were set to music by Vaughan Williams. To see one, I would need to become a birdwatcher and sit tight in a hide for still and patient hours. As soon as I set foot on the chalk, they serenaded me on every high path. So many larks that I thought at first this must be some other tuneful bird because if an amateur like me could see so many, they could not be rare. I never see them rising, but they are always present, the waterfall of their song tumbling down from the sky, a reminder that the unexpected and beautiful things can be anywhere and don't require expertise to find them.

At the same time, it's as well to remember that the lark is not singing from joy in the summer sky. All it wants to do with its swooping and its music is to distract me, to make sure I don't attack its fledglings in their ground nest somewhere at my feet. Its song is born from fear and danger.

The road carries on and on with no shade, just different kinds of tarmac or granite hardcore, or more reconstituted road debris, or chalk dust. All of them are hard. The wheat is now ripe enough to shimmer in the sun, and when the wind passes over each field murmurs with light. Swallows skim over the ruffling surface while the crows are sitting on the track waiting for an accident to happen, so that they can eat it. They might be in luck today because now I am being passed by a long run of army traffic, truck after truck, then Land Rovers and transporter lorries too. I pass wire fences and signs and digging. A kestrel hovers over the hedgerow, waiting.

Eventually I catch up with the troops. At first I see only a couple of vehicles parked by a barn, but they have settled in, camo nets pitched by one truck, dome tents by another. As I get closer I can see inside the barn where there are tables and soldiers looking serious. Another Land Rover pulls out of the farmyard next door and only then do I see that the gate is guarded by soldiers with machine guns.

Further along the track the lorries have disgorged their cargo onto the grass, where the soldiers are now arranging their kit into neat rectangles of order, boxes of food stacked up beside them. They are planning to be here for some time. Others stand by, holding their guns loosely down, like sickles. A medical unit has been set up nearby, where someone sits doing paperwork. She's wearing a t-shirt which looks as though it's some kind of rock concert souvenir with a list of gigs, but when I read the locations it turns out to be from a tour of duty in Iraq.

We like to imagine the countryside as the inverted image of the city: simple, slower and connected to nature. It exists as a balm for our urban souls, a corrective, a medicine against modern life. Yet not everything which lives in the country is simple and good; it holds hunger and poverty, ugliness and back-breaking labour. It's home to all manner of unnatural things from nuclear power to quarrying. But what takes up most space of all is defence.

The infrastructure of warfare has little place in the city, apart from the occasional monument like Admiralty Arch. A lot of this is down to practical considerations: airfields and tank exercises take up a lot of space and are best put where land is empty and cheap. And it's generally best not to practise shooting in a built-up area. So the army tend

to be rural, yet they are rarely mentioned as a feature of the English countryside. That is the preserve of farming, parkland and, if you want to be political, grouse-rich moorland. Yet the Ministry of Defence are the second-largest owner of land in the country.

They first came to Salisbury Plain in 1898, choosing it for cavalry practice because the horses could gallop for miles across the soft unhedged grassland. Renting land from the farmers, they erected rows of bell tents to stay in and paid damages at the end of their summer stay, like a militarised version of a music festival. This worked so well that the War Office started buying large tracts of the eastern plain and the army exercised on it every summer.

This happened at a turning point for warfare. Within twenty years the First World War was underway. Attacking was now about tanks and machine guns, even aircraft, and the horses were only used for pulling supplies. Salisbury Plain could contain all these changes and more. The army bought further farms and land to hold gun ranges and tank paths; they constructed long networks of trenches to prepare their volunteers for France, where they would be digging in the same chalky soil. The wide flat landscape was perfect for aircraft too, so the first Army Flying School was founded on the plain and by 1918 six airfields had been built, one right up against Stonehenge. The soldiers and airmen have been present ever since. We just spend our time pretending they aren't there.

The track goes on, long and straight and hot. I pass a field labelled as a dangerous firing range, but a green tractor works calmly up and down its slopes, making the hay. Ahead a flagpole flies a red banner, meaning beware of

firing. I take a picture of it, the only landmark on this featureless stretch.

I'm up here entirely alone. People find it very strange that I want to walk by myself. It's seen as odd or subversive, something which needs sympathy. They offer to come out with me or, worse, to bring a dog. That would be a different experience entirely and not one I want. I could no longer walk at my own pace, thinking my own thoughts; they might make me stop for lunch instead of just eating as I go.

I am starting to realise that one of the reasons I come out on these journeys is to be released from expectations. The rest of my life is so full of urgencies and necessities and other people's needs that I sometimes think I will be buried by them. What's for supper, does E have a winter coat, why is the tumble dryer beeping at me again? The house is a whole universe of demands until on a bad day even a programme I enjoy on television can seem like the final straw, insisting that it needs to be watched. The noises are the worst; all the machines cry out when they need attention and the doorbell rings and nothing will leave me alone. As I write now the washing machine is sounding off in the kitchen and so clothes need to go out on the line and all too soon it will be time for food, again. However much I do, there is always something else to be added to the list and so it can never be ended. Tomorrow will bring more meals, another set of clothes used and discarded, deliveries to be taken in, questions arising and time spent. Only on a road with nothing else to do can I escape this great mound of chores and requirements. Only on a road do I feel that I am going forwards instead of around.

Even then, the tasks come up and find me in my high secret place.

The mobile phone is a great boon and one of the reasons I am not afraid to walk. It gives me maps and weather forecasts and safety, but I still do not love it because it has another side, pulling me back to the house however far away I take myself. I have questions about milk and lunches, whether E can go on the climate change strike and where someone has put the cat litter.

Men, it seems, find it so much easier to walk away from the domestic noise. Often, like Edward Thomas, this is what they are fleeing in the first place. His modern successors are not much different. So often a book will begin with a man walking out of the door with scarcely a mention of the family left behind him. Only as the narrative goes on does a picture form, of the crumbling house in need of renovation, the garden which has to be tamed, never mind the children who have to be fed, taken to school, have their uniform washed, be driven to and from clubs and matches and friends' houses. Someone has to remain at home, but this work goes on invisibly while the gentle author is at liberty to find himself in the landscape, away from the sapping effects of home and womankind. In one of my favourite examples, a man returns home at one point in his walking narrative to find his wife, left in the as-yet-unrenovated house, digging a potato patch while the children run wild on the trampoline. This domestic picture gladdens him; that she doesn't beat him to death with a spade is a perpetual surprise to me.

I have one child and a supportive husband who works from home, but even so the domestic responsibility falls mostly into my hands. There are plenty of ways of describing this situation nowadays, but most of the meaning you need is contained in the word housewife. What takes place

in the home, to do with children and provisioning, is my responsibility, and the logistics and forward planning take place in my head.

If I go out, even for a day, I need to leave instructions for food, make sure that T knows the time of pick-ups, appointments or visits. Should I want to set out as these other writers do, on an expedition, I would have to write a document of such complexity, buttressed with shopping orders and meal plans, timings and school admin, that the doing of it would put me off going in the first place. No wonder it is mostly men who write about walking.

Perhaps it is my fault in taking on so much responsibility, but these tasks, the mental labour, fall to almost every woman I know who has children, regardless of how long or little they work, or what their partner does. The idea of the mental load, of the way that the mother takes on board the whole domestic world, is all around me, and I belong to at least three Facebook groups of women my age for whom this is one of the main complaints. And we are all intelligent, educated women with careers, all bewildered as to how this lifework happened to us when we thought we knew better. It's in articles and magazines too, in comic memes and on social media. A thread on a women's website just this week was entitled 'Does anyone else want to run away from home?' Plenty of people did, perhaps just for a couple of weeks. But all we can manage to do is talk about the fact that it has happened to us; no one has an answer as to how we solve it. There is so much more at stake here than just my own choices. Women, it seems, still belong to the home and the domestic; only men are allowed to leave their families behind and get away.

It is possible for a man even to become a recluse, and

yet still have the woman doing the work for him. Thoreau wrote of his time in Walden as though he had been entirely alone, communing with nature in solitary silence, but in fact his mother lived nearby. She washed his clothes and brought him food so that he didn't have to climb down from his intellectual heights and worry about where his next meal was coming from. He fails to mention this in the book, never mind thanking her.

It's not only writers who succumb to this, they're just the ones who shout about it the loudest. This male getting away is embedded into our culture. It lives in our homes where men put the bins out while women sweep the floors and do all the cooking, except for the barbecue, which takes place outside the house and so does not belong to them. Men love their sheds, outposts on the furthest border of the domestic territory, as far away as they can get without leaving. I see it most in the MAMILs, the middle-aged men in Lycra who take up cycling, and whose weekend aim is to see exactly how much distance they can put between themselves and their home life.

This flight exists in other countries too. On Father's Day in Germany, the celebrations involve *Herrenpartien*, where groups of men go out into the countryside on a communal walk, taking with them handcarts full of beer. I'm not over-interpreting this either. The men believe they are going into nature, while a few years ago a female government minister caused outrage by saying that she thought the custom was awful and they should be playing with their children instead. Wild or domestic, you choose.

Underlying all this is the myth which still shapes too much of our lives: that men belong in the outside world and women should stay at home. This is the lens through

which we see the land, the countryside and our history; it's the story being played out in the panels at Barbury Castle. The men are loading carts, getting ready to go out beyond the earthen banks, while the women are weaving or cooking, done within the roundhouse or at least close by. Women are not meant to wander, and I am crazy to think that I can be any different.

The road makes a sudden switch to the right and all at once I am in a place I know well: the wide open grasses of Bratton Camp, yet another hill fort on the ridge. Bratton is huge, able to hold walkers and their dogs, people flying kites, cyclists and small children. Below is the village of Edington, thought to be the Ethandun where King Alfred defeated the Great Heathen Army in 878.

Although most archaeologists and historians are no longer interested in the pre-history of roads and trackways, there's one big exception: those who are interested in discovering exactly where King Alfred fought the Danes. Chronicles of his travels and battles exist and people are fairly certain that the Ethandun they speak of is the Edington which I can see below me, but plenty of places along the way here remain to be pinned down.

In order to calculate where things happened, these historians pay a lot of attention to how the army got from place to place. The practicalities of troop movements were so important that the Anglo-Saxons of Alfred's time had a very specific word, Herepath, or Army Road, which meant one wide and direct enough for an army to march along – and stretches of lane are still called this up and down the country, including one which leads down from the Ridgeway into Avebury itself. But mostly the historians conclude

that when Alfred travelled from Athelney in Somerset to Ethandun, he must have used the Ridgeway and Harrow Way. Roads do have a history, it turns out.

The biggest landmark on this hill, however, is one I can't yet see: the Westbury White Horse. This hill figure isn't primitive or mysterious, it's a rather stout and agricultural white horse engraved into the slope beneath the fort. It might be old, or it might not. The current design was cut in the eighteenth century, but it might have covered up something more ancient. There's only one, disputed, picture of what came before – a kind of demented sausage dog with a dragon's tail, a saddle and one boggling eye – so we will probably never know. The emblem could have been cut into the hillside to celebrate Alfred's victory, or out of respect for the House of Hanover, or for some other reason entirely. Whatever it was, and whenever it was carried out, the modern horse still stares out across the vale, visible from miles around and revealing nothing as it surveys the human business beneath.

I follow the edge of the ridge until I am looking at the figure across a fold in the hillside. This is one of the best-known views of the Westbury horse. In 1939, Eric Ravilious painted a famous watercolour pretty much where I am standing, the animal foreshortened by the angle, the green hill behind and in the valley below, a tiny black steam train heading through the fields. In the same year he also painted another view, as though seen from that train. In this image the horse is framed by the tawny wood veneer of the carriage window. He shows us the painted figure 3 on the third-class train door, and the diamond pattern of the seating moquette: a modern setting for the much older horse and hills. The two pictures together make a slightly

disconcerting pair, as though the Ravilious on top of the ridge could wave at the train and the other Ravilious, at work in the carriage, could wave back.

Brought up in the South Downs, Eric Ravilious had a passion for all chalk landscapes, and painted many scenes around Wiltshire. He had a particular love for white horses and the other chalk figures, and was putting together illustrations of them for a book at the time of his death in 1943.

This fascination was more than a personal quirk, the result of a boyhood on the downs; it represented something of the times he was living in, because his love of the chalk was shared by two other important artists of the time, Paul Nash and John Piper. All three were in various combinations friends, teachers and influences on each other's work, and all three have been my guides and companions on the chalk and its roads over the years.

Nash painted the chalk landscape of the Ridgeway throughout his life. At the very start of his career he became fascinated by Wittenham Clumps, a pair of hills topped with beech trees, barrows and a hill fort, just off the Ridgeway in Oxfordshire. The place became part of his personal iconography and he painted them both before and after his experiences at the front in World War One. Much later on, in 1933, he arrived by accident in Avebury and was profoundly affected by both the ancient stones and the downland which surrounded them, inspiring him to create an entire series of rural but modern paintings as well as many photographs. In painting these old, almost abstract places, he felt he could humanise his art without having to tell a story. Or indeed draw people, which he wasn't very good at.

Although John Piper is now best known for his studies of churches, great houses and ruins, he had a longstanding interest in archaeology. In the 1930s, as his painting was turning away from abstraction, he produced a collage, *Archaeological Wiltshire*, which shows an avenue of stones, with the downs, a hill fort and the line of the Ridgeway behind. It's one of the most evocative images of the place I know.

His life was also intertwined with this countryside in a more practical way. In 1935, he and Myfanwy Evans, who would become his wife, moved to a remote farmhouse in the Chilterns. Fawley Bottom farmhouse sits in a small valley just a short walk away from the Ridgeway path, and they would remain in this place for the rest of their lives.

These connections are not just accidental. The simple uncluttered lines of chalk downland helped all three artists resolve a question which haunted each of them in the years between the wars. How is it possible to be modern and at the same time British? Paul Nash first articulated this question, but it was Ravilious who explained why the downland was the answer. Its design, he said 'was so beautifully obvious'.

Up here, it's easy to see what he meant. As I stand above the white horse and look down into the vale, each patch is a tangle of hedgerows and paths, roads and pylons, sheds and barns and houses clustering into villages. Fields of oats and wheat are patchworks edged by darker hedges and trees. I can see ponds, quad-bike racing tracks, pubs and garden centres, old manor houses and new estates. Below the road, a field of solar panels glitters in the sun like a lake.

In comparison, the chalk ridge on which I am standing

is easy to take in. Up here are few hedges, fewer farms. Instead there are tracks and space and hawthorn, and between them only a flat and even sheep-grazed green. Where the gradient allows, some of the slopes are planted with corn, but not many. Along the edges of the hill there are mounds, earthworks and ditches, but all smoothed off by time so no sudden edges spoil the lines.

Chalk is the countryside reduced to its most essential features: green grass, the curve of the hills, the sky above, in the same way that a modernist building strips away all the fripperies of decoration to reveal an essential form. This is the place to be modern and British at the same time.

When I first discovered these landscapes and the Ridgeway and walking, I took Nash, Piper and Ravilious as comrades. They understood the mystery and joy I had found here and could – in a way I was not able to do – transmit this magic in their art. Nash's paintings in particular worked their way into my mind as I walked, and consoled me when I could not be there. Stuck in a hot and airless London, I would go to Tate Britain and study his modern geometric megaliths set against sharp-edged hills, wanting them to explain the downland back to me all over again. It was like drinking cool water from a tap when I could not get to the spring.

Their works also offered hope that there was a way of being in the country which might suit me. I wanted to be a modern person and at the same time love these pastoral places. I didn't want to hunt foxes and pheasants, nor to prefer historic architecture and chintz. These pictures reassured me that I did not have to wear mental tweed, that I could be both rural and contemporary if I so chose.

Returning now to these places and their pathways, I found that these artists also had something else in common which spoke to me differently in my new state, and I did not like it so much. Ravilious, Piper and Nash each married an intelligent, spirited and extraordinary woman, but kept them tamed and domesticated so that they, the male artists, could devote their time and energy to painting. Despite their professed modernity, their domestic arrangements were no different to all the other men who walked away from home while relying on their wives to stay behind with the children in an unsuitable house. Edward Thomas may have died in the First World War, but his spirit roamed the countryside long afterwards.

Each of the three wives was unusual in their own way. Dark-haired, elegant and wry, Tirzah Garwood met Eric Ravilious when he, five years older, was teaching her at Eastbourne College of Art. Garwood was a talented artist in her own right, whose woodcuts were praised in *The Times*, leading to commissions to illustrate calendars and books. Some critics believed her more talented than her husband. But after marrying Ravilious in 1930 she never made another engraving again.

The couple moved out to Essex and had three children. There Tirzah spent what little spare time she had creating marbled papers to be used as lampshades or the endpapers for books. Beautiful and subtle as they are, it's hard not to think that she chose an outlet for her talents which could fit around children and the domestic chores that she never really cared for. In the early days of their marriage, the Raviliouses shared a house with Edward Bawden and later also his wife Charlotte. Eric Ravilious rhapsodised this

domesticity in a painting of Tirzah in the garden, shelling peas. Tirzah was less keen.

> Living like this with Eric and Edward was very hard work and I didn't have much time to enjoy the country and I got annoyed with Edward if he was unreasonable which he was almost continually, being fussy about his vegetarian food and childishly silly about housework, doing nothing unless Eric did exactly the same amount.

Bawden would invite guests and expect Tirzah to cater while her husband barely paid attention. She wrote that she wanted a holiday away from people and from housework. I know exactly how she felt.

Eric, of course, could get away when he liked, visiting friends and travelling to find the right vistas to paint. For most of their married life he was also having a series of affairs, leaving Tirzah briefly when she was heavily pregnant with their first child. Even if this tumultuous life was what she desired – and Tirzah too had a lover, she was not just the passive subject of her husband's actions – it was living with him which crushed her creativity. And, of course, it was always her who was left holding the baby. Nonetheless, Eric and Tirzah were still together when the Second World War began. At the end of 1941, aged just thirty-two, Tirzah was diagnosed with breast cancer, requiring an emergency operation. Six months later, her husband was dead, shot down over Iceland while working as a war artist. His first biography was written by his mistress, perhaps one reason why Tirzah's story has fallen by the wayside.

Despite the war, being a widow, having three children under eight and remarrying in 1948, the following years were her most productive. She created small, unsettling paintings of dolls and domestic objects in garden settings, as well as 3D paper models of shops and houses. Eerie and intense, none of this work is like her woodcuts, or indeed anything else being produced at this time. Soon after she remarried, her cancer returned, but not even this prevented her from working. In the last year of her life, often bedridden, she produced twenty paintings. The only thing which ever stopped her creativity, it seemed, was living with another artist.

Myfanwy Evans wasn't an artist when she met John Piper, but she was intelligent and unusually driven, winning an exhibition to read English at Oxford. Although from a conventional middle-class background, brought up over her father's chemist shop in Kensal Green, she felt no need to conform. When she first met John Piper in the summer of 1934, he was already married. Divorce then was slow, but they didn't let that get in the way of their life together. Six months after meeting they moved into the semi-derelict farmhouse at Fawley Bottom and for the next two years lived there in sin. Her parents did not approve.

At first they travelled around England together, finding locations for John's painting and photography, while Myfanwy founded and edited the modern art magazine *Axis*. Once their first child arrived in 1938, though, all this had to stop; she remained at home while John carried on travelling with others.

The Pipers had four children in all and the abiding

image of Myfanwy, always quoted whenever she is mentioned, comes from Natasha Spender. She visited for the first time and was met at the door by Myfanwy with a small child in one arm and, in the crook of the other, a bowl of eggs which she was whisking with her free hand. She loved cooking and was serving gazpacho, sorrel and seabass with fennel at a point when tasty food of any kind was a rarity in England, but producing it must have been hard work in the kitchen at Fawley Bottom. When the couple first moved in, the house had no electricity, gas or even mains water – the kitchen was lit with paraffin lamps and Myfanwy cooked on a wood-burning stove. It took nearly twenty years for the electricity to arrive.

Despite having a huge studio created from their barn, John Piper's love of architectural subjects meant that he was often away, painting buildings which could not come to him. During the war, while Myfanwy was coping with two children under five and rationing in the spartan conditions of Fawley Bottom, her husband received three commissions, each of which had the advantage of a luxurious billet while he worked. As well as a set of drawings of the great house at Knole, he also completed eighteen paintings of Osbert Sitwell's family house, Renishaw Hall in Derbyshire, which meant a series of visits to a life of quiet leisure, with a butler and dinner served every night.

The third commission was the grandest of all: watercolours of Windsor Castle, for the royal family. Piper stayed in the castle for weeks at a time and their family friend, John Betjeman, noted the sharp contrast between the worldly benefits of John's work and Myfanwy's mundane round of duties. He sent them a letter with a set of comic drawings

in which John paints surrounded by great luxury, while Myfanwy stays at home, sighing and weeping as she washes the dishes.

All of these women were unusual, but Margaret Nash was probably the fiercest and most individual of them all. Her husband's close friend, Lance Sieveking, described her as 'the most extraordinary woman who ever lived'. The dark-eyed daughter of an Egyptian Anglican bishop and his Irish wife, Margaret Odeh arrived in England aged sixteen to be educated, an experience which culminated in a first-class degree in History from Oxford.

Bunty, as her friends called her, was a committed suffragette who threw herself into direct action for the cause, regardless of the danger. At the time, some wealthy women were refusing to pay taxes while they had no vote. Bailiffs would be sent in to recover the debt, but members of the Women's Tax Resistance League, including Bunty, would be there to obstruct them and drive them away. Her speciality was driving into the fray in a low milk cart, carrying a dog whip which she had bought after a brush with some anti-suffragette medical students.

'. . .what you want, sweetheart,' said one, grinning into her face, 'is raping.' Margaret hit him across the mouth as hard as she could. He bled alright, but it hurt her fingers which were too soft. So she bought the dog whip.

Nothing about Margaret Odeh was straightforward or submissive or in any way average. Her feminist beliefs meant that her London home was the International Women's

Franchise Club, home to a collection of multinational campaigners and a very opinionated parrot which her husband remembered with little fondness.

> If you trod on or 'fouled' the parrot in any way [quite likely because it was a green parrot on a green carpet] it would call out 'A spy, a spy' in a terrible voice. Sometimes it just bit you out of sheer irritation at not being provoked.

Margaret Odeh was an activist, but she also got things done. In 1911, aged just twenty-five, she was one of the founders of the Committee for Social Investigation and Reform, which worked to assist prostitutes. Until this point, almost every charity trying to get prostitutes off the streets had been driven by evangelical Christianity and the desire to save souls, but the CSIR was set up by feminists. For the first time, prostitutes were not judged or punished for their sins, simply assisted with secular social work. The CSIR's main project was the Women's Training Colony, set up in an old Berkshire mansion, Cope Hall. This innovative and humane community gave the women a new life in the country, allowing them to learn skills and free their minds. Those with children, illegitimate or not, were allowed to bring them and the views of the 'colonists' were heard in weekly democratic meetings.

Odeh seems to have been appreciated by the Colony's residents. When she married Nash in 1914, 'her girls' took up three rows of pews and one of their friends noted that 'judging from all the glances and whispering, they evidently doted on Bunty'.

Yet when her husband returned from the war in 1918,

Margaret Nash entirely gave up her own projects and devoted her life to supporting his work. Paul wrote to a friend giving a vignette of married life in Amersham, where he was sharing a studio with his artist brother John.

> We all lunch together in the studio where there is a piano so our wives enchant us with music thro' the day. A phantastic experience, as all lives seem these days but good while it lasts. . .

This idyll did not last, and nor did it end because Margaret Nash decided she had better things to do than play music to enhance her husband's creativity. The couple returned to London because Paul had been having an affair with a local woman, whose husband was threatening to kill him.

Despite this and Paul's later affairs, including a long one with surrealist artist Eileen Agar, Margaret never gave up on him and the needs of his art. Lance Sieveking saw how all of her energy and will went in the service of her husband's career.

> She devoted her whole life to sustaining him, protecting him, encouraging him and more than once actually saving his life. What differences there would have been in his life and work if he had not married this woman of powerful character is a matter for conjecture. But that her presence in his life had its effect is indisputable.

In some ways I find Margaret Nash's situation the saddest of all. Tirzah Ravilious and Myfanwy Piper are remembered

in biographies and recognised as people even now; both have created works which remain, even if their posthumous memory mostly relies on the importance of their husbands. Bunty Odeh was fierce, bewitching and made a huge impression on everyone who met her. Intelligent, political and practical, she could have achieved so much in the world. As Margaret Nash, she disappeared entirely, a pale entity overshadowed by the husband she worked so hard to support. Paul died in 1946 but she lived on for another fourteen years, her only function as the keeper of her husband's flame.

I resent and mourn these oceans of wasted talent and energy. Even the brightest and most independent women were forced by marriage to channel their lives into domesticity and someone else's work. How much more could these women have done, and how much further might they have gone, with freedom.

Of course, in doing this, I am making judgements from the perspective of the present. I cannot speak for these women. Perhaps Tirzah, Myfanwy and Margaret liked their lives and chose the way they lived. That was my consolation, until I found a recording of Myfanwy Piper being interviewed late in life, a few years after John had died. Was it hard to come here, to Fawley Bottom, she was asked. The answer was surprising. Myfanwy described herself as a town person. She had loved London and really missed it.

Perhaps these women weren't even as happy in their domestication as I would like to believe.

The Ridgeway, ish.
Four miles near Wantage and eleven miles around Avebury

Today I am walking a part of the Ridgeway which I have followed before as it heads from the Thames west through Oxfordshire, past Wantage and Faringdon. But I have chosen this repetition because I want to look for a stone which I missed on my first visit. It's a clue about another woman who lived with an artist who loved these high chalk landscapes, but for a change she left a record about how she felt. More importantly than that, she set out to explore these places on her own and ended up, after a long time, walking away from home on her own.

Now I am not just treading on old ground but reshaping it, trying to transform the landscapes of Nash, Piper and Ravilious into places which are also inhabited by women. I want to fold these histories into a new shape and then walk through them again, differently, creating a new space in which I, too, can live in a different way.

The other reason is that I am here anyway, passing on the way back from seeing friends. The journey home takes me across the Vale of the White Horse, overseen by what

is perhaps my favourite piece of crumpled-handkerchief time, where past and present sit very close indeed.

Nine white horses have been carved onto the English countryside, and even though the chalk hills run from Kent and Lincolnshire all the way across to Dorset, most of them can be found in Wiltshire. The exception is the Uffington White Horse which began its life in Berkshire but became included in Oxfordshire during the 1970s. It's the best known, and the most resonant. Rather than looking like a squire's trusty steed as most of the rest do, it is abstract, streamlined and inscrutable with a square head, a single eye and limbs and body formed out of the simplest of lines. As early as the twelfth century, it was noted as one of the wonders of Britain, in a list which is an early medieval precursor of a guide you might now read on the internet.

That the horse has survived at all is a kind of miracle, described by one writer as 'the most astonishing fact in British archaeology.' It remains because of folklore and tradition, which meant that every seven years the local community got together to clean up its white outline, 'scouring' it back to bare chalk and then holding a huge fair in the hill fort above. They must have performed this ritual without fail because other, modern hill figures have disappeared within twenty years or less.

For a long time, archaeologists debated whether the Uffington figure dated back to the Iron Age, when similar stylised horses appeared on coins and metalwork, or whether it was Saxon, created to mark one of Alfred's victories in battle. That it might be properly prehistoric was never really considered. As with roads, archaeologists resist the idea that anything can survive that long through tradition alone.

There could be no proof: the horse is composed of nothing, just an absence of grass, and so it could not be so old.

But new techniques are now available to interrogate the world, and one of these, optically stimulated luminescence, proved that the horse is far older than anyone believed. It dates to the Late Bronze Age, which means that villagers and their helpers have been climbing up the hill to re-make the horse for more than three thousand years. And of course the Ridgeway runs its high way along the crest of the hill just above its head. If these diggings in the chalk can be the remnants of an idea from prehistory, perhaps the roads can be too.

Uffington White Horse proves that continuity doesn't have to be a delusion. It proves that stories and tradition can link us with the people who lived on this land thousands of years ago. I want the roads I am following to have existed for as long as people have walked on this island, so that I can journey on the same tracks. Uffington White Horse tells me that I should have faith. It is possible that all of these things could be true.

But today, the horse itself is not my destination. Instead I'm in search of a rather lesser-known monument which also sits alongside the Ridgeway. Here, just outside Wantage, I can drive right up to the pathway so there is no need to climb. When I get out of the car, I see a red kite banking and swooping in the air currents over the vale, the arc of its wings and forked tail exactly level with my eyes.

The rise and fall of the downland surrounds me like a display of farming prowess. Each field has already been striped by haymaking, like the pattern of mattress ticking

or twill, fine green lines of new growth springing up between the pale cut stalks.

As I walk along the track, after a mile or so it opens out into a wide space, enough for two sets of ruts to run in parallel with great wide verges beside. Further along it becomes a huge triangle, marked by a dent which must have been a dew pond, and a stand of tall pines to one side. A good place to stop and rest your sheep overnight.

I'd thought the walk would only take fifteen minutes or so, but it turns out to be much further, mainly because I've forgotten the scale of the maps in my old guidebook. I arrive with hope at one copse of trees only to discover I'm not even halfway there.

Even when I find the right place, I can't see what I am looking for, until I climb over a stile into a field. There, set up against a fence, is a single sarsen stone, facing out over the vale like a person taking in the view. Placed in its holes and hollows are three flints and a piece of bright red plastic, so I am not the only person who has made this pilgrimage. Set into the stone is a slate plaque, engraved with the words: 'In memory of Penelope Betjeman, 1910–1983, who loved the Ridgeway'. This memorial is what I have come to find.

Penelope Chetwode, who married the future Poet Laureate John Betjeman in 1933, is yet another of the intelligent, fascinating and undervalued women whose husbands so loved the downland that they shackled their wives there while remaining free to walk away themselves. Betjeman discovered this landscape when he was a schoolboy at Marlborough, and it was his choice entirely that their first family home should be in the village of Uffington, right below the White Horse and the Ridgeway.

Penelope is usually portrayed as horsey and overpowering, a typical loud-voiced English woman of the upper classes; the kind who went to finishing school, came out as a debutante and then spent the rest of her life riding in the country. If people know one thing about her, it's that she was eccentric enough to bring her horse into the house. However, history isn't only written by the victors: it's also written from the point of view of the husbands. None of the tales about Penelope are false, but at the same time the prevailing picture does a hatchet job on the idiosyncratic, smart and witty woman she was. Let's deal with the horse in the house first.

Yes, there are pictures of Penelope and a few friends taking tea with a horse in a very smart neoclassical drawing room. And it's her prize white horse Moti. But this isn't her house, and if we look at a few more photographs from the sequence it's clear that there is a very good reason for what is going on. Penelope has brought the famously elegant Moti to the house of her friend Lord Berners, so that he can paint the horse. Berners was a talented amateur artist, who exhibited his works in London, and lived at Faringdon House, a few miles from Uffington. Most importantly, he was whimsically eccentric and had the money to indulge this, dyeing the pigeons in his garden all colours of the rainbow, and occasionally requiring monochromatic meals, so if his mood were red, he would eat beetroot soup, steak, tomatoes and strawberries. In the grounds of his estate he erected the last folly to be built in England. Serving tea and cakes to a horse would be right up his street. But in history, it's Penelope who gets the blame.

In reality, Penelope was anything but frivolous. Even her conventional father described her as having more than

the usual share of brains. She did go to finishing school, but spent her time there learning to fence, becoming fluent in Italian and developing a deep love for art history. She hated coming out into society, complaining that the conversation at dinner parties was always dull and no one she spoke to had ever heard of Giotto.

Penelope emerged from her debutante summer sulky and being pursued by someone that her parents thought unsuitable, so as a distraction, they took her to Delhi, where her father was Commander-in-Chief of the Indian Army. There she fell in love, not with an eligible suitor, but with Indian art and architecture – and also the married archaeologist who was teaching her. She travelled the country with him and her unsuspecting mother, feeding her enthusiasms until she decided that she was going to spend her life as an academic Indologist.

That was still her intention when the family returned to London in 1931. The family could have returned to a white-stuccoed house in Kensington, like the rest of their class, but instead they bought a blowsy Italianate mansion in St John's Wood built by the high-Victorian artist Lawrence Alma-Tadema to his own design. The Chetwodes bought it directly from his family and kept its many eccentricities, including a brass staircase, the marble sunken bath often depicted in his classical paintings, and his double-height, aluminium-walled studio.

Penelope had her own sitting room, created by Alma-Tadema as a recreation of the Ship Tavern in Greenwich, and decorated by her in clashing modern colours with bright cushions. This was where she was living when she first met John Betjeman, bringing her photographs of India to his office at the *Architectural Review*. At this point,

she was definitely on the eccentric fringe of the upper classes and the house was a marker of that. Perhaps it also had an effect on her suitor; Betjeman, who mocked his in-laws relentlessly, is often seen as the first person to really appreciate the exuberance of Victorian architecture, but in fact it's his mother-in-law who was the true pioneer.

When they became engaged in 1932, Penelope was twenty-three. She wasn't at all certain about getting married, but not because her parents disapproved of John – although they did. His father was in trade while hers held one of the most senior ranks in the army, and her mother had always assumed that her only daughter 'would marry someone with a pheasant shoot'.

In order to try and dissuade Penelope, they took her back to India with them for a few months. Betjeman's biographers usually describe what happened while she was away as a flirtation with another girl in their circle, but seen from Penelope's point of view it was far more vindictive. Billa Harrod wasn't just any other girl, but Penelope's best friend since childhood. They'd known each other since they were eleven, meeting in Aldershot where both their families were stationed. And John did much more than flirt: he proposed to Billa. Betjeman was goading Penelope, threatening to replace her with her very oldest friend. Despite this she came back at the end of the summer still his fiancée, albeit one who still had very grave reservations about getting married.

But these were not because John had behaved so badly. Her uncertainty was that marriage would interfere with her ability to study, and if she ended up living in the country with John her 'love for Indian stuff would boil up like lava'. She had no idea how prophetic this would be.

The two of them came to an arrangement that Penelope would go off to study in Germany for six months, as German was the language of most Indian scholarship at that time, and then they would marry. Whether consciously or unconsciously, John again set out to scupper her plans. This time he had an affair with the maidservant who was helping him get their new home ready. Once again, his tactics worked, and Penelope came back to England after three months, not six.

At this point, Penelope Chetwode should have put John Betjeman in the bin, where he belonged, and got on with her studies. Both these affairs are a portent of her future life with him: of his constant infatuations, one following another, and the way he will sulk over and wreck her academic interests. For their whole married life he will never write her a love poem.

But she did not walk away. Instead she married the scruffy buck-toothed poet from the middle classes (her mother speaking there). From then on her life consisted of riding and socialising and the WI in Uffington. This wasn't what she wanted, it was what she was permitted to do.

Penelope also had to teach herself to run a household. Living in the middle of nowhere was an absurd choice for someone like her. As the daughter of such a senior officer, Penelope had never had to do a single thing for herself and had no idea where to begin. Always resourceful – a trait which would turn out very handy given her choice of husband – she brought a German cook/maid over from Berlin and got her to explain the practicalities. John was away, often, in his London flat for a day or two each week and then

travelling the countryside with John Piper and others to research the Shell County Guides. Penelope was left to get on with it, in a house which hadn't left the nineteenth century: the rooms were lit by paraffin lamps and water had to be fetched from the village pump. When her father came to stay for their first Christmas in the house, he described it as 'like living in the dark ages'.

At first she tried to keep up with her studies, and two years after her marriage, she attended the Congress of Orientalists in Rome, but when their first child, Paul, was born in 1937, even that stopped. Penelope ended up doing what so many women have done subsequently, and took a part-time job which fitted around the children. In her case, this meant writing cookery articles for the *Daily Express*, although she was sacked after a couple of years, when she failed to check a recipe that a local informant had given her for marrow wine, and the error resulted in explosions in larders up and down the country. Then the war intervened, John was sent to Ireland as a press attaché, and all Penelope could do was follow.

Throughout their marriage, Betjeman bullied and abused his wife. His bolthole in London enabled him to indulge his infatuations and affairs, and there he ate lavishly and drank champagne while not giving Penelope enough money to run the house properly. When back, he was demanding, filling the house with guests and complaining endlessly about the food and the smell of cooking and the children, while being intensely rude to any of Penelope's own friends she might invite to stay. One weekend, he bought a cafe in Wantage which Penelope wanted nothing

to do with but, being practical and not in London, inevitably ended up running.

She was also the butt of his slight but repetitive cruelty. He always referred to her legs as 'the Broadwoods', not only for their size, but because he said they looked like the legs of a Broadwood piano. Penelope brushes this off, but in letter after letter he sends his love to 'the Broadwoods', not her. This relentless attention to a flaw would chip away at anyone's sense of self.

On some level, Betjeman knew he wasn't being kind or fair. His caricature of Myfanwy Piper crying into the sink didn't just arise as a flirtatious tease, although that was almost certainly part of how it was meant, because his friend's wife was yet another of Betjeman's crushes. He must also have known that he was running away from domesticity every time he fled to London or off in the car, leaving Penelope alone in the house with a heap of drudgery. The difference is that their relationship seemed to lack the joy which Myfanwy and John Piper found in each other.

The desire to preserve John Betjeman as a cuddly national treasure is so intense that no one wants to examine how badly he treated Penelope. He was often angry and unpleasant, and she despairs in her letters about their arguments.

Her husband was also grumpy on a daily basis, particularly at breakfast, where he would complain about marmalade on his cuffs and 'missing newspapers', which would usually be found underneath him on the chair. John was also relentlessly unpleasant to their first child, Paul, whom he referred to as 'it'. Paul carried the scars of this for ever, becoming totally estranged from his father and moving to America. 'He wanted to keep me down,' was his verdict in later life.

Perhaps his biggest cruelty to Penelope was that he kept

his wife at home. This was a very deliberate act. She loved travelling, far and adventurously, but for all their married life, John refused to have anything to do with abroad in any shape or form. His friends warned him about this before he was even married, telling him that he would have to learn not to be so parochial if he wanted to make Penelope happy. He didn't listen to them and for years they never left the country. Betjeman changed in later life, when he was having a long affair with Lady Elizabeth Cavendish. Then he was happy to visit France and Italy and Greece. But not with his wife.

As well as travelling, he also writes her letters from Lady Elizabeth's home of Chatsworth which make me flame with anger on Penelope's behalf. Her husband is sitting in this grand house because he has got his feet under the table with his mistress's family. He is loving the aristocratic high life, despite having taken his wife away from this kind of exist-ence and leaving her to subsist on insufficient money in a house with no mod cons, never mind servants. And he's writing to tell her all about it. The only pleasure I can get out of the situation is in imagining a modern Penelope posting online for advice on her marriage. Betjeman would have been pinpointed as abusive and coercively controlling within minutes, and she would have been told to value her-self more highly and get away from him as soon as she could.

All of this matters because Betjeman's appeal and pro-tected status comes from the sense that he is England. His dishevelled, overcoated, stout form represents an essence of the nation, in particular the parts which are often passed over: ribbon development and polychrome Victorian build-ings, the kinds of schoolgirls who will make good mothers and wives. His behaviour reminds us that this whole edifice

depends on keeping women in their place. And in England, that place is at home – even if the wife concerned would far rather be trekking across the plains of India on a horse.

Despite the many eccentricities on both sides, the Betjemans' marriage was profoundly typical. Penelope was as intelligent and forceful as any woman in England at that time, but this didn't allow her to break free from the pattern of life into which she was expected to fit. Wrongs were done to her not just by her husband but by the institution of marriage; by the society which kept her at home but allowed him to range free all over the country, having a life which she could only envy but never live herself. What hope is there for the rest of us, even now? I too thought I was strong and atypical, and look at me, fettered to the home as much as she ever was, despite having a better husband and living in more enlightened times. Will women ever be able to escape the domestic?

Although she never chose this as a place to live, the stone in front of me says that Penelope came to love the Ridgeway, and I believe she did. During the Second World War, she worked as part of the Observer Corps, looking out for planes and incoming spies, a job which meant she had to ride out on the downs at all hours, from dawn to late in the dark. For her, as for me, the long rolling pathways of the Ridgeway meant a brief escape from home. Even so, it doesn't mean that these chalk hills were where she most wanted to be. The place she loved above all was not in England, but in India: the Kulu Valley.

Ever since I left India . . . the vision of this valley has repeatedly come before me during the day as well as

during the night and on downland rides at home in Berkshire I have sometimes half closed my eyes and there it is again, replacing the distant view of White Horse Hill.

Like so many women, Penelope could only make do with what was given to her. She had to stay at home.

On the way back from her memorial, another monument is set alongside the track. I'd hurried past it on the way out, but now I have time to stop and consider it properly. It's a stone cross commemorating local grandee Lord Wantage, standing on a Victorian ornamental base like a marketplace fountain, and it's hard not to think that this and Penelope Betjeman's memorial have been designed in opposition to one another. Hers is tucked away, so that only those who know will ever find it, and it takes the shape of something which could easily have arrived on that field edge by accident. Lord Wantage's, meanwhile, stands on the crest of the ridge, the tall cross visible for miles around, and it's even been situated on a Bronze Age barrow, for maximum height. The people who built that barrow would probably appreciate the symbolism of the two stones as well: his tall, male and erect, hers recumbent and rounded, with crevices and niches.

Men also need to have more said about them, it seems. All we know of Penelope is that she lived, and loved this place. Lord Wantage has to remind us that he owned this entire area and that this cross has been raised up by his wife and that he will lift his eyes up unto the hills from whence comes his peace.

These days, though, should you lift your eyes up from

Lord Wantage's monument, peace is not the first thing they will light on. Down below the ridge sits a spread of grey buildings, and when I drive back down the hill, the signs are directing me to Harwell Science Park, another reminder that not everything in the countryside is fruitful.

The emptiness of the chalk downland is not just handy for the army. It's also a very good place to hide things that you don't want other people to see, or to put dangerous things which take up a lot of space. Harwell is here for both those reasons. What's now the Science Park used to be the Atomic Energy Research Establishment. When I first walked the Ridgeway, the chain-link fencing here bristled with red danger warnings and signs emphasising that this was a prohibited site. Not surprising, because Harwell was the place where Britain's atomic bombs were begun.

During the Second World War, the site was initially yet another airfield, RAF Harwell, used to send gliders to D-Day, but this was requisitioned in 1946. The nuclear scientists were looking for a location with plenty of existing buildings, particularly hangars to house large reactors and engineering workshops, which basically meant an airfield. It needed to be close to either Oxford or Cambridge for easy access to boffins, but as far away as could be managed from other people, in case something went wrong. Cambridge had a higher boffin quotient, but, with the Cold War looming, the RAF insisted on holding on to all their airfields in the east. Other sites nearer Oxford were surrounded by suburbs, so Harwell it was. Within ten years, six thousand people worked here, bussed in from nearby towns and villages. Not everyone was impressed.

Foul Harwell, ugliest village of the downs,
Where labs and aluminium prefabs sprout
And houses camouflaged in green and brown
Their military architecture shout.

These lines were written by one of the resident scientists rather than Betjeman himself, but he hated the place too, cornering the first director of the AERA at a local function and berating him for covering the downs with prefabs.

John and Penelope's daughter, Candida, writes about Harwell and the downland in a novel, *The Dangerous Edge of Things*, which is in most part a barely disguised account of her upbringing, with a more invented sub-plot about atomic science and spies. This shows how Harwell loomed large in the empty countryside when it was meant to be concealed. The site was a physical manifestation of the atomic threat, a cloud always visible at the edge of the primary-coloured gaiety of the 1950s.

But the book also says something about Candida's childhood, that it was perhaps not quite as safe as she remembered it. Candida was the favoured child, her father's darling and the editor of his letters in later life, but she also seems to have understood that her joy came at a profound cost for her mother and brother. In the book, she represented this darker side in the form of atomic energy, that dangerous looming presence close to home.

Being practical and realistic, Penelope Betjeman also saw the countryside for what it was rather than any kind of arcadia. In particular, she's one of the few other people I've found who speaks about the presence of the army on the land.

In 1957, she began the adventuring which marked the second half of her life by taking herself off to Avebury with a friend to explore the area on horseback. She adored this downland too, but a night ride to Silbury Hill showed her its other aspect. Exhilarated by the moonlight, they rode on past the hill and down a concrete track which should have led them to the massive ditch of the Wansdyke. They somehow missed the earthworks and came across a scattered artillery range, 'with huge guns and mysterious radar cones with red lights on them making a humming noise but no human beings in sight. All the grass was covered with what looked like lots of sarsen stones but on closer inspection proved to be chalk potholes made by the shells.'

What she'd seen was at the heart of countryside I thought I knew, yet I'd never seen any trace of it, nor could I discover any references online. I decided that I would follow where she had gone, to see if I could find any remains of the radar equipment and shell craters, or even the concrete road which had brought her there.

Harvest is beginning, and some ground is already scalped and golden, while other fields are newly ploughed, one dark brown speckled with flints like some kind of tweed, the next almost pure white. I walk along a rutted path which traces their edge, while in the distance a lorry grumbles down a farm track, loaded down with bales of straw. Despite the fact that I am miles from the army redoubt of Salisbury Plain, a matte grey helicopter flies alongside the ridge, parallel with my route. Perhaps it too is looking for the artillery range.

The path is narrow and greenly lush from rain. It's hard going; the grass sticks to my feet, dragging on my

boots and it hides the rabbit holes too, so I keep stumbling. I think about what it would be like to be stuck out here with a wrenched ankle. I can see for miles but have no idea how an ambulance would get to me when I am so far from the road. Perhaps I should have ridden, like Penelope.

Halfway along, the track comes good. I enter a small holloway, where hawthorn bushes bend down over me, and, as I walk on, this gets wider until it opens up onto the high downs and I can trace the full line of where I am going through the fields.

Marking the length of the ridge in front of me is the Wansdyke, the ancient ditch and bank which wanders along these hills from east to west, a prehistoric stop line. Even from this distance it's easy to see, as if a boundary line from the map has been carved into the earth itself. Or a scar, perhaps, from where two parts of England have been sutured together. The cow parsley and ground elder have lost their white blossom and become stiff stems topped with papery seeds. I crumple the heads between my fingers and scatter the remains on the path like confetti. Something, I hope, will grow.

When I've crossed the Wansdyke before, it's been worn down so I cannot believe how much remains here: the ditches are sunken and the banks still high. It's as vast and impressive as the earthworks around Avebury, if not more so, and yet no one seems to ever speak of it. Standing here, I cannot imagine why. The banks dwarf me, impossible to avoid as they follow the curve of the chalk ridge, running off into the distance like a path, an invitation.

What is the Wansdyke for? What did this digging and effort mean? Because it blocks the Ridgeway, some

historians think it might have been a customs barrier, like Hadrian's Wall, controlling what came in and out of the Wessex uplands. In truth, as with so many earthworks, no one really has any certain answer.

Ahead I've seen a man on the slopes but then he disappears. He's dressed for running and unlikely to be a danger, but you never know. By now I should be able to see him again, but he's not there. Has he hidden down in the ditch? I approach slowly, climbing the steep face of the bank so that I can see him before he notices me. Then it's fine because a couple are climbing the stile in the next field, heading this way. I'm on alert, processing all these movements like a deer in an open field. When I do see him again, he's sitting on the grass in the sunshine, cordless headphones in his ears, talking to someone about opportunities in the pharmaceutical industry. He has not had to think for one second about the people around him. I hate him for it.

I'm on the very top of the Wansdyke now. The turf here is beautiful; dense and feathery, nibbled into a fine fabric by sheep and rabbits, patterned with different plants that I can't name – tiny little yellow daisies with a button centre, amethyst clovers and pale lilac buttons of scabious, the remains of meadowlands which once covered the whole downs.

Up here, the ditch and bank make even less sense. It's impossible to see what they were built for, who it means to keep in or out. The whole structure is gargantuan, banks and ditches so massive that they could deter tanks, never mind armies of men bearing only swords and spears. But it's in the wrong place to be any use. The dyke sits below the ridge of the hill, but on the high side of the

downs, so it's impossible, even from the highest point of the bank, to see over the edge. The whole vale below is invisible, so it's useless as defence.

I walk along the crest of the banks, heading up towards Tan Hill. This is the second-highest place in Wiltshire, but the summit doesn't stand out as much as I expected when I reach it. Instead it's one part of a long ridge which runs to Milk Hill, which is just 10 cm higher and so the peak of the downland. The slight differences don't matter though; up here I am on top of the world with the green hills bubbling in front of me down to the Vale of Pewsey. The sky is blazing blue and the air is so clear that I can see right across the ordered world of the valley to the faded shapes of Salisbury Plain where the hills rise and fall behind one another, disappearing into infinity.

In front of me, one green summit, Rybury, stands separate from the rest, its edges shaped with banks and ditches into a hill fort, although an odd one because its ditch sits inside its banks, another place which is no use for defence. Underneath that lies another causewayed enclosure, so people have been coming up here for a very long time. The maps demonstrate how much this place once mattered. If I could see its hatchings projected onto the landscape, every contour around me would be alive with black markings and words: earthwork, crossdyke, tumulus, ditch, each one noted in the thick gothic script by which the Ordnance Survey mean the past. These all surround the top of Tan Hill, marking it as a special place, but whether they mean to enclose it or exclude people or channel the movement of animals we have no idea. A chalk figure once stood on its slopes too – unusually, a donkey, but that too has vanished. Only the Wansdyke can really be read on the land, a

wrinkle in its fabric, heading off west, perhaps all the way to the Bristol Channel.

There's also no trace up here of what Penelope Betjeman found. Tan Hill is where she saw the lights of the range and the pockmarks of shell impacts in the sides of the hill, but all of that has disappeared. Apparently a single concrete plinth remains, somewhere, but the grass has grown so thick and lush that I can find nothing of what the army were once doing. This is one of the few parts of the chalk from which they have retreated.

Nor does anything remain of the people who once thronged here. What the map also records in black script is that this place was the site of a sheep fair. Tan Hill Fair was a huge gathering whose origins reached far back into the past, and like the causewayed enclosures, a place on the borderlands, not owned by any town or borough.

This is a very odd place to site a fair. Up a steep hill, to start with, which seems like a lot of extra and unnecessary effort. What's more, Tan Hill doesn't stand out as a landmark, but even so, the fair flourished each summer. Horses came from as far as Ireland, and at the start of the nineteenth century twenty thousand sheep would be penned, ready for the buyers. There would be drovers and gypsies and policemen and farmers, and cider and broken heads by the end of the day.

Th' used to reckon as anybody could get a pint o' beer an' a smack on th' yead ver dreepence up at Tan Hill.

Tan Hill Fair had another peculiarity, too, which was that it began very early, with the shepherds arriving before dawn to buy and sell, and always telling the story that in

the past they used to get up earlier still, and that the last use of the pagan bonfires was to light the way to the fair in the darkness. The word Tan might derive from St Anne's Hill, which it is also called on some maps, but equally that might be the Christianisation of a more pagan identity. After all, in Welsh, Tan means fire.

A rare golden relic was found near the hill too, on Allington Down, unearthed by a labourer who was digging for hard chalk.

At first the finder thought it was brass, and hung it on a hurdle near where he was digging, and there it stayed for about a week; he must have had his doubts about it, for he then took it away and showed it to his master, who offered him half a crown for it; this he refused, because he thought, if the master was willing to give him half a crown, it's likely as not to be worth more; so he took it to a bank in Devizes, where they soon found it to be solid gold, and thus led it to being claimed by the lord of the manor.

What had been hung on the hurdle was part of a flanged torc, a kind of object made in the middle of the Bronze Age. The word torc calls up warrior-Celts wearing thick rings of gold or bronze around their necks, but those came much later.

The kind found on Tan Hill is a thousand years earlier and thin, made from a rectangle of gold stretched out into a long rod and then twisted to make a kind of wire or rope, finished at each end with a thin cone, bent over to form a fastening. This was skilful work, and keeping the twist even and regular would have challenged even an experienced goldsmith.

Flanged torcs are found all over the country, from Stafford to Cornwall to East Anglia, and they are remarkable for two reasons. One is that some are very long – well over a metre in the case of those found in Peterborough and County Fermanagh. The other is that not one has ever been found in a grave, so we have no idea how they were worn.

Or indeed if they were even meant to be worn by people. The possibilities of meaning and use are almost endless, but given that they resemble smaller torcs which were designed for human necks, it has been suggested that they might have been worn as girdles by pregnant women, or around the neck of a horse or a prize bull.

Standing up here on the site of an ancient fair, where domesticated species would have been traded to improve the stock, it's very tempting to see the torcs as a kind of symbolic rope, leading the animals which have been tamed out of the wild and into civilisation. And it's not too much of a stretch to see that same rope around the belly of a pregnant woman either.

This might not be very far from the truth. When the torcs have been found, they are usually buried in a way which suggests they have been decommissioned, put out of ritual use. And the long torcs are coiled up around themselves three or four times, exactly like a rope.

Of course this is archaeology and anything is possible: they could have been used to denote a sacred stone, or a tree, or a totem which has entirely rotted away. All I know is that over the years there have been far more animals and people up here than there have been stones or trees.

★

Tan Hill Fair endured until 1932, but its tradition lasted longer still. In August 1996, a group of travellers, the Dongas Tribe, hauled their carts and ponies and goats up to the top of the hill, claiming their ancient chartered right to hold a Lammas fair. Six riot vans loaded with police, three dog units and a helicopter were called in to stop them. The officer in charge forced them back down the hill with the words: 'When will you people realise that this is Wiltshire and you don't belong here?'

Who does the countryside include, and who is allowed to belong? Most of the time there is an accepted answer to this question, administered by land ownership, tradition and the National Trust. Those who are middle class and above, those who own either a piece of it or the right clothes can expect to be granted admittance wherever they go. Perhaps in the past the labouring classes were permitted to feel that they belonged as well, but they weren't expected to express this. Their betters could do that for them.*

Now, though, people can find many ways of identifying with the land and finding meaning in it. A few miles away in Avebury, where I have left the car, the archaeologists and the pagan worshippers and the villagers, the farmers and the National Trust all perceive the stone circle and its land-scape in myriad different ways: as a sacred site, a home, as heritage or just a field which needs harvesting. The conflict is low-level but perpetual, and always requiring manage-ment and compromise. The travellers who brought their carts up here went even further. By using the countryside

* Even so, class seems to be less of a barrier than sex to being out in the coun-tryside alone. Men of all classes are free to walk out, both now and in the past; women are much more likely to be hobbled by labour, domestication and fear.

to represent freedom, anarchy and traditional rights, they had deviated too far from the authorised version.

The policeman's taunt carries the echo of another phrase as well. 'You don't like it, stay away. What the fuck do you think an English forest is for?' These are the words of Johnny Byron, outcast spirit of England in Jez Butterworth's play *Jerusalem*. Flintstock, his home in the play, is based on Pewsey and so Byron's rural hideout is somewhere in the fields and copses in the valley in front of me. Although I am not sure I would like to find it.

Damaged but immortal, Johnny Byron is the voice of a countryside which has not been tamed and organised by the classes above him and he refuses to speak the words they require. He's another reminder that the countryside is so rarely the bucolic and restorative place we want to imagine. He speaks for both a deeper version of time, and a rural England which is refusing to conform.

As such, I ought to love both him and the play, but Johnny Byron does not speak to me and for one reason alone. I am not a man. The women in *Jerusalem* are mostly mute and always ciphers, symbols playing a supporting role, there to be used by Byron or to abuse him. None of them have his power or agency, none of them are England. The spirit of England does not respect women, nor even like them very much. This is what I am finding in my travels too, but I don't like to be reminded of it by art.

I've seen what I need to, or what I can, so I turn back along another open track towards Beckhampton and Avebury. I dislike this one just as much, and for the same grassy potholed reasons. The concrete road which Penelope Betjeman followed runs alongside me to the west,

but it isn't a right of way and so I can't follow it. Its name, Gunsite Road, is the only memory left of what she saw. It is the place of another, modern story too, because in 1996 a barn and a farmhouse were built at the end of the road for the film *Saving Private Ryan*, so that the rolling downland of Wiltshire could imitate Iowa. Nothing remains of that either; the landscape does not always remember.

The flat downland here is wide enough to be a prairie and the fields unfurl around me for miles. In the distance wheat has been grown around a high barrow which sits, grassy and unchanging, in the middle of the golden stubble like a green whirlpool. A kite heads directly towards me, low and close, skimming the surface of the land in search of an upward current. As it passes directly over its wings and tail are translucent against the arc of the sky. I am neither food nor threat so it has no interest in me. Oddly, its disregard makes me feel better. I keep going.

The Ridgeway, from Gore Cross
to Battlesbury
Nine and a half miles

A few weeks later, I am back at Gore Cross again but this time I am not breaking my rules about re-walking because I am here to take a different route. Today, I am crossing Salisbury Plain itself.

For a few days each summer the army take a holiday from shooting at each other. The gates are lifted, the watch-towers unmanned and the training area is open to visitors, as long as they stay on the road. And I feel I need to take my chance to walk into what may be the dark heart of the landscape designed by men. Or if that sounds too portent-ous I will at least be walking a new part of the Ridgeway.

So T drops me off at the crossroads once again, but today there is no gunfire. Nor is there any need to be afraid of highwaymen or the wilderness because the roads are quick with traffic, everyone taking their chance to drive into what is normally forbidden. I seem to be the only person on foot.

The first part of the walk takes me through an ordinary farming landscape of hedges and cattle and the harvesting of wheat. Plump and rising clouds are touched with grey

at the base. Ahead of me is the checkpoint, a white box of a building, shuttered up and not interested. With the barrier raised, cars are driving in one after another as though on a visit to Legoland or Longleat.

Over the next hill though, we are all entering a new world. Long meadow grass is studded with pink and blue flowers, and all the field boundaries have gone. The whole plain was once downland like this, pale and unfeatured with just the occasional stand of dark trees to break up the expanses. The army likes to present itself as the custodian of both archaeology and wildlife here. The Training Area contains almost half of all the unimproved grassland in the country (improvement here being in the eye of the farmer) and a big part of of it is also a Site of Special Scientific Interest, home to rare butterflies like the marsh fritillary and Adonis blue, along with a tenth of the UK's population of stone curlews. At the same time, it is also very dangerous. Sign after sign tells me to stay on the road, not to be tempted by the pale tracks which wind invitingly up the hillsides. This landscape may be presented as unspoiled, but it is booby-trapped and tense, ready to kill anyone who strays onto it.

From the next crest I can see halfway across the plain. The road rises and falls ahead, rolling gently down into the hollow which holds Imber. This is a remote place and just two hundred years ago there were no roads to the village, only trackways.

Imber is famous, or notorious, for what happened in December 1943 when all its 150 residents were evicted with just ten days' notice, so that the British and US armies could practise the door-to-door fighting they would be doing in France after D-Day. The villagers always believed

that they would be allowed to return at the war's end, but that never happened.

Perhaps they shouldn't have been so surprised. Throughout the inter-war years the army had been buying up more and more land, and this included Imber and its farms. Land prices were low, so farmers were happy to sell to the government for a premium, even if their new tenancies had a clause which allowed the army to take possession of the land if necessary. That's what they did and they've been at Imber ever since.

On the slopes leading into the village, I can see cows. At this distance it's impossible to tell if they are fenced in or not, and I tense up. All along the next stretch of road I am wondering what I will do if I have to walk through the herd until eventually I get close enough to see that they are confined by a slender electric fence. Of course they are. If they wandered freely, they'd be blown up into mince.

I am starting to realise that my constant vigilance about cattle is also a version of another fear. Whenever I walk, I am always aware of what might happen should I meet something bigger than me, and unpredictable. This might not always be a cow, and this is the threat which keeps so many women a bit scared, at home, safe and domesticated.

Past the cows, on the edge of the village, a couple have parked their car in a gravelled lay-by and are focusing their binoculars on the hill opposite. Despite looking and looking, I can't see anything and it's only after I've walked on that I realise they might be taking their one chance a year to see a bustard.

Bustards are stupid birds, the closest thing Britain has to a dodo. Looking like a brown turkey, with the head of a pigeon set on an elongated neck, they hate flying and also

taste good, a combination which meant they were hunted to extinction in the UK before the end of the nineteenth century. They like grassland and open space, so Salisbury Plain has always been their perfect habitat, and they've been reintroduced here since 2004, a few times. The first couple of attempts failed, because they used eggs from Russia, and an unexpected homing instinct meant that the birds tried to head back to the land of their birth. Not being good at flight, they mostly drowned in the North Sea. The next batch came from Spain, and these imports seem more content here with no urge to head back south: there are now about a hundred, apparently breeding happily.

All the way so far I've been able to sight myself on the tower of Imber Church with its gothic bobbled pinnacles and flag of St George drooping from the pole, but as I come down this last hill it disappears. Imber was always known in folklore for being sunk in the plain and far from everywhere.

> Little Imber on the down,
> Five miles from any town.

The army probably thought no one would notice if it disappeared.

Along the street, signs have been affixed to the various buildings, explaining what they once were. Council Houses, 1938. These visions of a better future had only been occupied for five years when the army came. Now they are brick shells, no shelter for anyone, no benefit. The handsome red brick manor, Imber Court, is burnt out, its windows blinded by green metal shutters while a reinforced lookout post peers over the high estate wall. Imber Post

Office is only a sign fixed to a thick tree in a grove by the road. It's hard to believe there was ever a building there.

Today the empty village is seething, with cars parked along all the verges. The church is filled with people, mostly elderly and wearing pale shirts and chinos, floral dresses with pastel cardigans. It's the only building which has not been wrecked. Outside there are portaloos and chain-link fencing, and yet more notices about danger and ordnance and not walking anywhere but the road. One large group of visitors, dressed in cheerful summer brights, picnic on a verge while their dog barks excitedly at passers-by. Behind them a stone and brick farmhouse has blank and gaping absences where its windows once were. Police tape is stretched across the doorway to deter explorers; notices stuck into the grass, like miniature estate agents' signs, say 'DANGER. KEEP OUT'. This looks like a day out at an attraction themed around the breakdown of civil society, a visit to the worst-case scenario, for a laugh.

Further along the street is a set of new houses; shells of unfinished breeze block with exterior staircases and green metal roofs like no home ever had. These were not built for living in, just warfare. What the army is training for here is FIBUA, fighting in a built-up area. The soldiers have another, starker, acronym for it: FISH. Fighting in someone's house.

Imber is not a sweet place. Another village was also taken over for the tanks in World War Two, but Tyneham, set in a forested hollow near the Dorset coast, is much more like the fairytale idea of desertion. Ivy climbs the walls and thatch remains on houses built from a soft grey stone. Wooden desks remain in the schoolroom, their inkwells

dry; a red telephone box stands sentry on the green. Tyne-
ham is picture book, chocolate box, heritage ready: a
preserved corner of Old England where the villagers might
walk back into their lives at any moment. Imber is much
tougher. Nastier, even.

What the two villages share is their sense of betrayal.
Once the war was over, people were no longer prepared
to sacrifice so much to the defence of England, and the
residents wanted to return. But the army decided that in
order to train properly they needed to keep hold of both
Tyneham and Imber for good.

In the case of Imber, the reason was 'owing to the size
and range of modern weapons', but the noose tightened
around the village only gradually. At first rights of way
were maintained and the villagers returned to look after
graves and maintain the church, sometimes with permis-
sion from the Ministry of Defence and sometimes not.

The villagers were still demanding to go back. One old
lady threatened to take her kettle and her bed and go back
to her cottage and let the ravens feed her as they had Eli-
jah. Usher's brewery, who still owned the Bell Inn as one
of the few landowners not to have sold up, kept the
pub's licence renewed right into the 1960s, in case there
might be a return, even while the building slowly fell into
disrepair.

The Ministry of Defence were also making getting
there difficult, restricting access on the rights of way, but
always under temporary orders. In 1961, they applied to
make the closures permanent. A protest march was organ-
ised, and seven hundred vehicles brought two thousand
people across the plain to Imber. This led to a public
enquiry which, unsurprisingly, supported the army. The

judge did rule that the Ministry should make concessions, including creating a route around the perimeter – the Imber Range Perimeter Path – and allowing the roads to be used for up to fifty days a year.

Now, though, almost all the original residents have died and with few people to protest, access has gradually diminished. Imber used to be open for two weeks in the summer, but for the last few years that has been reduced to just a few days, because people keep trying to go into the buildings.

The road slopes gently up out of Imber's hollow, taking me into a different kind of countryside again. The grass here is greyer, speckled with scrappy trees and low hawthorn bushes, windblown into contorted shapes. An odd black helicopter with stunted side wings skips along the edge of the hill like a swallow chasing insects.

Meadow flowers throng even thicker here: yellow daisies and pink, pale-edged orchids and all sorts of others I cannot recognise, along with a strange plant like a mutant cow parsley which seems to flower by turning itself inside out. I can't name even a quarter of the plants in front of me, and I don't know if I'm getting even those right, but I am not sure this really matters. The thing is, when I read other nature writers listing plants by their proper name, I have no picture in my head. All I see are complicated words in another language, setting me outside nature, like someone who does not belong. Naming is a form of ownership too, or at least of entitlement.

Here and now I am looking at the purples and the yellows, the scratchy dark stems, the deep stamens, the ebb and flow of grass heads in the wind and I know them to

be good even if I cannot name them all. That I can call the yellow flower a buttercup doesn't make it any more real than the others, in fact perhaps I observe it less. I belong here as much as anyone else does whether they have guns or title deeds or botanical names for the flowers and weeds. We all do. The scattered beauty of the meadow makes me want to dive in, to swim in its sheer vibrancy and excess. Except I can't because I don't want to be exploded.

This part of the plain is not as empty as it first seems. Strange shapes lurk on the crests of further hills, and when I get closer they sharpen into the silhouettes of lorries and petrol tankers, rusting old hulks left out for target practice. At the top of the next hill I meet an entire tank, dead in its tracks, gun pointing down to the valley below. Cars slow down to peer and take pictures, as though they are passing Stonehenge. Further along, all that remains of another vehicle are its tracks, twisted and stacked into a modernist sculpture. Were I Paul Nash, I could take a crisp and haunting picture of this accidental piece of surrealism. The photograph I bring back is far less striking than the object.

As I climb the last hill, I'm approaching the end of the military plain, and arrive at an area which looks like a derelict racecourse grandstand, facing a square of dusty concrete. A notice says *Fire Power Demonstration and Stand Contractors Only*.

Here is where government ministers come to see how their money is being spent, on large bangs or prototype tanks; where the generals of friendly armies come to be impressed by our weapons and manoeuvres and, perhaps, to be sold weapons of their own.

In 1942, Winston Churchill and General George

Marshall, Chief of Staff in the US army, were due to come to these stands to see how the joint combat forces were working together. A few days beforehand was a rehearsal. Six Hurricane pilots dived down to attack dummy tanks but one aimed at what he thought were dummy soldiers. He hit the spectators instead. Twenty-five English infantrymen and members of the Home Guard died, while over seventy more were injured. I look across the stony square at the battered grandstands but I cannot feel their ghosts.

I head down the concrete road towards Warminster. Rising to one side is yet another hill fort, Battlesbury, one of a pair scrutinising the traffic along the Ridgeway. Being in a high place is a good defensive move. The Romans quartered their garrisons up on Battlesbury, probably arriving along the Ridgeway because no Roman roads pass nearby. During the Second World War, big guns were set up here, just as they were at Barbury. Even this century, the army practised for the war in Afghanistan by placing their communication aerials on hill forts inside the plain. The high point has always had the tactical advantage, whether you are fighting with flint-headed arrows or armoured, remote-control drones.

'There is no head or tail to this story, except that it happened. On the other hand, how does one know that anything happened? How does one know?'

Mary Butts

Westbury to London Waterloo
102 miles, by train

I have not been wholly honest. There's one more layer to this story which I haven't admitted to so far. And that's because I am hiding from it myself. I am afraid of what it might mean, and what the consequences might be.

All the way so far – both in this book and in my own thoughts – I've been pretending that my journeys are a rational return to walking, in which I am simply tracing more of a path that I had followed before. Rediscovering a previous joy. Just the kind of thing which a woman might do a while after having children in order to retrieve her old, independent self.

Which all sounds well and great, but not a shred of it is particularly true. The Ridgeway, you see, belongs to the past. Of course it does, it's the oldest road in the country, but at the same time it is part of my history and that's the problem. I'm following the same old track when I should be setting out afresh. Other ancient roads are available, and these are the routes that I am meant to be following.

I have known this all along.

I started walking again because I received a sign, one

which meant to set me on a different course. But I don't want to acknowledge this, never mind act on it, because I am not at all sure that this is something to be welcomed.

The revelation had arrived two years before I returned to walking: no shaft of sunlight from a dark cloud or a voice in a silent room but on a standard issue summer-holiday train trip of Formica tables and scuffed lino floor, the orange and blue seats hot in the July sun. While T and E read, I looked through the windows at a landscape made fuzzy by scratches and dust. After a run of towns, stopping and starting over and again, we were heading for open country, past wheat fields already silvered, the trees dark in contrast. Clouds were stacking at the edge of the sky, while sheep grazed. The curved edges of the train window were framing a picture of England doing what it had always done. Beyond the fields, low hills rose in a single wave of green. The downland, again.

I opened the map on my phone, wanting to put a name to the places speeding by. A blue dot blinked on a grey grid, waiting. Outside the landscape was becoming more suburban; we skimmed past red-brick estates, kerbs and street lights, then ran alongside a main road edged with petrol stations and modern pubs, the only grass now on the verges.

We were close to Andover, at least that was what the phone said. But another name jumped out at me. Next to the track ran something seemingly much older. I looked up but saw nothing but a stand of trees and more houses. Even so, I knew it was there.

What I'd seen was a short stretch of road and its name was the Harrow Way. I understood immediately, and Wikipedia

confirmed what I already knew. This small chunk of suburbia was an ancient road, perhaps the most ancient of all because it was also called 'The Old Way'.

At the same time I also understood that this was a coincidence of the highest order: the chances of my seeing this road and recognising it were vanishingly small. What I had been given was an instruction from the universe to get walking again, to go somewhere new on old roads. But that felt impossible. E was about to start a year of being home educated: walking out alone was as impossible now as it had been when she was a baby.

At least that is one story, but I was looking for any excuse I could find to not follow this new road. Look at what the Ridgeway had done to me when I had found it; my whole existence had been changed entirely. I was settled now, content; I did not want to be tumbled over like a load of washing, have my entire life crumpled up and rearranged into a different shape. But that's what following an ancient road might mean.

I put the Harrow Way firmly to the back of my mind as something that I did not have to do. Even though I knew that was unlikely to be true.

I might not be going to walk it but nonetheless I couldn't resist trying to find out more about the road itself. This wasn't straightforward. The ease with which I had discovered that small stretch by the railway line was entirely a fluke. I had, by chance, stumbled over one of the few bits of the Harrow Way which are still marked on the map, and there were scant mentions of it on the internet either. This made me uncomfortable. In discovering something so difficult to find, the chances of it being an

accident were even smaller. The Harrow Way had placed itself in front of me, determined not to be overlooked.

Books offered up a few facts. When the Harrow Way was first a path it most likely ran from coast to coast, beginning at the Channel somewhere near Dover or Folkestone then following the chalk of the South Downs and heading on past Stonehenge until it met the Ridgeway near the border of Devon, the two roads joining for the final stretch towards the sea.

Beyond that simple idea, the track becomes complicated. The old road, as a single line going from one place to another, no longer exists. Instead it is evasive and mutable. It stops and starts, its lanes are suddenly woven into bypasses and double-lane highways, while in other places it disappears entirely. Nor does it have only one name. Only around Andover is it definitely called the Harrow Way. Elsewhere it is the Hardway or the Herepath or the Old Way. One map labels it 'Supposed British Trackway'.

The eastern stretch of the road was later taken over by medieval pilgrims heading between the two great shrines of Winchester and Canterbury, so this part has yet another name: the Pilgrims' Way. Despite this, the remaining stretch of the Harrow Way carried on westwards. Parts of it are still rutted and empty and bare, but others thrum with lorries, buses and cars.

It turned out, too, that the Harrow Way and I were old acquaintances. T and I had, when we lived in London, walked a section of the Pilgrims' Way in Surrey one hot June, passing eccentric art-nouveau chapels and daytime badgers in the woods. The path was followed by another chain of brick pillboxes running along the ridge of the hills, a further stop-line defence against the invasion which never came.

I'd travelled stretches by car as well, because a huge stretch of its middle section has now become the A303. For years this had meant only one thing: the excitement of the yearly trek to Glastonbury and the dull exhaustion of the journey home. But I had never known what road I was travelling on.

A third stretch of the Harrow Way also passed very close to my home. I'd seen it before, although without ever knowing that it had a name or was coming to find me. And how I had come across it was deeply tied up with my domestication.

When E was small and pram-bound, I wanted to get out into the green, any way I could. The only suitable place I could find was the gardens at Stourhead, in the care of the National Trust. They have ensured that the path around the lake there is well-maintained, flat and accessible; the only place for miles around where I could push the pram for any distance and see green. So I returned, week after week, through grey days and biting cold, in rain that dropped off the huge waxy leaves of foreign trees, and finally in the dappled sunshine of spring. The gardens were the only place that offered the trees and space I wanted, but at the same time they provided me with a whole new source of fury.

For all that I was outside, I was still not free. The pram confined me to the path, and so I trudged around it like every other woman with a small child, out for fresh air and a break from mashed food and books with ten words in, walking in circles with nowhere else to go. I couldn't even choose the lower path for a change, because this led to the grotto with its narrow stone steps which foiled

the wheels of the pram as surely as if I were a Dalek. I could walk one path round the lake and back to the start, no more.

Unlike most journeys, my walks with E got slower the more often we did them. In the beginning I could push the pram twice round at speed while she had her afternoon sleep. When she got more alert, I could only manage one circuit, interspersed with stops to look at ducks and trees and the glitter of sunlight on the water. Then she wanted to walk some of it by herself, then more, picking up leaves and examining flakes of bark, wanting flowers to hold for a second and then throw away. A season later she insisted on tracing every swooping arc of rope which ran from post to post, marking out the spaces where visitors were not meant to tread. Each one had to be followed with her hand, its scratchy texture felt, its nature understood. Now we didn't even get halfway round. The soaring trees and the wax-leaved laurels and rhododendrons seemed to close in on me as I felt the compass of my world shrinking further still. I hated the place but had nowhere else to go. These neatly gravelled paths were the only way forward open to a woman with a pushchair.

Stourhead has been preserved for the nation because it is one of the great eighteenth-century gardens, a composed arrangement of temples, grottos, prospects and imported heritage objects carefully placed into a miniature valley which holds the source of the River Stour. The infant stream has been dammed into a lake, surrounded by an exotic variety of trees and shrubs, in whose groves stand the classical pantheons and other follies. This demonstration of perfect good taste was created by several generations

of the Hoare family, London bankers who retired to the country in order to launder the base profits of trade into aristocratic land. The first Henry Hoare concentrated on building the house, an austere classical building of columns and pediments in pale grey stone. When this was completed in 1725, it was one of the most modern pieces of architecture in England, as stark and shocking to his contemporaries as a white and glass modernist box would be now. His son, the second Henry Hoare, gave his attention to its setting, creating the gardens over many years after he inherited the estate in 1741.

The entire landscape is intended as one complete work of art, perfect from whichever point it is viewed. Looking out from the stone bridge, the Temple of Apollo is framed by trees; in another corner a nymph sleeps by the water under a rustic stone arch while on the high ridge above sits an obelisk, topped by a gilded sun disk, overseeing all. Columns gleam white in the sun, set against the shadows of trees; tawny leaves and red stems reflect in the glass-smooth water of the lake, while in the distance the curve of an arched bridge suggests where another vista will reveal itself. A gentle pathway takes the cultivated and suitably awed visitor around the lake, permitting them to contemplate beauty while pondering elevated thoughts of honour, philosophy and the noble virtues of antiquity.

All my rage at being trapped in the domestic became focused on Stourhead, which is a ridiculous reaction to something so beautiful. The gardens are, objectively, ravishing; on a sunny day it's hard to take a picture of the place, from any angle, which couldn't be used for a jigsaw puzzle or to sell the glories of the National Trust. But it

drove me mad. There could be no revelations here, no surprises. Every single thing I saw was intentional, forcing me to like it, and I saw the views as just another sign of how I was confined. The prison might be beautiful, but I was captive here nonetheless.

In fact, the gardens of Stourhead sit right on the edge of a different, almost contradictory landscape, but it took me a while to realise this. One day, in fresh sunshine, E and I needed a change, or at least I did. We began our walk the same way as always, crossing over the arched metal bridge spanning the road below, E, now a toddler, looking down solemnly at the tarmac below, hoping for the excitement of a car. The path took us to the walled garden where fat splotched goldfish swam in the murk of a stone-edged pool. E stared hard at these too, her hands clasped tight around the metal railings, following the white and orange shapes as they slipped in and out of shadow, under the lily pads and behind the steps. She would have been happy to do this all afternoon.

'Shall we go a different way today?' On the way in I had seen the sign: House Entrance open today. Warmer days were arriving and with them more and more visitors, not just the middle-aged couples in Gore-Tex and the other resigned mothers with prams of winter.

'No.' E carried on staring at the fish. Like most small children, she preferred everything to be the same, always.

'It will be fun, you'll see.' I had no way of knowing if this would be true but managed to distract her by pointing out the knobbled trunks of the ancient oaks lining the drive, then the lambs in the field alongside.

We paced slowly up towards the house. Either side of

the entrance were immense classical vases, like giant stone rose-bowls, each being pecked at by two crouching eagles.

There was no point going in; I didn't want to be that person holding a thrashing toddler in rooms stuffed with porcelain and gilded plaster when I didn't even care for it myself. Despite this, I walked her all the way up the front steps simply for the pleasure of being somewhere different. Only when I turned around and looked back did I see what I had failed to notice all this time.

Opposite, no longer hidden by the trees, was the perfect line of a chalk ridge, pure green, its silhouette as smooth as the line of a ship's hull. A long bank divided the summit in two, while another ring of earthworks circled its furthest flank. The landscape that I thought was lost had always been there, right in front of me, had I only known where to look.

This place, I discovered, was called Whitesheet Hill, but getting up there wasn't that easy. The first time I got lost, chose the wrong track which went nowhere, so I gave up and returned to Stourhead and its signposted carpark, defeated.

The second time, we were with friends and got lost again, turning the cars around in a dead-end farmyard watched by an ancient ginger cat, but this time, embarrassed, I persevered until we found the narrow road up. They had teenage boys, and let them loose to run over the whole hill, up and down ditches and over its crest, giddy and wild in the wind and space. E was still small and unsteady on the lumpy grass, so I stayed with her while she picked at daisies, looking out over the steep edge. Crows wheeled below us while on the other side of the

hill men in navy fleeces unpacked a model aircraft, getting ready to fly.

From the base of the hill a tree-lined lane led directly to Stourhead, the house visible in its parklands. Up here I understood why the gardens had weighed so heavily on me. They were the exact opposite of where I wanted to be. Instead of smooth, rabbit-mown turf, they offered me dense trees, thickened with underplanting. Their paths went round in circles instead of taking me somewhere new. But what struck me now was that each was the inverse of the other. Literally. If I took a shallow soup bowl and turned it upside down, its shape would make the hill I was now standing on. I was on top of everything, like a bird or god looking down on ordinary life below. This felt good.

Stourhead was the bowl the other way up. It trapped me in the hollow, with land, trees and buildings pressing in. Even if I climbed up to the highest temple, there were always branches above. No matter where I went, I could never see over the edge. Its landscape blinkered me, and this was what had upset me most as I pushed the pram round and round its paths.

A couple of years later we returned to Whitesheet Hill, just T and E and I on a much hotter day in summer. The wind still blew – I've learned now that it always does – so we sheltered in the hollow of the great cross-ditch to have our picnic.

The summit of the hill is a catalogue of classic chalk-downland archaeology. At one end of its ridge are the thin ditches of an early causewayed enclosure, perhaps five thousand years old; at the other is an Iron Age hill fort,

two or three thousand years younger. In between, a selection of Bronze Age barrows have been scattered across the hilltop, and the deep ditch cut across. As a finishing touch, the top of the hill also holds a post-war bunker which would have sheltered observers in the case of a nuclear holocaust, at least for a week or two.

I left T and E finishing off the strawberries and went off to explore. First I stood on one of the barrows, for that extra bit of height, and looked out across the whole hilltop. The model-aeroplane pilots were here again, grim-faced and concentrating as they sent wide-armed gliders and buzzing planes swooping out into the blue. Cows regarded me from behind a wire fence.

From here I could also see that the road which had brought us up to the car park carried on, climbing to the summit, then curving round the edge of the hill and its fortifications. I set off towards a stile and climbed onto the track, its muddy ruts hardened into ridges. I needed to see where it might take me, so followed it to the far side of the hill fort, where it turned. I carried on along its gravelled and rutted way to the next ridge, to see if I could understand a bit more. When I reached that next rise, hot dust scuffing up around my trainers, the view made total sense. The road carried on, up and down, as far as I could see. Edged with high banks and wire fences, a car and a half wide, it was not any road I had ever walked on before but at the same time it was instantly familiar. This was a road which knew its own worth, a road which had been going somewhere for a very long time. I went further, to the next high point and another view. I could have carried on doing this for miles, and would have done, before.

The bonds might have become more elastic but they still pulled me back. I retraced my steps to the dip of the ditch, the last sandwiches, the cool bag and spotted picnic rug.

'There's a proper road there,' I said, looming over them from the lip of the bank. 'I want to see where it goes.'

What I had seen but not yet recognised was the Harrow Way, heading over the hill from the A303, its course set firmly towards me.

Discovering more than these few scattered stretches was hard work. Now that the archaeologists and historians have lost interest, we don't really think about roads. They are a means to an end, a way of getting somewhere or a route which has to be learned. On maps they are red and yellow and green, on the ground they are black, and that is all we need to know. They are part of the mundane infrastructure of our lives, nothing more. We might as well think about internet cables. Our travelling is interesting, not the road we do it on.

This has not always been so. In the years either side of the First World War, a whole spectrum of writers became interested in roads which were seen, each one, as having a life and a biography and perhaps even a spiritual quality. Paradoxically, this happened because for many decades before this, they had been irrelevant and disregarded.

Dull, slow and dusty, roads belonged to the past. The railway was the only modern way to travel. In 1870, roads were at their least used ever, carrying only farm carts and local traffic. Chickens bathed in the dust, dogs slept on the highway. A village without a station was a backwater to which no one came.

When the car was invented, this slow rural world opened up. And writers were interested in what they found.

As a result, the best book I could find about the Harrow Way was ancient, and is itself called *The Old Road*, written in 1904 by Hilaire Belloc. Belloc was a prolific writer who threw out books, articles and opinions like a dog shaking water off its back. One of his early bestsellers was the account of his solo walk from the heart of France to Rome. *The Old Road*, written two years later, was most likely an attempt to capitalise on this with another, British, adventure.

Despite being born in France and married to an American, Belloc had a deep emotional attachment to the downland of Sussex and considered himself rooted there even though he was almost always somewhere else. He's one of the original writers who sets out on a long walk leaving his wife at home with the children in an impracticably ancient house. The trip to Rome took place when his wife had three young children and not enough money, but fortunately for him the book was a resounding success. Even so, Mrs Belloc was more accepting of her domestic lot than I would have been.

In *The Old Road*, Belloc seeks to discover, by walking, the route of the Pilgrims' Way from the Channel coast to Winchester. He understands that this is the oldest road because it is formed from the Harrow Way, and he is interested in it because he wants to walk in the footsteps of not just pilgrims but ancestors too.

Belloc can't resist a generalisation or two, or more. He believes that the road is one of the great instincts of humankind itself, although he would almost certainly have written 'mankind' there. Nonetheless, I cannot help

enjoying the life in his opinions. At the very start of the book he lists what he sees as the primal things which move us: fire, two voices outside at night, a roof over our heads, a tower so that we may see into the distance. I am with him already, sitting on the edge of a hill fort, looking out into the empty dark beyond.

> We craved these things – the camp, the refuge, the sentinels in the dark, the hearth – before we made them; they are part of our human manner.

The final item in his list is also the humblest and the most subtle: the road. Nothing but a track, he says, will save you from false journeys. It is in itself a form of knowledge.

If this sounds like the beginning of a sermon, it's probably meant to. Being religious, Belloc is not only looking for insights but also humility. By treading a path which has been travelled for thousands of years, he is reminding himself of his very inconsequential place in history.

While the book is both enjoyable and thought-provoking, it wasn't much of a practical guide. Belloc is interested in the section of the Harrow Way to Winchester while I wanted to know about the parts beyond that. Even so, he is a pioneer, one of the first people to set out in search of an ancient road. His explorations are so unusual that at one stage, in Alresford, he and his companions are arrested by the local police. No crime is ever mentioned but their real transgression is doing something unexpected: walking on the roads.

I do learn one important thing from him. When Belloc says the real truth is in the road itself, he is right. I can't

discover much more from the books, however much they tell me that the path is referred to in Saxon charters or remains as a line of hedgerow between fields. The only way I can really discover it is by walking. But with no time to call my own back then, I couldn't even think how this might be done. Not that I wanted to anyway.

From Winchester via Weyhill, by car
Fifty-seven miles

Despite my reluctance to get involved, the Harrow Way still nagged at the edges of my mind. So the year after the train journey, I decided to at least visit the one part I was certain existed, near the small section I had seen marked on the map at Andover.

On a day when E and I needed to drive to Winchester anyway, I took a detour back through Weyhill, which is where that scrap of road I'd seen had been heading. Weyhill is a tiny village, without even enough identity to count now as a suburb of Andover, but once upon a time the whole south of England knew it for being the place where 'the greatest fair for sheep is kept that this nation can show', as Daniel Defoe called it. Many of those tens of thousands of animals walked here along the Harrow Way.

The biggest sheep fairs were mostly held at the end of summer, when animals are well-fed and ready to travel. Weyhill, in July, was no exception. At its peak, more than a hundred thousand sheep would be sold in one day, alongside geese, pigs, horses and cattle. Hops from Kent and cheese from Somerset had also been brought to sell; labourers and domestic servants stood with the tools of

their trade seeking new positions, while hawkers sold trinkets and kitchenware and gingerbread, along with all the sideshows which such a gathering attracted: the feats of strength, fortune tellers, the ale tents, waxworks, merry-go-rounds and peep shows.

Railways and diesel engines gradually ate away at the fair's purpose until the last sheep sale was held in 1957. And that was the end of Weyhill Fair.

When E and I arrive at Weyhill, not only is the fair long gone but the place itself has almost disappeared. A main road rushes past, its immense metal signs overshadowing the few houses, the unremarkable Victorian church and the one building which remains of the fair. This had been built as the booths from which the finest hops in the southern counties were sold, but as trade had shrunk they were used to store lorries and finally converted into a craft centre. The ring of stalls has been refaced and given new windows but the vast gravelled space in the centre, once filled with buyers and sellers, is now too big for the few cars who stop and the place feels abandoned and without purpose. Roads no longer have stopping places, instead they tear out prosperity and send it shooting past.

I can't find anything to look at. The backs of the booths are wattle and daub but that's the only hint of any history. At an eco-housewares stall I buy a coir scrubber to be encouraging, and a book about the history of the fair. Maybe this will tell me what the place itself cannot.

Some locations are resonant, with vibrations of their former lives and importance remaining in the air even when the visible traces are gone. Much of the Ridgeway feels this way to me, but Weyhill holds onto nothing from

its past. These last buildings stand marooned behind an industrial estate of pressed steel boxes, holding removal firms and food manufacturing. The sheep do still come in and out of Weyhill, not by foot but in packets.

The tearoom is closed too so we get back in the car and go home without even finding an ice cream for E. Both of us are disappointed.

The book I have bought tells me two important things about Weyhill. One is an ancient tradition, the ceremony of 'horning' which took place at the fair. Any strangers or first-time visitors would be taken to an inn at the end of the day. There the landlord would ask 'Are there any colts to be horned?' and the newcomer would be handed a pair of silver-mounted horns – from either a ram or a deer – with a cup between them which could hold a pint of beer. This would be placed on their head and the crowd would chant a rhyme.

> So swift runs the hare, so keen runs the fox,
> Why shouldn't this young calf grow up to be an ox,
> And get his own living among briar and thorns,
> And drink like his daddy with a large pair of horns?
> Chorus:
> Horns, boys, horns; horns, boys, horns,
> And drink like his daddy with a large pair of horns.

I like persistence in both roads and customs, and this ceremony clearly goes back some time for shepherds and drovers. That said, horns and antlers appear on the heads of gods and men all the way back to the very beginning of English history. Men dressed in stag headdresses and skins

dance in the margins of medieval manuscripts, while tenth-century religious tracts specifically warn against the wearing of animal pelts and skulls. In Roman times, a native British god is sculpted sitting cross-legged and sprouting horns, while the being wearing antlers on a rare Iron Age coin might be the same god, or his priest, or a king. More peculiar is the fact that, as late as the sixteenth century, a stag's head on a spear was paraded around the old St Paul's Cathedral to the sound of horns, and some sources say that a stag and a doe were sacrificed on the steps of the church too.

The wearing of antlers can be traced right back to the Mesolithic, the very earliest Stone Age, when the first humans came to Britain. A small group lived at Star Carr in Yorkshire, where the remains of their lakeside settlement were preserved by layers of damp peat. Within this, an extraordinary find was made: thirty-three deer-skull headdresses, many with their antlers still attached. Not only had they been cleaned and shaped to make them easier to wear; some had a pair of holes drilled into the bone so that they could be tied on. A seventeenth-century engraving of a shaman in Siberia shows him wearing identical headgear. The archaeology cannot tell us whether the people of Star Carr made their antler crowns for hunting or for ritual and perhaps the people who wore them saw no difference between the two.

None of which is to say that the horns of Weyhill date back to the Mesolithic, but they are not toys or fancies and belong to an ancient tradition. One other set of horns reveals how long uses can endure. At Abbots Bromley in Staffordshire, on a Monday in early September, the locals perform the famous – if you are a folklorist – Abbots

Bromley Horn Dance. Although the troupe contains a fool, Maid Marion and a hobby horse, the central performance is by a small group of men carrying antlers, and the act is meant to ensure another year of good hunting. It would be easy to dismiss this as a medieval mummers play or even a misunderstood tradition revived by the Victorians were it not for one thing. The horns have been radiocarbon dated and found to be more than a thousand years old.

Weyhill holds another message too, a reminder of how closely equated women and livestock can be. The fair was notorious as a place where wives were sold, as well as sheep and cattle. In Thomas Hardy's *The Mayor of Casterbridge*, the defining incident of the whole book is when Michael Henchard, on a drunken whim, sells his wife Susan to a sailor. This happens at Weydon-Priors, a fictionalised Weyhill Fair.

For many years Hardy's plot was criticised as improbable or anomalous, but in the eighteenth and early nineteenth centuries, when the book is set, wives were undoubtedly sold at Weyhill. These sales, though, were usually arranged in advance and worked as a form of public separation and remarriage for the very poorest who could not afford a divorce. Payment was nominal, made only to formalise the deal. Although in one case, recorded at Weyhill in 1823, a man tried to sell his wife for fifty shillings but had to settle for twenty and a dog.

Hardy understands that this could happen because wives are perceived as a type of possession.

'For my part I don't see why men who have got wives and don't want 'em shouldn't get rid of 'em as

these gypsy fellows do their old horses,' said the man in the tent. 'Why shouldn't they put 'em up and sell 'em by auction to men who are in need of such articles? Hey? Why, begad, I'd sell mine this minute if anybody would buy her!'

Women are a particular kind of property: not chattels or goods but domesticates, just like the sheep and the cattle which are also for sale at the fair. In the eyes of men, these all exist to be useful, to stay where they are put and to provide offspring – and also to be disposed of when they are no longer required.

Hardy is far from the first person to notice this. Some historians, most notably Friedrich Engels, suggest that women's status changed when farming began, and that this happened precisely because of domestication.

In breeding and domesticating animals, the argument goes, humankind began to understand how fertility worked. Women's ability to procreate was no longer extraordinary or magical and men understood that they too had a role in producing children, and so the nature of relationships changed.

At the same time, the advent of farming also meant that land was no longer a general good, like air or water; it ceased to be something which everyone could wander over to get food as they wished. Instead, it became a private possession, something which men wanted to pass on to their sons, along with the herds which grazed upon it. To do this, they needed to know for certain who their sons were, and this meant policing how women reproduce.

Why did it not happen the other way around? Why did women not want to pass land on to their daughters instead?

The other side effect of settled agriculture is that it intensifies the need for male brawn. In hunter-gatherer societies, things tend to be shared differently. One study suggested that the gatherers brought in more than three-quarters of the food requirements of a tribe, making the hunted meat a dietary bonus rather than an essential. We have no way of knowing who hunted and who gathered in the earliest situations, but in a way it doesn't matter. Anyone can survive by finding their food in the landscape. But once survival is dependent on ploughing and being able to defend one's own land, women are at a disadvantage and find it hard to survive, and certainly to rear children, without a man. The combination of these factors resulted in what Engels called 'the world historical defeat of the female sex'.

Evidence supports this. A group of archaeologists plotted the emancipation of women in various countries against the history of farming in these places, and the correlation was clear. The longer that a nation had farmed, the less likely it was that women would have jobs or be represented in parliament, and the later they got the vote. Domestication has done women no favours at all.

Yet these disadvantages are rarely considered when you read about it. On the contrary, domestication is seen as a turning point in human development, a sign that mankind, with the emphasis on the man, has become civilised. The wild has been cultured: animals and plants and clay have been brought into the house or the enclosure and put to use. And with them has come the energy of female reproduction, understood and tamed and now functional too.

Domestication is what sets the humans apart from the animals; it's what elevates European white men above the so-called savages and justifies the burden of the Empire.

The idea that domestication is the origin of civilisation itself goes all the way back to the Romans and is rarely ever challenged.

That's a lot of history to be living with in my daily life, but the upshot is that the domesticated are now seen as lesser or degraded, while the wild is still romantic and admirable. We don't have much regard for sheep; they are stupid and inert. What's more, we blame them for this, even though it is us, the humans, who bred them to be this way. Tame animals are inferior to the wild: a dog is not as glamorous as a wolf, a domestic cat can never be as profound as a tiger. Women are seen as lower status because they are domesticated and stuck at home, but at the same time men very much prefer them to stay there.

The need to keep women at home is what makes passing strangers shout at women who are out running, to remind them that they have strayed too far from the hearth. While it's the fear of being domestic, of being weak, lesser and confined which impels men to walk away from their houses and sleep up wild mountains which are clearly more important and interesting than any field can be. It's a grim story, and one which defines women as inferior, stuck at home chewing the cud and leading a less meaningful life. Perhaps this is why I have come to dislike cows so much. I'm afraid of them because they might trample me down, but increasingly when I come across them I see that they represent my lot in life. I too have been trained into being less than my wild self.

But if we accept that domestication isn't the natural order of things, that it's a phase of history rather than a biological absolute, then women have more choices. We are no more designed by nature to be in the home than

goats and sheep and cows are meant to be stood in fields. This state of affairs can be changed, if we put our minds to it.

There is one more thread of hope as well. However much animal behaviour is altered by breeding and fences, the process of domestication is never certain or final. Almost any animal can revert to the wild within a generation or two.

Maybe this explains why I have begun walking again. When I had a child, I did not know that this would make me domesticated in every sense of the word. Perhaps it's time to experiment with going feral. Is this the message that the Harrow Way has for me?

The Ridgeway, from Warminster to Sutton Veny
Nine miles

My own personal domestication runs deep. I am still frightened of what might happen if I break too free, go too far from home, of where a new path might lead me. I'm circling my past on the old paths rather than setting out, as I know I need to, for somewhere new. What scares me is where following the Harrow Way might end up.

For now, I keep telling myself that simply getting out and walking is what matters and so it's fine if I keep following the Ridgeway on from where I left it behind at Battlesbury. This is an avoidance strategy, but at least it's one which takes me somewhere.

I also have a particular reason to want to see this stretch from Salisbury Plain because it takes me to Sutton Veny, which was home, for a change, to a woman writer whose subject was this landscape and its roads. Ella Noyes was a contemporary of Edward Thomas, who, like him, walked out and wrote about what she saw. I need to repopulate this landscape with the missing women, to give myself replacements for the old idols like Nash and Ravilious and Thomas and make up for all the wives they left at home.

And yes, my excuses are plentiful and persuasively wrought. They serve me well.

Even on the Ridgeway, following where the path goes next is not necessarily straightforward. Once again a river stands in its way, the Wylye. Despite being only a small stream, running from the chalk above Warminster south towards Wilton and then Salisbury where it eventually meets the Avon, its valley is still enough to send the path into confusion.

To find out, I resort to the books. I have three on my desk which might tell me the answer, all of which try to explain the ancient trackways of Wessex and the south-west. Two date from the late 1960s, which is perhaps the last moment when historians and writers paid significant attention to roads. Both are thorough but dull, bristling with directions and notes which are so dense that I cannot see through them to where the roads might go, or even which route I am meant to be following, plus they are prone to divert alongside paths or other trackways until I am so confused that I cannot find myself on the map. Sometimes I don't even know what county I am in.

Perhaps this is more the fault of the roads. Clarity and direction are rarer than I think; the path is often confused or multiple. This is what a sense of direction looks like in the middle of my life: complicated and tangled up with confusions and distractions. Choices have to be made all the time. No longer is there one single route to follow with wooden fingerposts marking the arc of my desire. A simple path or a fate is a rare thing, to be cherished when it is found.

The third book, fortunately, saves the day. It's much

older, published in 1914 when people were less afraid to be definite and it's called *The Green Roads of England*, written by Robert Hippisley Cox. Cox was not perhaps the most obvious expert on the history of landscape: trained as a surgeon, he was for a while personal physician to the Marquess Conyngham, then entered the medical corps of the Coldstream Guards. After leaving the army, he became manager of both the Inns of Court Hotel and the celebrated bohemian restaurant Romano's, in the Strand, where the future Edward VII had dined with artists and actresses. At the same time Cox was also friends with many archaeologists – who back then were closer to bohemians than scientists – and he put in his own fieldwork, travelling the length of the Berkshire Ridgeway in a dog cart.

His book is a joy. Its fold-out maps are finely hand-drawn and coloured, with sepia scrolling marking the contours of hills and its text broken up with elegant diagrams mapping the hill forts and other earthworks he meets along the road.

It's easy to read for other reasons too. Cox is good at noticing what is around him, and his text flows. I also like his writing because we agree with each other. He thinks, as I do, that the hill forts were waystations, each a day's walk apart. He also suggests that the tumuli and barrows were, in part, signs to guide people along their way. Perhaps we come to the same conclusions because we are both looking at the landscape through the same lens, the point of view of the road.

His thoughts hang together because he has a theory, which is that the key to these old roads is the watersheds. All the main highways of ancient England, he asserts, run

along the watersheds between rivers, and I don't disagree with this either.

The greater Ridgeway hates crossing rivers. Its route can be pretty much guessed, with no prior knowledge, by taking a map of all the waterways in Southern England and trying to draw an east–west route which runs along the watersheds, weaving its way between the sources of almost every stream and river. This high, dry road can take you all the way from Norfolk right down to Devon on the barest minimum of river crossings, starting at the Wash and finishing up at the mouth of the River Axe. It's hard not to believe that this is how the old path was first made, only on the ground rather than on paper. The Harrow Way can be traced out in just the same fashion. These paths abhor water.

In a time before secure bridges, avoiding rivers was the safest and more straightforward way to go. Back then, rivers were less controlled and orderly, braiding and snaking across the valley floors, creating expanses of wetlands and bog as they went. And they were hard to cross. Walking where they were not would have been the easiest way to go.

But Hippisley Cox also sees the watersheds as having a near-sacred dimension, as the means by which the inhabitants of England first understood their land. He argues that Avebury, not Stonehenge, is the chief temple, because every watershed route meets here. In fact the exact place where this happens is not at Avebury circle itself but Tan Hill, the site of the early-morning sheep fair and the golden torc, and all the ditches marking out the sacred space.

Perhaps he is on to something with his theories; I will follow the path he suggests.

T drops me off at the road alongside Battlesbury hill fort on the far edge of Salisbury Plain, where the road from Imber drops down off the scarp. The top is a thick meadowland, studded with plantains and grasses running to seed; a complex of different shapes of leaf, of stalks and pink and white, tussocks and scrubby hawthorn bushes scattered over its slopes. Larks sing out as I pass. At the same time, the signboard at the gate reminds me that Battlesbury, while open to the public, is owned by the Defence Estates (now the less threatening Defence Infrastructure Organisation, even though the sign hasn't changed yet).

The army presence on this side of the plain suffers from an overdose of nominative determinism. The nearby barracks are named after the hill fort, and how could Battlesbury Barracks be in anywhere but Warminster which must in turn become Headquarters of the Field Army. The military are inevitable here.

I can't ignore them even if I don't read the names. It's a busy day of exercises today, Operation Wessex Storm, and the army are throwing all their firepower at each other. I've no idea what is going on but the sound is familiar, the booms and clatters which resound in the background when a journalist on the news is reporting from Baghdad or Beirut. Somewhere in Wiltshire, an insurgency is being put down.

A haze of light cloud covers the sun but I'm happy with that; it's easier for walking. Rather than crossing the fort, I walk around its high banks, gazing out. The red-brick army huddle of Warminster lies below, although some of the time I can hide it behind clumps of trees. On the other side, the harvest is mostly in, the

grasses of the Plain tired and faded, a washed-out khaki green.

With the name and the barracks spreading out below it's easy to believe that warfare has been part of this place since the beginning of time. We know what hill forts are for; the clue is in the name and also their shape. All those banks and gates have to be defensive, why else would they be built? And so for hundreds of years antiquarians – who admittedly are almost entirely men – have imagined that these are the early equivalents of a motte-and-bailey castle, places born out of conflict and warfare and distrust, set up high to scan the horizon for enemies. We are taught to stand at the base of the hill and replace in our mind's eye the timber revetments on each bank, the fortified gates, and to see the armed bands trying to attack up those steep slopes. But first impressions are not, even in the case of a fort called Battlesbury, correct.

In fact hill forts are an object lesson in how the landscape is seen almost entirely through the eyes of men, with a side serving of the way in which archaeology is very often not a science but a wonky, dark mirror with which we examine what is bothering us in the present.

Perhaps the most famous excavation of any hill fort happened when Sir Mortimer Wheeler dug at Maiden Castle in the late 1930s and uncovered a cluster of bodies at the foot of its banks. Paul Nash came to visit, photographing the tangled skeletons as though they were an abstract carving standing out in relief from the white soil.

For Wheeler, overseeing excavations in his dapper fedora and bow tie, this was clearly a war cemetery, with bodies thrown in carelessly, and one even having been killed by a

Roman ballista bolt to the spine. Paul Nash labelled his pictures *Nest of the Skeletons (The Last Defenders of Maiden Castle)*.

After the dig was over, Wheeler wove the excavation evidence together in a dramatic report which described how the II Augusta Legion stormed the settlement, won the battle and set fire to its buildings.

> Under the rising clouds of smoke the gates were stormed and the position carried . . . Men and women, young and old, were savagely cut down before the troops were called to heel . . . and the dazed inhabitants were left to bury the dead amongst the ashes of their huts.

The imagery and action made exciting reading, and turned Wheeler into a celebrity, but his interpretation was mostly fiction. Subsequent excavations have shown that the areas of burning were more likely caused by smelting iron than by arson, the cemetery contains bones from many different periods, buried with care, and the ballista bolt is, in the end, a standard old spear point. Most tellingly of all, Maiden Castle was never defended against the Romans. By the time they landed on the English shore, the site was on the way to being abandoned, its ditches silting up and its population falling, home perhaps to just a handful of households.

Mistakes can be revealing though, so why did Wheeler see the site as he did? At the moment when he was excavating, between 1934 and 1937, the war to end all wars was still fresh in everyone's minds, and another was clearly looming. Wheeler himself had been a major in the First

World War, had fought at battles including Passchendaele, and enlisted for another spell of service while he was writing up the report in 1939. The circumstances of the present made it impossible not to think about conflict.

So what was the hill fort for if not for battle? Increasingly it seems hard to say. Nor to know if a site meant the same thing for its whole existence, or even that one hill fort meant the same as another.

Hill forts are at least in some part about show. Many have far more ditches and banks than would be required: designed to look defensive rather than to be defended. Other than that, we have no clear idea of what happened within. They were occupied, but Iron Age people lived in plenty of other places too, and the inhabitants of a hill fort don't seem to have been more wealthy or more powerful than any of the others.

What have been found at Battlesbury are the remains of corvids – ravens, crows and rooks. In particular, what was kept were their wings, which were laid out at the bottom of pits. This is true at other hill forts as well, further east along the ridgeways. At Winklebury in Hampshire, a raven was buried with its wings spread, set between two human skulls, while at Danebury 80 per cent of the bird remains were ravens or crows. One bird showed signs of old age, while another had an injury to its foot which was long healed, suggesting that they were not wild but familiars, or pets, or something in between.

Perhaps we can imagine a new story for the hill forts, as high enclaves housing a whole caste of gatekeepers and messengers, who ran the paths and the hill forts as a kind of motorway, studded with service stations. The birds were their sign and mascot and familiar, just as they still

are at the Tower of London. After all, we still call the most direct distance between two places 'as the crow flies'. This is not just me being fanciful, it's as likely and as proven as much of what archaeology can tell us. We might be better off if we looked at the ancient landscape through the eyes of poetry as well as science. And perhaps we should not always see things through the eyes of men.

I've walked halfway round the fort now and come to what would have been a gateway. Ahead of me, the land dips down into a wide smooth valley before rising again. On the face of the next rise are strip lynchets, giant steps running across the slope which are the terraced remains of prehistoric fields. Beyond that, oddly, is a second fort, Scratchbury, its ditches and banks more tentative and perhaps unfinished, but there all the same. Paired hill forts like this are meant to be rare, yet I keep coming across them on the whole length of the Ridgeway. They stand like gatehouses,* watching with their crow eyes.

I'm not climbing up to Scratchbury, not today. Instead I am following what I hope is the path, which runs along the hollow in between them. This is no ancient hedged track but a broad, ridged concrete path, designed to keep the tanks on the right lines and off the archaeological heritage. It feels like walking along an airport runway.

The valley is green, the trees dark against the bright grass. From here I can see three hill forts: Battlesbury and

* I'm not the first person to think that hill forts might be a kind of motorway services and observation point combined, something which is also hinted at by the fact that, as Hippisley Cox notes, they tend to be a day's walk apart. But like so much of archaeology, we will probably never know.

Scratchbury either side, while on the right is Cley Hill, a single outcrop of chalk west of the plain. Eventually the tank road turns into a narrowing lane, its tarmac cracked and potholed from disuse. Last night's rain lingers in the crevices, leaving the surface patterned like the back of a tabby cat.

As in the Vale of Pewsey, the modern forms of transport run through the bottom of the valley, but this time they don't block the path. This road heads straight for a hump-backed bridge over the railway and then alongside what was once the local manor, Bishopstrow House, now a hotel. Lurking in the grounds, inaccessible, are a tumulus and a long barrow. This kind of monument usually stands on the edge of a ridge, designed to be seen from the valley below. Down here they are not much use as territorial markers and I can't help thinking that they are here as Hippisley Cox suggests, as a signal to travellers that they are on the right path.

The next obstacle is the river, which I cross alongside a mill, no longer grinding, and transformed into a pair of desirable residences. The path still heads in the same straight line, which reassures me. From the wooden footbridge, I stand and look at the Wylye, flowing clear over stones but only a few inches deep. It's hard to imagine that in prehistoric times this was a major communications route, when a paper boat is about all that would sail here, but that's what prehistorians like to think. One of their big arguments against roads is that it was much easier to transport stuff by river, so who would need the great long ridgeways?

I don't buy a lot of what is said about rivers, and not just because the Wylye, like the Kennet at Avebury and the Avon at Marden, is so shallow. Archaeologists categorise

the first inhabitants of Britain as primitive people, with primitive tools, and so they are seen as being like the only tribes of that kind left on earth, who canoe through the deep jungle where they live. But why would you do that in a land which was already partly cleared, where the uplands were bare and very much walkable?

There's also the presumption that human beings are logical, which is quite a leap of faith. When records begin in the early Middle Ages, transporting heavy goods by road cost five times as much as transporting them by water, but that doesn't mean that people used rivers. When Faricius, Abbot of Abingdon (then in Berkshire), wanted some large oaks to rebuild the monastic church in 1100, he did not use boats, but six carts, each drawn by twelve oxen. What's more, he sent them all the way to North Wales to get the materials, a journey which took six weeks and passed several large areas of woodland on the way, some of which were owned by his abbey. Rational calculation had nothing to do with his plans.

The Wylye also reminds me that river crossings are the sites of henges. Stonehenge and Avebury and Marden all stand where either the Ridgeway or the Harrow Way meet a river,* so really there ought to be some kind of great earthwork in Bishopstrow too, even by this shallow stream. But I dismiss that idea because the last thing in the world that anyone needs is me, not an archaeologist, coming up with odd theories which can't be proven.

* There's another one called Waulud's Bank, which sits unexpectedly in a housing estate of tower blocks in Luton, and marks where the line of the Greater Ridgeway meets the source of the River Lea.

Much later on, researching the details of another monument altogether, I read a small comment noting that English Heritage were very interested in a field in Bishopstrow called the Bury. I'd been walking right along its edge. What had been interpreted as medieval earthworks was now thought to be a far earlier enclosure. Perhaps, suggested some English Heritage experts, it might be another mega-henge.

I couldn't help feeling smug at this, not just for myself and my deductive powers, although that clearly plays quite a big part. What also pleases me is that the old way of investigating landscape and history by walking over it and seeing how it fits together still works. This is the method of Hippisley Cox and his friends; so perhaps we should take what they say about roads and connections a bit more seriously.

From here the route takes me onto a dull B-road towards the village of Sutton Veny, the earthwork markers still guiding me as I trudge on. In a field to the side, a large barrow rises out of a ploughed field. A bit further and a sign points to Southleigh Wood. In here stands Robin Hood's Bower, an uncategorisable square earthwork enclosure with an inexplicable name. The bower is hard to find in the woods but easy to pick out on aerial photographs because it's entirely planted with monkey puzzle trees. These lands belong to Longleat, and the decision was made by the late Lord Bath simply on a whim. More things than we think happen for no reason. We need to remember irrationality when we are looking at what has been done in the past.

A concrete bridge carries my route over the final

obstacle, the speeding vans and lorries of the A36, then I head down a lane which smells like the seaside when the tide has gone out and takes me into Sutton Veny. The village is long and thin, more agricultural and less tidy than the villages around Pewsey. Tractors thunder along the road like civilian tanks.

I've been wanting to come to Sutton Veny for a while because of Ella Noyes, who was one of the first people to write about the chalk expanses of Salisbury Plain in an appreciative way. More than that, Noyes is a woman author whose subjects include antiquity, place and exploring England at the same time as Belloc, Thomas and Hippisley Cox.

Her book, *Salisbury Plain: Its Stones, Cathedral, City, Villages and Folk* was published in 1913 and illustrated by her sister Dora. The book is still intensely readable. Noyes wrote from clear experience of the chalk and seasons: 'its paleness, its airy spaces and its lark-filled silences'. She appreciated the layers of history visible under its thin skin of grass, and its trackways too.

These white roads travelling endlessly on over the low swells, in a swift solitary course now mounting to the skyline, now descending a long slope and rising again, disappearing, reappearing, still descried far off, streaking the distant ridge. Mystic lines, uniting things unseen with purpose as remote as the telegraph wires.

Ella Noyes is not just describing the plain from a distance, she has walked across it too. One chapter of the book describes her journey from Stonehenge to Old

Sarum, a healthy nine-mile hike along trackways and paths. When she reaches the hill fort of Old Sarum, excavators are just beginning to rescue the earthworks from under the growth of centuries of trees and bushes. She sees them excavating a skeleton; perhaps, she thinks, it might have been a soldier.

I would have been very happy to have written her book. Noyes has ranged over the city and the plain in all weathers, she has asked questions and looked hard at what she has found, she tells stories, but she is also very present within the pages, an engaging, curious personality.

She could write about the plain so well because she lived close to its edge for most of her life, first near Durrington and then in Sutton Veny, where she shared a house with her sisters Dora and Mary. Dora was an artist in her own right as well as illustrating Ella's books, while Mary was a singer, and I can't help but think of them as the Three Graces, each taking on a different art.

As ever, the biographies of women are sparse, so it's hard to say what took the Noyes sisters from their conventional background as the daughters of a solicitor in Harrow in the 1870s to their artistic menage in Wiltshire. It probably helped that Ella and Dora were the youngest of a family of twelve. Not only had their parents probably run out of expectations which needed fulfilling; the two girls were orphans by their mid-twenties, in charge of their own destinies and with private means to fund their choices as well. Even so, their lifestyle, their independence and their feminism were unusual.

What survives of the sisters is hearsay, from people who knew them when they lived in the village. This is still the recent, memorable past, because Dora only died in 1960,

at the age of ninety-six. The local library put me in contact with a farmer's wife turned local historian who spoke of her as if she had only just walked out of the room.

The Noyes sisters, she told me, lived together as a feminist decision. They were very interested in the local children and Dora would often paint portraits of them, but never signed them, ensuring they had no sale value. The sisters told the neighbours that they would have loved to have had children themselves, were it not for the fact that this meant being involved with men.

Not being married was probably the only way for the Noyes sisters to live the adventurous and creative lives they did. Dora was one of the youngest students ever admitted to the Royal Academy Schools. She exhibited regularly at their summer exhibitions over twenty years and, before moving to Wiltshire, resided in a purpose-built block of artists' studios in Chelsea, alongside other artists and sculptors, and feminists too.

From about 1904, she put a lot of her artistic energy into illustrating her sister's books. This would have been a time-consuming job, because Salisbury Plain was the only local subject. Ella's best-known works were travel books about Italy. All the sisters were apparently fluent in Italian and travelled there often, but their Italy is not the travelling aristocrat's country of the Grand Tour, of classical ruins and smart hotels. Ella did her own research and travelled deep into the countryside where few foreigners ventured. Her best-known book is *The Casentino and Its Story*, a guidebook to the homeland of both St Francis of Assisi and Dante. Writing it involved miles of walking through a landscape of sheep folds and chestnut trees, scrambling down slopes and discovering routes amongst

people who were not used to tourists. And of course her sister travelled with her. For single Edwardian women these were adventurous journeys, but had they been married, this kind of life would have been entirely impossible.

Their house, Fosters, still stands in Sutton Veny, white-washed and square, substantial enough. The three of them had a comfortable life, living on their investments and able to employ a servant right up until the Second World War.

Although their books are still remembered and respected in Italy, the Noyes sisters have been almost entirely forgotten in their home country, even though setting out into Italian backwaters and writing about it would make them brave and adventurous and worthy of a book contract even today.

Ella's writings about Salisbury Plain are noteworthy too. Her book is an evocative read, so why is she not as well known as Belloc, or Jefferies, or even Edward Thomas? That's not an entirely random pairing. In May 1913, *The Times Literary Supplement* reviewed her Salisbury Plain book jointly with Thomas's *The Icknield Way*. It's hard to call a winner from an Edwardian book review but if anything it's Ella who comes out better, in terms of both her writing and her knowledge of place. Thomas, on the other hand, 'gives the impression that the Icknield Way soon begins to bore him'. There is no sense that the future of nature writing begins here.

In truth, *The Icknield Way* is a patchy book. Sometimes Thomas enjoys both his travel and his research, but sometimes his travels turn into lists which remind me of the pieces in the Bible where so-and-so begat someone else in endless succession. We don't always get to visualise the

places he travels through, and then in other moments he sticks in a piece of writing – most notably about rain on the roof at night – which may be a tour de force of prose, but one which has little place in the book. Ella Noyes is a far more coherent author.

The *TLS* reviewer seems to agree, and if a reader came away from the article planning to buy a book, it would probably be Ella Noyes'. She ought to be an inspiration today as much as Thomas. Perhaps us women need to start looking after our own better.

I turn left out of the village, heading up Hill Street towards the downs. As I climb away from the green fields, the sun goes in and an odd, heavy atmosphere settles on me. A hunched farmhouse is set into one side of the hill. Cement rendered and low, it would easily belong in the hills of Yorkshire, or even Scotland. Beside it a field of sunflowers are waiting for better times, heads bowed.

Ahead, a clump of dark trees shelters a set of battered agricultural sheds, built from girders and corrugated iron. I'm not feeling comfortable, and the fear, absent for a while, is rising again. When I pass, there are men at the open back of the buildings, standing around a Land Rover and talking. This is a furtive and secretive place, but I feel miles from anyone and all I can do is walk faster. They are not interested in me and I have seen nothing anyway.

When I reach the summit of the hill, the road unfurls, an old trackway setting out across the wide downs. The fields are yellow, the oats and wheat gathered, and the way forward shows as a stripe of green between them, dotted with dark bobbles of hawthorn. Battered metalwork gates block the field entrances, abstract sculptures of squares and

rusted lines. Up here, unsheltered, the wind is buffeting me but I don't mind. I'm far more worried about people than weather.

Either side of me, the chalk rolls for mile after mile, steep slopes alternating with gentle folds, faded grass and harvest. Above the furthest hills, thick grey clouds are piling themselves higher, getting ready to rain. I can see the green verges of the path offering me the way forwards. But I can't go too far. This track soon merges with the A350, another fast road of cars and lorries; not a stretch to be undertaken on foot. I will turn back before that, where two trackways meet and are crossed by a Roman road.

At least that's my plan. At the next crossroads, I am about to open the gate when I see a herd of cattle heading towards me, led by a teenage boy on a red quad bike. I have two thoughts. One is that this is what a droving track must have looked like in the past, the cattle filling the whole width of the lane, moving purposefully, the drovers keeping out of the way of the livestock as much as guiding them. The other, more practically, is that I don't want to be in the way of such purposeful and muscular traffic, so I go back to the crossroads and step into the shelter of a bush.

Except no cattle come. When I look back down the lane, they have been herded into the field alongside. I am about to climb over the gate and back into the lane when the boy buzzes up on his bike to tell me that they will be moving cattle up and down here all day. 'So if you don't mind that, but they are cows with calves.' That's where his sentence ends. He can't tell me not to go down there, it's a right of way, but his polite and measured manner is still saying that it wouldn't be a good idea as the cows can't be

trusted to behave. He has no idea that I am the last person in the world who wants to confront a cow.

I head back down the hill, on another track which will take me to the far side of Sutton Veny. This turns into a great sunken holloway, bordered by ivy-dense trees and deep brown ditches, but passing prehistoric fields and yet another tumulus, as good a way as any other.

Were I to follow this road further, it would take me back onto the plain further east, where another road comes out from Imber. These trackways meet at Bowls Barrow, which is a notable place. A sliver of a bluestone, those first stones at Stonehenge, the ones from Wales, perhaps brought by Merlin, was found in the grave when it was excavated. The stone, or what we think was that stone, then had a chequered history and ended up being given to the museum in Devizes by Siegfried Sassoon.

When I find my way back to the High Street, T and E are there in the car, ready to pick me up. It took twenty minutes to get me over to Battlesbury this morning, it won't be much longer to get back home.

For a long time when E was small I believed that I had left the chalk landscape and its pathways far behind, or perhaps they had abandoned me. It turns out that they had been close all the time, if only I had thought to look.

Sutton Veny contains one more surprise. On the way out, we pass the Deverill Road Trading Estate, a collection of concrete huts scattered across acres of pot-holed tarmac. Now it's home to car repairers and parts companies, paving contractors and a craft brewery, but the shape of the slab-built huts and the spaces between them make it easy to recognise as something built by the army. I am not yet

far enough from Salisbury Plain to have left war and soldiering behind.

When Ella Noyes wrote the introduction to her book on Salisbury Plain, in February 1913, she found the army almost a pleasure to encounter:

> . . .the cavalry exercises are even picturesque to see and the sound of squadrons trotting over the turf with the clangour and ring of innumerable accoutrements – like the sound of many waters – almost makes up for their intrusion . . . the shepherds feed their sheep there as usual and all is as it was except for a few ugly tin buildings, and a hard road in places where formerly only a down track ran.

Within eighteen months the army had spread across the plain and into her valley, which filled up with tents and huts and men. During the First World War, Sutton Veny became an army town. Ten camps were built around the village, which was now served by its own branch of the military railway, and ten thousand troops passed through for their initial training. Villagers would watch them marching in when they first arrived. Before their uniforms had been issued it was easy to see who had done what in civilian life: the clerks still wearing their stiff collars, the fishermen their blue jerseys.

As well as accommodation, Sutton Veny held a military hospital, a branch of the YMCA operating out of Sutton Veny House, and three cinemas, one of which was burned down by furious troops when the projector stopped working. The owner did offer them free tickets for the next day's performance, but many of the soldiers were due to

depart for the trenches early in the morning so they didn't think much of the bargain. Once they'd set the building on fire, they dragged the piano out and gathered round it to sing 'Keep the Home Fires Burning'. Then they chucked the piano back into the blaze.

In 1916, the Sutton Veny camps became home to the No.1 Australian Command Depot, who remained until 1919. After the war was over, the Australians took advantage of their rural location and set up an agricultural training college to prepare soldiers for their return to civilian life. Once this was wound up, the camps were cleared and the lines of the military railway removed.

The trading estate we passed wasn't a survivor from that war, whose huts were flimsy and wooden, and when most of the soldiers slept and ate under canvas. These more enduring, concrete remains were built on the same site, but for World War Two, when the village housed soldiers all over again, British and American, engineers and artillery corps. All three of the Noyes sisters lived long enough to see this too.

Newton Tony to Amesbury
circular walk near the Harrow Way
Eleven miles

The freshness of early summer has gone. The Gulf Stream is bucking and twisting in the ocean and the clear weather has broken. I want to get out but weighty clouds linger in the sky and the threat of rain is never far away. Pushing my body through the atmosphere is hard work and the breeze is too warm, as though I am stuck in a hot car with stale air being fanned past me. Ox-eye daisies and poppies fill the verges now, the year is moving on.

The world smells of damp towels and washing failing to dry. It's no weather for the old paths. The chalk tracks will be soaked and slippery, the long grass fraught with rain, drenching my clothes as I pass. I would need waterproofs or special wicking clothing that I don't own. For now, I am not going anywhere.

In any case, what's the point? I don't know what I am trying to achieve by walking, so why bother. Although it gives my days shape now that E is older and more independent, I plan a walk, I do it and then I think about the next one. Without that I am a pointless husk. No one is bothered what I get up to as long as I am back at five and

there is some supper and I do not know how this state of things came to be.

The answer is biology, twice over. I have stopped being essential to my child, that is one thing, but my periods have also finished, finally, and so I am not even any use for breeding now. Were I a cow or a sheep I would have been sent to the abattoir a long time ago.

The only purpose I have is to carry on, putting one foot in front of another and seeing where this will take me. The rain will end, they say, on Friday, but I will be so relieved to be out once more that I won't even mind the damp dripping from the end of the bramble sprays. At least I will be moving forwards.

That is if I can work out where to go. The Ridgeway after Sutton Veny is no longer a path; from there it's an A-road as it heads south for miles. I have no choice except to start the Harrow Way. But when I go back to look at the maps, it's still a mess of double-track road and missing stretches, apparently unfindable. I have been given directions in a language I ought to be able to read – after all, I deciphered the Ridgeway well enough – but which make no sense however hard I try. Perhaps this is the way of paths in middle life; they are tangled and unsignposted. No clear way ahead here.

I want to start at Weyhill, but for at least the next thirty miles west the road is buried under the A303, known and travelled over but entirely unworkable. Rather than leave this section out entirely, I map myself a walk which goes around the Harrow Way rather than along it. My aim is to explore the territory and not think about the many ways in which I am still avoiding the path itself. I am still afraid of what it might put me through.

I also have another motivation for choosing this route. Ella Noyes has inspired me, and now I don't just want to stumble upon the women who have written and walked before me, I am seeking them out. This walk also means starting at the beginning, with the very first woman traveller who not only set out away from home because she wanted to but wrote a book about what she saw and understood. Her name was Celia Fiennes and she was born in 1662 in Newton Tony, a small Wiltshire village just south of the Harrow Way.

Most of what we know about Celia and her life has to be deduced from her writings. Her family were Puritans, and her father Nathaniel fought against the Royalists in the Civil War but somehow managed to survive the Restoration unscathed, keeping the family house and disappearing back into a Wiltshire gentry life.

Of Celia herself, records show that she lived in Newton Tony until she was nearly thirty, then moved to Hackney, then a prosperous village near London, to live with or near her married sister and she died there in 1741, aged seventy-eight. And that would be all, had she not written her journeys down.

From this we know that she did a very unusual thing for a woman of her time and class in breaking free of the family home and travelling. Between 1684 and 1702 – so between the ages of twenty-two and forty – Celia Fiennes visited almost every county in England. For some of her journeys she was accompanied by relatives, but often it was just her and a servant or two, which is about as alone as a woman of her class ever got to be.

Fiennes' travels were revolutionary. Of course she wasn't the first woman to go places; they had been on the

road for hundreds of years before this for business, for marriage or on pilgrimage, but Celia Fiennes set out from sheer interest and wrote down what she saw, and that's what makes her such a pioneer. We may think of this period as being full of writers like Daniel Defoe and William Cobbett, who explored their native country and wrote about what they found, but Celia Fiennes was the first – the men followed in her wake, thirty years or more later. And so her journals are some of the most innovative and important writings about England in the seventeenth century.

Her travelling was even more extraordinary for being undertaken at a time when other writers were united in their opinion that women who went too far were, well, going too far. Simply leaving home was frowned upon, so women who travelled were almost certainly dubious, dishonest and promiscuous to boot. Celia needed a reason to set out, a passport that would permit her to travel. She said that she wanted to regain her health. This does seem to be a ruse though, because she never records being ill at any point in her writings; in fact she seems remarkably sturdy. Her health is simply the socially required excuse for setting off.

Being female, unmarried and mostly riding side saddle rather than riding in a carriage, Celia Fiennes would have stood out on the road. At one point in her account, in an aside which suggests that she was keeping records as she went, Fiennes states that she had covered 1,045 miles, 'of which I did not go above a hundred in the coach'. Despite the distance, and the absence of any male relative to protect her, she seems only to have been in danger once, when highwaymen accosted her on the way to Chester.

Fiennes and her company coolly rode on until they arrived at a busy market town and the would-be assailants gave up.

Not having several years to spare, nor a horse, I can only follow a very small portion of Celia Fiennes' tracks. I have chosen to walk from Newton Tony to Amesbury, a journey she would have done very many times, the first stage in getting away from home.

Little sense of the seventeenth-century past is left in Newton Tony itself; most of the housing is post one war or the other and only a scattering of older buildings remain. It's impossible to say with any certainty where Fiennes herself lived. Her family were gentry and owned the manor, but reports vary as to where this was. It might have been a building on the main street which was demolished in the nineteenth century, leaving only the kitchens which have become the village pub. Or it could have been a much grander house in parkland to the north, which was replaced in 1715 by a new neo-classical mansion. Either way, nothing remains now for me to point at. Newton Tony doesn't seem very interested in its famous resident either, but perhaps the absence of relics makes it hard to construct a story or conjure up a sense of local pride. Or perhaps they don't approve of women gadding about even now.

It's time to go. I begin on a mixture of roads and footpaths and tracks which were probably once thoroughfares but are no more. Even so, I'm reasonably confident that I will be retracing at least some of Fiennes' journeying because to travel west she would almost certainly have headed to Amesbury first, as the nearest place she could cross the River Avon.

Her achievements are even more remarkable because she set out at a moment when the roads of England were

probably at their worst ever. In the medieval period, pilgrimages ensured that at least the main routes were maintained, but now that these were forbidden, long-distance travel had dwindled. The highways of England were narrow, sticky with mud and rutted by carts and carriages; they began and ended on a whim with few signs to guide the traveller. Clay soils in particular meant claggy roads which might be impassable for half the year. The irony was that people could see that it didn't have to be like this because Roman roads still ran across large stretches of the landscape, raised and dry and metalled. Within a couple of generations, these would disappear, mined for their gravel and hardcore, but for now they remained, an embarrassing reminder of the current limits of civilisation.

My way is at least dry but the path takes me not alongside woods as the map suggests but through them and I am not feeling comfortable. This is also the noisiest walk I have been on so far. Army gunfire is only ever sporadic but here there are helicopters – two already – and the mangled-dustbin clatter of combine harvesters bringing in the last of the wheat, then underneath that the low relentless thrum of the traffic. Whenever there is a clearing in the woods I can see where this comes from because stretched across the hill in front of me is the A303, thick with lorries, vans and cars, the modern take on the Harrow Way.

Celia Fiennes might well have liked this view for both its modernity and its sense of an industrious life being lived. Her writings are very interested in the present that she saw as she travelled, through trade and commerce and novelty. Her Puritan heritage is demonstrated in her desire that every place and person should be engaged in profitable work. Business and busyness were both good.

Historians who read her writings tend to concentrate on the parts where she reports about industries such as paper-making in Yorkshire, not only because it is useful, but also because it is the kind of information that Defoe and Cobbett focus on too. But this is just a small part of what she notes. Fiennes is good company because she is interested in all kinds of miscellaneous sights: in fairs, or stones which mark the meeting place of four shires, or how excellent the bread is in Oxford; she sees people blowing glass and observes the qualities of the cellars and the beers in Nottingham; in York she visits the mint and in Hull a warship.

She is a spa tourist and a connoisseur of their different waters, and also has a great delight in seafood, such as the lobsters and crabs she eats on the Dorset coast 'boyled in ye Sea water and scarce Cold – very large and Sweet'. Hungerford, she comments, is famous for crawfish.

But if there is one thing which interests her above all else it is buildings, the newer the better. She relates detailed tours of grand houses and smaller ones too. Quite a few are stately homes which she is visiting just as we might do, but others belong to her relatives, some of whom are interestingly idiosyncratic.

Thence to Woolfe 4 miles to a relation – Mr Newbery a man of many whymseys – would keep no woman servants – had all washing, ironing dairy and all performed by men.

She walks us through these houses room by room; in churches she notes monuments, while in towns she singles out new brick terraces and smart civic buildings. At times

her descriptions are so detailed that the book feels like a seventeenth-century version of the Pevsner guides. But Fiennes sees architecture as very much the province of people: houses are most often identified by the name of their owner rather than the place, and it is the monuments to gentry and nobility which detain her the most in churches.

In short, she is an excellent companion, covering the essentials of what you might want to know about each place she visits, but with some particular enthusiasms of her own.

The difference between us is that I like to observe the old as well, so when I look at the road in front of me, I see not only the A303 of lorries and cars but also the Harrow Way. From here, I can see what's not easily understood by car: that the new road overlays the old on the classic line of the ridgeway, following the edge of the hill along the driest southern side.

The summit behind is Beacon Hill, marked by a quiver of radio aerials, some round barrows and – this I know but can't actually see right now – a triangulation point. These concrete markers are dotted all over the hills of Britain, used by the Ordnance Survey to map the nation, but Beacon Hill has a particular place in this history.

In 1747 the British army decided they needed to know where they were, and this meant maps. They began in Scotland, because the Jacobite Rebellion, in which Scottish rebels repeatedly evaded capture by disappearing into areas of unknown wilderness, had taught them how important understanding the landscape was for winning wars. Once that was done, they turned their attention to the south coast of England, out of fear of a French

invasion. These early maps relied on rough measurement and, to some degree, the eye of the surveyor. But after 1784 the process became more scientific.

To make an accurate map, the army turned to the science of triangulation, which meant measuring the angles between one high point and two others to work out distances. The squat concrete bollards are later markers of this work. But to make their calculations precise, the surveyors needed to measure at least one base line on the ground, as accurately as they could. The first was laid out on the flat expanses of Hounslow Heath (now partly under Heathrow airport, which also appreciated the lack of hills) and south-east England was mapped from this point. In addition, the surveyors also needed to double-check their results, to make sure inaccuracies hadn't slipped in, and this is where Beacon Hill comes in. A second line was measured, running south from the hilltop, all the way to Old Sarum hill fort near Salisbury. The place was chosen because hedges and fencing were enclosing more and more of southern England, and Salisbury Plain, even then, was one of the few open spaces left.

What we forget, when we get out our orange tourist maps or plot a new walking route on our phones, is how our simple leisure has been made possible by the army. The word Ordnance is now reduced to just one letter in OS; even spelled out in full it fails to register as guns or bullets or tanks in our minds. Yet the whole work of mapping was military: performed by soldiers, managed by officers and paid for out of defence funds. Only in 1983 did the OS become a fully civilian organisation. Wherever I go, I will always carry the army with me in my pocket.

Not that I can avoid them here anyway. As the path

leaves the woods I am, for a brief moment, on the perfect track, a rough grassy way on the high downs. But within twenty paces, I can see that this isn't going to last. Where the route should continue over the brow of the hill there's a metal fence and then – exactly aligned with the way I want to go – the longest military runway in England. Welcome to Boscombe Down.

I had hoped that here I might be getting away from the warfare of the Ridgeway but that's easier to imagine than to do. These ancient tracks seem to attract soldiers wherever they run. All along the Harrow Way, from Weyhill, where a World War One aerodrome is now the Army Headquarters, as far as Stonehenge, the road is edged by barracks and airfields, test sites, shooting ranges, military churches, ammunition dumps and the Dunkirk Social Club. Ink-green lorries and tawny jeeps rumble up and down amongst the traffic day and night. It's impossible not to see the army as I walk.

I also notice their every move because I am fascinated by their presence. The army is everywhere but no one ever mentions this fact. We live alongside them like some strange family secret which can never be spoken out loud. And I am sure that a part of this is because they don't fit our idea of the countryside as a simple and unspoiled place. Nature is meant to be in control here, not weaponry. So we never mention the dark green transporters which rumble along the Harrow Way, the firing ranges and Nissen huts, the dark grey anonymous planes gliding low over the hedges, even when we see them every single time we go out.

The countryside is not what we imagine it to be, and the British don't much like facing up to that.

But the other reason the army fascinates me is because, for a topophile, they are very much part of the folded and complex history of the places I walk through. Auden said that a neo-Tudor tearoom is as valuable as a cathedral, and so an aerodrome belongs on this wide plain as much as Stonehenge. The grassed-over ammo dumps echo the low ridges of the long barrows, and up on Beacon Hill, practice trenches from the First World War cross prehistoric ditches. Both are now listed monuments.

I want to point out this history which has been laid out in front of me. It's a reminder that the landscapes I walk through are never natural and unchanging, and the army are just the latest people to dig and reshape what they find here. More than that, whatever I see is very much the work of men.

The runway blocking my way now is a reminder that the military uses of this landscape were many. As soon as flying became possible, the army realised that the great flat expanses of Salisbury Plain suited aircraft as well as horses and manoeuvres. By the end of the First World War, there were fourteen airfields scattered across Wiltshire, six of them on the plain.

Boscombe Down was erected in 1917 and since 1939 has been the RAF's centre for research and testing, a top-secret facility which is sometimes home to top-secret new technology and experimental aircraft.

Because of this, I have some hopes that a walk along its perimeter might at least be interesting for the nosy. Within fifty metres, I realise that I am going to be disappointed. The pedestrian path – overgrown enough for the Ministry of Defence to have designated it a nature reserve – gradually sinks down into a cutting, metres deep on either side. I

can see nothing at all apart from the first floor of a red-brick office building and some barbed wire on the roof of a mouldering concrete bunker.

That so much effort has been put into keeping the airbase out of sight makes me rethink my ideas about Boscombe Down. The wilder fringes of the internet try to portray the airfield as Britain's Area 51, a classified base where concepts which we think belong in science fiction are tested and perhaps even stranger events take place, involving aliens and extra-planetary craft. I've assumed this all to be nonsense, but if they have gone to so much trouble to bury the path perhaps some of it might be true.

By the time I am level with the ground again, I am passing only mown grass and 1950s accommodation blocks. Nothing to see here. It's only when I come to a metal and brick bridge, clearly Victorian, that I realise the true meaning of this landscape. Secrecy is nothing to do with it; the path follows the line of an old railway, and the cutting was simply to keep the track level. There may not be aliens at Boscombe Down after all.

From here on it's a long suburban trudge into Amesbury, a land of houses and ring roads and roundabouts, the support structure of barracks life. I'm starting to wonder whether there is a point to this walk at all, when, at a crossroads, I suddenly find the cluster of older buildings which form the old centre of the town: a neat but spacious Arts and Crafts pub (now a Wetherspoons); a baker with the huge gold letters HOVIS still over the door, the Georgian offices of Bonallack & Bishop, solicitors. Also preserved is the Friar Tuck Cafe, whose fascia is perfect 1950s moderne, and interior of orange pine booths and Artex only twenty years later than that. The menu is also

unchanged since the 1970s and I eat scampi, peas and chips with tartare sauce. I do not drink the coffee.

I've chosen to come to Amesbury not only to follow Celia Fiennes but also because I want to inspect a couple of places which can't be seen when you rush past them on the main road. The first is a hill fort, a possible service station on the route of the old path. It sits in the grounds of Amesbury Abbey, a priory which then became an aristocratic house. Now it's a nursing home and the grounds are still as closed as they ever were, so I circumnavigate it by road. This takes me up alongside it, but all I can see, through a gate marked 'Private', are woods.

This fort is called Vespasian's Camp. Despite the name, it has nothing to do with the Romans, and was christened by an Elizabethan antiquary who thought that was as far back as history could go. It turns out to be a place which is far more ancient than he could ever have imagined.

For a long time the site was ignored precisely because it was in the abbey grounds. The original religious buildings had been replaced by a great eighteenth-century house, its paths and hills enthusiastically remodelled into walkways and grottos. No one thought that any archaeology would remain. Then it was noticed in some old estate papers that one side of the fort had been left unimproved, so the archaeologists went in for a quick look. Ten years later they are still working.

A pond called Blick Mead, right next to the A303, turned out to be an old spring, one which had been visited by humans ever since the Mesolithic, so for seven thousand years. Left behind there was an extraordinary quantity of finds; more than 35,000 pieces of flint and thousands of animal bones, perhaps evidence for meeting

and feasting. Some of the bones are from aurochs, giant cattle so huge that one carcass could feed two hundred people. People returned to the site over and over again for thousands of years, making Blick Mead the first 'place' in the entire Stonehenge landscape. Everything seems to have begun with gathering.

The discoveries here have many implications. The first is that Amesbury now calls itself the oldest settlement in Britain, more ancient than Thatcham or Colchester. For Stonehenge fans, it's early evidence of the importance of the area, while for those of us who like roads, it also proves that people walked long distances far earlier than we'd ever dared imagine.

We know this because one of the visitors to Blick Mead brought their dog. All that remains of this animal is one tooth, but that's enough to show that the dog and its owner (assuming that it didn't travel alone like some prehistoric forerunner of *The Incredible Journey*)* came all the way from Yorkshire, or maybe even Scotland. Perhaps these were some of the first travels along the Harrow Way, many thousands of years before the roaring A303 had even been thought of.

If I followed this road on it would bring me out on top of the hill by Stonehenge, but this would leave me stranded on one side of the dual carriageway with no way to get over. So I am turning back, in search of a much older crossing point instead.

Ratfyn, where I am headed, is one of the few Celtic

* Although don't discount this. Welsh drovers, if they stayed in town for a while, would send their dogs home ahead of them. The dog would be fed and watered at all the stopping places along the way and the drover would settle the bill when he himself returned.

names remaining in this southern landscape. In Irish it would mean the ford or passage for chariots, so it may mark the place where the Harrow Way crossed the Avon. Just north of Amesbury, and shown on the map, is Ratfyn Barrow, which might have been a way-marker. But when I get here, I can't see it on the ground. (I find out later that it's behind a fence in someone's garden.) What I have found though is a completely hidden and unexpected landscape. The A303 is screaming away, really close now, but beneath its flyover lurks something wild. A few hundred metres away by Amesbury Abbey the Avon is flat and running through flood meadows, but here it lies in a deep, tree-thick gorge with the river glinting way below.

In contrast with Celia Fiennes and the travellers who came before her, my journey is not determined by the bridges over the river; there are plenty enough of those now. Walking, it's the main road which blocks my path, and so I am heading for a footbridge where I can cross the ceaseless traffic.

This deposits me on a very ordinary minor road, where I walk alongside the turbulent roar of the A303, past grass verges and the remains of the harvest in the fields. After a few minutes, I realise that I am singing. Despite the tarmac and the pollution and the fact that this is a place where not many people would choose to walk, I am happy here. This could be the scampi and chips, or just the gentle rhythm of the path, but then I realise. What I am walking on is the old road, the bit of the Harrow Way left over after they replaced it with all the lanes of the A303, nearby but not quite covering its course. On some level I have understood this and it is what makes me sing. I've given up trying to figure out why I like the old roads so

much; all I know is that it pleases me when I find them. Perhaps I don't need to fear the Harrow Way after all; it, too, means well for me.

This harmony of walker and path does not last for long. The Old Way brings me to a New Roundabout. Here I will cross back over the dual carriageway into the Solstice Business Park and Services. I don't want to be judgemental and call this a late-capitalist hellhole but there aren't many other descriptions that will do. Coffee, chicken and burgers for the driver are surrounded by distribution centres for Greggs, Home Bargains and Screwfix. The sign for the Toby Carvery stands dusty and half abandoned, up to its knees in the scruffy grass of the verge. This place is not intended for pedestrians, although they have at least provided a pavement in places.

At the furthest end of the fast-food strip stands a giant metal statue called *The Ancestor*. He – the twenty-two-foot high figure is very definitely male – kneels on the grass, seemingly worshipping nature, although there's not much left of it here. Perhaps he is in awe of the road.*

The nearby Harvester pub is named the Amesbury Archer, after the most spectacular ancestor to have been found here in recent years. His remains were unearthed when a new housing estate was being built just south of the Harrow Way. As well as the archer's wristguard which gave him his title, he'd been sent to the next world with bronze and gold, arrows and pots, an assembly so rich that the newspapers called him the King of Stonehenge. Although back then he might have seemed more to be a

* Like the ancestors, the statue is fond of festivals and has appeared at Glastonbury and Green Man, as well as near Stonehenge for the solstice.

magician, or even a god, because the treasures he was buried with are some of the first metal ever to be seen in England.

The finds aren't the most extraordinary thing about him either. What the Amesbury Archer shows is how far it was possible to travel three thousand years ago, at the start of the Bronze Age. As our teeth form, the minerals they are made from vary depending on where we live. So analysing tooth enamel can now show, broadly, whether a person was brought up in the same place that they died or moved around. Plenty of people did stay put but others, like the Archer, did not. While he died in Britain, he had grown up in the Alps. It seems that he had been in England for a while too. The Archer was in his forties, but an adjacent burial was of a young man in his twenties. The DNA shows that the two were closely related, perhaps father and son, but the younger man had grown up in Britain. More than that, at some later point he had visited the Alps, the land of his relative, and then returned. This is a much more complex form of travel than just the one-way adventure of immigration.

Not only rich foreigners moved around. Another Amesbury grave, found even closer to the Harrow Way, contains the remains of seven more males, children and adults together. One of them had followed the same route from Europe as the Archer, but none of the rest of them were local either, having come from either the Lake District or Wales. And all these people must have made these journeys at least in some part by road. Of course these paths existed.

I turn left through the fringes of the industrial estate, past corporate public art and metal fencing until I reach the downland again. From here I can see what is invisible

from the car: clump after clump of ancient barrows, grouped alongside the road, signalling to the travellers of the past. With the airfield in my way, there's nothing to do but retrace my steps. I don't like this, but even so I am still singing.

I fill in more of the Harrow Way by car as I go home. Two theories exist about its name. One is that it is related to the Old English 'har', which means ancient, giving us the modern word hoary. So, Belloc's Old Way. The other is that it comes from the 'hearg weg', meaning the road to the temple, the shrine way. The road to Stonehenge.

I get to the A303 just past Blick Mead, where it climbs to the crest of another hill. Dark swirls of trees in the hayfields mark where more barrows lie. A lay-by sits alongside the summit, one of my personal landmarks. This is the place where, once a year, the old cars and campervans pull over, spitting and coughing from the stress of the steep hill on their way to the Glastonbury Festival. The urge to travel, to meet others, form a temporary community and perhaps even meet a mate has always been with us, ever since the first groups and their dogs made their way to Blick Mead.

Beyond the next crest there is, as always, a traffic jam as people slow down in anticipation long before Stonehenge has even become grey shapes on the skyline. This may be, perhaps, the end destination of the Harrow Way, and the pilgrims still come in their thousands. As I slow, along with everyone else, the stones are surrounded with people, ropes keeping them safely separate from the power of the past, only ravens allowed into the sacred space, sitting on the lintels, observing.

We know now that some of the stones were travellers too. The larger, grey monoliths which make up the outer

circle are sarsens, a word which comes from saracen and means they are foreigners, but in fact they've only come from near Avebury, twenty miles away. They surround smaller blue dolomites and rhyolites which glitter in the sun and may have comprised the first monument here. These are not local and demonstrate, once again, that ideas can last longer than we sometimes think.

In the twelfth century, a cleric called Geoffrey of Monmouth set down his *History of the Kings of Britain*, a chronicle which gave Shakespeare the basis for several plays but which is usually dismissed as having no relation to the actual historical facts. As early as 1190, one critic proclaimed tetchily that 'it is clear to me that everything this man wrote was made up' and opinions haven't changed much since then.

Geoffrey says that Stonehenge was erected as a memorial to Britons treacherously slain by Saxons at a truce meeting on Salisbury Plain. So far, so unlikely, but he also notes that at the suggestion of Merlin, the stones were brought over from Ireland. Oddly, the archaeology of the blue stones now suggests he was at least a bit right. The monoliths did travel here, from Wales, which was considered to be Irish when Geoffrey wrote. Their quarries have been found in the Preseli mountains, with half-finished monoliths still left in place, alongside the camp fires of the workers who shaped them. This is enough for some archaeologists to suggest that the germ of a true story exists within Geoffrey's tale and that the oral tradition had preserved a myth which might date all the way back to the Stone Age.

Perhaps there are connections which reach this far back; my love of continuity may not be ludicrous after all.

But Stonehenge consists of far more than just the stones;

they form one part of what experts like to call a ritual landscape. Within this, there are practicalities to consider. Rock god and prehistoric enthusiast Julian Cope says that after years of touring he would look at the labour involved in building a stone circle and think, but who did the catering?

The answer for Stonehenge lies at Durrington Walls, a less dramatic site just a mile or so east, close to Ratfyn. Here, within a vast circular bank like Marden, were the houses where the builders lived, the hearths they cooked on and the bones of the animals they ate. Just like at Marden, the story these pig bones tell is that people travelled far to get here, from the north of England and perhaps beyond, and they too brought their catering with them on the hoof. The cars heading for Glastonbury, loaded up with wine boxes and cans of beans, are only part of a very ancient tradition.

Stonehenge and travel are still very much connected. The place is a literal landmark, a sign on the way to our holidays, a mystic symbol on the Glastonbury road, a marker for its own festival too. It seems constructed to be viewed by travellers: first from the distant hills and then stark against the sky as you get near.

Yet roads are seen as the enemy of Stonehenge, problems which need to be erased from the landscape. In the last few years the old A344 to Devizes, which used to skirt the edge of the monument's ditches, has been surgically removed. A stile now replaces the turning and where there was once tarmac, grass now runs between faint ridges, the fences and hedges gone too. Only someone like me, looking for the road which once was, would see that it had ever been there.

But what if that road was as old as the stones them-
selves? Perhaps it too was part of the ritual landscape. But
the mistake could have been even bigger than that. What
if the road determined where Stonehenge was set up in
the first place? After all, just like today, if you were going
to build an attraction, you'd want to make sure that get-
ting there was as easy as possible.

To stop and visit Stonehenge, it's right at the next
roundabout. This runs up to Airman's Corner, although
the Celtic cross monument for which it is named has now
been moved to the Stonehenge visitor centre car park.
Originally it marked the place where two pioneer army
aviators, Captain Loraine and Staff Sergeant Wilson died,
when their Nieuport monoplane crashed in 1912, the first
British soldiers to be killed while flying on duty.

They were flying from Larkhill, just over the ridge, but
during the First World War, two separate airfields were
built right up against Stonehenge itself. Stonehenge Aero-
drome Night Camp, for sorties in darkness, was close to
where the visitor centre is now, while the Day Camp strad-
dled the A303, its hangars, messes and accommodation
blocks almost bang up against the stones. Aircraft skimmed
over the sarsens as they landed while commentators in *The
Times* lamented that the mystery of the site had been ruined
for ever.

None of this is mentioned or remembered today. The
concrete foundations of the buildings lasted on the ground
for many years, and are still visible in dry summers as pale
marks in the grass, but the aerodrome is forgotten entirely,
only the memorial a sidelong reminder that it was ever
there.

The land is not a written truth; it can be as unreliable a

witness as Geoffrey of Monmouth. In every argument about building a tunnel for the A303, the land around Stonehenge is hymned as virgin territory, one vast carpet of undisturbed archaeological remains which should never be touched by modernity. As the roads and hedges disappear and this part of the plain is gradually returned to its former, ancient shape, it's easy to imagine that nothing else ever happened here. That is not so, and we should not pretend otherwise.

For those who don't want the visitor centre, head past the pig farm, through the village of Winterbourne Stoke and up a slight rise. Beyond this stands another hill fort, Yarnbury Camp. From the road, which is pretty much how every single person views it, the banks and ditches are low and unremarkable. That's if they even spot it in the first place.

Getting off the road to appreciate how these rings enclose an unexpected high point with views all around to a fading horizon of hills is more difficult. The camp stands on private land and there are no metal heritage signs to explain what remains. The map gives some clues. The track to the east of the earthworks was once the road from Warminster to Old Sarum, although this now disappears in the middle of the plain, scrubbed out by tanks. Older maps note that not only is this a hill fort but that sheep fairs were held here too, with earthworks marking where the sheep folds once stood. The fairs ended in 1916, when the army rather than the railways put an end to them, but what I wonder is when they began. Whose were the first sheep to come to this ancient place?

From the very beginning, fairs like Yarnbury and Weyhill and Tan Hill were not only matters of commerce.

Their transactions had another aspect too. Herds need what we would now think of as fresh genetic material to prosper. The exchange of rams and bulls and ewes and sows prevents a group from becoming weak, inbred and even infertile. This is one reason why gatherings and fairs like this must have happened even in the very earliest days of agriculture, as places where different groups of farmers could meet and exchange their animals each year.

Small groups of humans need fresh breeding stock too. Otherwise the members of a settlement would end up marrying their cousins, so the early clans would also have to meet and swap members in order to thrive. This is why we find feasting and fairs and meetings all the way through history, from the first settled humans right up to Glastonbury now. It's one more reason why there always needed to be roads as well as causewayed enclosures and fairs and festivals.

As I head home, there's one final landmark before the Harrow Way parts company with the A303, but at first sight it's no more than a small junction with a sign pointing away to Shaftesbury. Yet this is possibly the oldest crossroads in England, where the Harrow Way and Ridgeway meet. This ought to be a magical place, humming with significance, but it remains entirely mundane, marked only by a concrete bridge and a lingering sense of disappointment.

'How womankind, who are confined to the house still more than men, stand it I do not know.'

Henry David Thoreau

The Harrow Way, from White Sheet Hill to Redlynch
Seven miles

The difficult thing about having begun was that I couldn't undo what I had done. Now there was nowhere else to go but forward. The choice was simple: I could stop walking, or I needed to find the rest of the Harrow Way. Wherever it might take me.

No neat wooden signs would mark out government-approved routes, nor was it so securely grounded in custom and place names. What's more, no one else seemed interested in discovering its path. Belloc had only followed its course from Dover to Winchester, in its later form as the Pilgrims' Way, the part I had least interest in. The mappers of old roads and writers of books had plotted its ancient route, from Andover to the sea, via Stonehenge, but they didn't give me many clues as to where I might find the Harrow Way now. Even when they did, the answer was all too often under the A303.

I could only find one other person who had done what I wanted to do, and the fact that this was done for a 1940s radio programme shows how hard I had to dig to find even this lone traveller.

Brian Vesey-Fitzgerald was a prolific writer of books about nature, the English counties, wildlife and pets in the years after the Second World War ended, and on the back of this became a broadcaster too. In 1949 he walked the Harrow Way and turned his experiences into a series of radio programmes for the BBC Home Service, also writing them up for *Out of Doors* magazine. Each episode covered a section of the path from the English Channel to where the Harrow Way meets the sea at Axmouth, in what he calls Devonshire.

Vesey-Fitzgerald is exactly the kind of gung-ho Englishman produced by World War Two. In the only photograph I can find of him, he is feeding a swan whilst in possession of a beard, a tweed suit and, as is only right and proper, a pipe.

This pipe turns out to be an important player along the Harrow Way. In a surprisingly modern format twist, the BBC set Vesey-Fitzgerald a challenge. He is to walk the whole path on only five shillings a day. But this will only buy him an ounce of tobacco, which is far from sufficient for the committed smoker he is. As a result he will have to sleep rough and work for his meals, which he does, helping farmers with heavy lifting and washing up in pubs to earn his supper.

He likes the old roads and recounts with delight meeting a shepherd on a high Wiltshire track who still knows his route as the Hard Way, the name his father and grandfather used before him. He notes where Roman roads overlay the old track, notes inns called the Harrow which mark the path and visits a crossroads where trackways meet on Salisbury Plain. At several points he comes across gypsies and shares their food, but that's as close as he gets

to romanticism. For the most part, Vesey-Fitzgerald is a highly practical man, focused on the details of walking, eating and sleeping, whether in barns or under a hedge. I can tell you that he was woken up by hedgehogs nineteen times in the course of his journey and from his description I can also tell you that he and I would not have got on.

Hedgehogs are creatures of an infinite and feminine curiosity. They are never content with just look-ing: they must be forever poking their noses into everything.

Vesey-Fitzgerald's quest at least proves that I have not hal-lucinated the Harrow Way into being but that's about its only use. Apart from the occasional mention of landmarks and villages, he never really describes his route, so is no guide. More than that, with his tweed and rough sleeping and observations on the mating habits of rats, he is the apotheosis of the Manly Man Walking Away. Again.

In fact when I get down to it, the way forward is surpris-ingly easy. From the A303, the Harrow Way – here labelled as Ancient British Trackway – runs over Whitesheet Hill where I had met it. From here on, its track is clear, run-ning almost entirely along narrow roads which I have travelled before, so close to home that it's a wonder I haven't walked it already. Nothing will be a surprise and I am certain that the cows will be behind fences. Only the very start is a new stretch, an unmetalled path, but it's not remote nor that long and I have no fears at all.

That is until I step onto the path. Within ten paces I have left every other human being far behind. Trees

overhang the hollow of the road and the edges are thick with brambles, fern and bracken. The air is completely still. I have crossed over into another world entirely, made up of green and presence, where lushness absorbs all sound and already I am too far away. Anything could happen here and yet it is not people I am afraid of. I would hear them coming for miles, cracking branches, swishing through the long grass. What frightens me is the feeling that the land or path has a soul which does not want to be disturbed. I am not meant to be here. Other people have passed through before; I can see ruts, the marks of cycle wheels down the middle of the track. Perhaps it is only me who is in the wrong place.

This atmosphere is so profound that I almost turn back for the easy route along the lanes instead, but that would be absurd, giving into something which exists only in my mind, so I carry on into the green and heavy air. A pigeon springs out of the hawthorn like a stone from a slingshot and I jump, my heart racing. A few minutes later a buzzard launches itself slowly out of the hedge beside me, but at first I cannot tell what bird it might be. Buzzards usually appear in two ways. Most often they are a flat shape, circling in a blue sky, recognisable from the white undersides of their wings and the cat-like cries they exchange as they climb. In winter they sit on fence posts in sodden weather, hunched like a vulture and miserable, waiting for the air to change. This one sails along like an owl, gliding down the green way so close that I can admire the wide spread of its wings, brown as a ploughed field, and the speckled softness of its feathers. So strange is this that I think it must be something rare, until it turns left through a gate, ready to sail upwards and I hear its distinctive mew, the only

sound in this silent waiting place, and I know what has passed me.

My feet are soaked from the damp grass; the ferns and bracken are dripping water too. Every growing thing is tense and twisted together; leaves and roots and tree branches, brambles and old man's beard, as though they form one living path, a sentient thing. The way goes on and on until I pass some unmarked boundary. Now the track is no longer rutted and grassy but the deep crumbly soil of a woodland path. Its course is still scored deep into the earth, the trees still meet overhead, but the atmosphere has lifted and I can walk on in peace.

I emerge by a field of chickens onto a country lane following the edge of the Stourhead estate, but this time skirting the dip which had kept me confined for all those years before.

Usually I'd assume that a road bends round a posh house to keep unwashed and unruly travellers from crossing the path of the upper classes. But the Harrow Way has been here long before any estate, quite possibly it existed before what archaeologists like to call 'high-status individuals' had even been invented. This route exists to avoid the hollow where the River Stour rises. Why go up and down, crossing mud and boggy ground when you can go round instead?

But aristocratic privilege takes many shapes, and one thing I am coming to realise is that, when land is involved, a significant part of it is about excluding women. That the land in England is almost entirely owned by men is a truth so obvious that we never remark on it or even bring it to consciousness. That's just the way it is. But not only is it true, the world is also set up to ensure that it remains that way.

Primogeniture, the custom that the land and buildings, all the title and treasure of an estate pass as a whole to the eldest son, has been around for so long that we rarely think about it. But it's worth examining. This is a system designed to do two things. One is to keep holdings of land together and so maintain and consolidate power. The other is to make sure that land – and therefore power too – is kept out of the hands of women. Land is the crucial factor here because inheritance tends to work this way in farming families too. Whenever a woman does end up with ownership, it's almost always because she is a widow, or because there were literally no other suitable substitutes to be found.

Women have not always accepted this as the natural way of the world. The plot of both *Pride and Prejudice* and *Sense and Sensibility* is not simply that our heroines need to make a good marriage. In both of these books, Jane Austen is very clear they need to do this because their father's money can never be theirs but will go to a male relative instead. The Dashwood sisters will no longer be well off when their father dies because all his net worth will go to their half-brother. He will be rich while they, unless they marry well, will have to subsist on very little. Jane and Elizabeth Bennet have to choose between marriage or genteel poverty because their father's estate 'was entailed, in default of heirs male, on a distant relation'. That this relation is the legendarily foolish and self-deluding Mr Collins leaves us in no doubt about what Austen thought about this state of affairs.

Not enough has changed. The crown can now pass to a first-born girl, but the aristocracy carry on as they always have done. In 2018 Hugh Grosvenor inherited the Duchy

of Westminster, in the form of a vast network of trusts and companies designed to secure this wealth for ever. The nine billion pounds' worth of assets include estates in Scotland and Cheshire as well as a significant chunk of Mayfair and Belgravia. His two sisters are both older, and while they may get money from the trust they will never be allowed to own the land. Their brother got the lot.

The road has been closed to cars and even though the works have finished, the signs haven't been removed so I can walk down the middle like any ancient traveller would have done. I keep going but I am still dragging the loneliness of the strange path along with me.

Edward Thomas walked here too. In his book on the Icknield Way, he mentions the roads at Kilmington as being part of an ancient road running from London to Exeter.

> Farmers will tell you that the Ox Drove 'never touched water' which they will qualify by saying you could go from Monkton Deverill to Marlborough without touching water or crossing it . . . they have the tradition of the road's character in their heads.

They had no need of maps or signposts because the road lived in their heads as a collection of landmarks and stopping places. More than that they understood, just as the earliest travellers did, that any proper path needs to keep away from rivers because these are a problem.

The road I am following now runs into the woods and either side are high ridges running parallel with the route and studded with trees whose roots reach out of the

packed earth. These are not old hedgerows but wood-banks, marking the border between a medieval road and the forests which surrounded it. The extra width was to make it difficult for brigands and robbers to hide in the woods and prey on travellers.

These prove that not just the road but the woods here are ancient. The trees I am passing are farmed timber, spindly and new, but Selwood Forest itself is ancient and in its prime was a thick band of woodland which ran north to south for more than forty miles, from Chippenham at the top along the edge of Salisbury Plain to beyond where I am walking now. So thick and impenetrable were the trees, and the forest itself such a landmark, that the border between Wiltshire and Somerset ran down its centre. Even as late as the 1950s, the saying was that a squirrel could travel between Wincanton and Frome without ever needing to touch the ground. Now small farmed patches like this are all that remain.

I know this stretch of road well because it leads to Alfred's Tower, a peculiar folly on Kingsettle Hill at the edge of the Stourhead estate. Tall and triangular, with tiny towers in each corner, it's built from red brick and looks like an elaborate castellated water tower.

In fact it is nothing so useful. The tower was erected by Henry Hoare II in 1777. It was intended to commemorate many things, including the accession of King George II and the end of the Seven Years' War. These days it is mostly known for marking the spot where King Alfred is supposed by some to have rallied his troops before the battle of Edington, below the Westbury White Horse. At the same time it was a garden folly, a place for the leisured family and their visitors to visit on horseback or by carriage.

Now it's open to everyone and people come to walk their dogs and have picnics instead, as we've done many times. Two women cross the road ahead of me with their dogs: three white Yorkshire terriers and something else brown and unidentifiable but still a terrier and also short. A lot of the women I have seen on my walks have dogs; they are a passport and a permission, a reason to be outside. I, alone, have no reason to be out here but do it anyway.

The sturdy backsides of the dogs head off towards the towers, followed by the women in their wellington boots, and I think about the fact that I still don't want a dog. Many of my friends have acquired one in the last few years, usually on the grounds that they are good for the family and will get the kids outside, but I suspect that it's the women who need them more. They are missing that unfiltered adoration that a small child gives, but their own are muttering teenagers who flinch when kissed and prefer to lie face down in their beds than run round the garden playing chase. The Germans even have a proverb for this, 'the last child always has four legs'. Not for me. I am an insufficiently domestic creature and don't want to prolong my captivity.

I'm not surprised to see the women. After all, it feels safe here. From ground level this seems to be a sheltered place. The old carriage ride still exists as a plain of flat grass, like an airstrip, which runs along the ridge and ends in front of the tower. Surrounding this are the woods, making it seem as though the whole space is an enchanted glade, invisible to the outside world. Nothing could be farther from the truth.

The tower stands at the end of a finger of high land running north-west from Longleat. From almost every

direction, Alfred's Tower can be seen like a lighthouse on a promontory, signalling across the miles. It stands so high that during heavy fog in 1942, an American Norseman aircraft hit one corner while trying to land at the nearby Zeals airfield. Five men were killed and the tower wasn't repaired for forty years. From down below none of this would be known. Only if you climb the winding staircase in one corner of the tower can you see how exposed this place really is.

This headland is also a junction point. From here another ancient trackway leaves the Harrow Way and heads south to Penselwood, while other, newer pathways cross it or set off on their journeys.

These days the landscape of southern England is covered in a mesh of themed trails, meandering through the fields and woodlands. Designed for long-distance walkers, these are the modern offspring of the Ridgeway, at least in its approved and signposted form. They've mostly been stitched together from footpaths and rights of way, barely touching a road, and are intended to com-memorate some historical event or person. Near us we have the Saxon Kings Way, which links sites associated with the tenth-century kings Eadred and Edgar, along with the Monarch's Way, tracing the journey which King Charles took when he fled England, although as he went from Worcester to Sussex via Somerset, this makes a rather meandering walk. All of these paths, I note, follow the journeys of men.

Beginning where I am standing on Kingsettle Hill is the Leland Way, which follows one part of the travels of one more man, John Leland. A sixteenth-century cleric, Leland is perhaps the first topophile we know about,

someone who loved his country for the historical remains it contained. He's also one of the first men to go for a walk and write a book about it, but for him the adventure did not go so well.

When Henry VIII first thought of dismantling the monasteries, even he could see there might be some collateral damage. What particularly worried him was the loss of books and learning which until now had been preserved in the monastic libraries, so in 1533 he sent Leland to investigate which ones held important or rare books (many of which, coincidentally, ended up in the Royal Collection).

In the course of his commission, Leland discovered a love of both journeying and of England itself, so he kept going even when the monasteries and their holdings were all gone, only now looking at the landscape and its antiquities. His travels took him through the edge of Wales and as far north as County Durham and right to the western edge of England in Cornwall. He noted the towns he visited and their main trades as well as the quality of their farmland, observed bridges and the distance from one town to the next, but he also recounted local stories as well as seeking out any relics of the past which might remain.

This may sound like a dull gazetteer, but Leland is a lively presence in his works, reporting very directly. In Bath he visits the famous healing waters and is not impressed.

The colour of the water of the baynes is as it were a depe blew se water, and rikith like a sething potte continually, having sumwhat a sulphureus and sumwhat onpleasant savor.

He also examines Roman stonework reused in the city walls and is quite happy to admit when he does not understand.

> Then I saw a grey-hound as renning, and at the taile of hym was a stone engravid with great Romane letters, but I could pike no sentence out of it.

Unlike most of his contemporaries, Leland is interested in ancient sites as well as Christian and classical remains. He measures Cadbury Castle very carefully, also noting that people locally 'telle nothing ther but that they have hard say that Arture much resortid to Camalat'.

Despite resigning from his church living to work on it, Leland never finished his book. He definitely began – his observations on Kent have the note 'let this be the first chapitre of the book', which is exactly the kind of thing I write to convince myself I am getting somewhere when I plainly have no idea. Three years after his last trip, Leland 'fell beside his wits' and was still insane when he died five years later in 1552. His book only exists as notes.

The road is cut deeply into the hillside as I go on, heading down to what seems to be lowlands but is in fact the edge of another ridge, giving me views out across hazy green lands. I pass only farms, the occasional house and one pub, marooned in the middle of nowhere now its Harrow Way trade is gone.

Down another hill, the track becomes a deep holloway again. I hear sheep cropping the grass and when I look into the fields I am on eye level with their feet. Edward Thomas relates that along here are narrow long fields adjoining the road, a sign that the way here was once

much wider but has been taken back into the farmland. He's right too, although the fields are so high above me that I can only see this from a map. However little used it is today, the old road has shaped this landscape for good.

Eventually I come to an open crossroads. At this point the Harrow Way goes straight ahead but it's the end of my walk so I am turning right into the town. On the map this looks like a lane, but in real life it's a fast highway for locals and as it twists and turns down the hill I am wedged against the verge at the mercy of their speed. A fine drizzle starts and I am not having fun. So much so that a police car stops and asks if I am alright. A woman shouldn't be walking out like this with no reason.

'Yes,' I say, 'I'm fine. I wanted to walk.'

'Well be careful then,' the policeman tells me. Like Belloc a century before, walking on the road is a dangerous and subversive act.

Eventually I am off the high road and back in the ordinary world, trudging down into town as the rain falls. On my way, I pass an art gallery which is showing the work of women artists. But when I go in I cannot see anything which looks like a way forward.

The journey does not feel satisfying, and not only because I have almost entirely found men. I also want to take the old turning from Alfred's Tower because I have discovered where it is headed. It connects the Harrow Way with another ancient site, Pen Pits.

The name describes exactly what is there. Pen Pits is a peculiar landscape of circular holes in the ground, long since overgrown and wooded and, mostly, forgotten. In the past the pits, each up to ten metres across, covered acre

after acre of fields and woodland, but most have been ploughed level these days. These were thought to be the remains of quarrying for circular millstones, made from the gritty greensand stone beneath the soil.

The place interested me for two reasons. First, the Harrow Way kept coming up as one of the reasons Pen Pits existed. Not only was the stone near the surface, it was also close to the road. Millstones are heavy and hard to move; no one wants to be hauling them over hedges and through ditches, and there is no river nearby. But stones from Pen Pits have been found all across southern England and therefore – and for once the archaeologists say this quite directly – they must have gone out along the Harrow Way.

The second is that the site existed before millstones were invented. Modern investigation reveals that the pits were first dug to extract querns, the very earliest forms of grinding stones, and so the site dates back to the Bronze Age. And, perhaps, therefore the Harrow Way goes back all this way too.

In researching the quarries I found one other notable feature: a beautiful modernist house, also called Pen Pits, set on the edge of the site. This was built by the composer Sir Arthur Bliss, who began his musical life influenced by Stravinsky but ended up as Master of the Queen's Music. In the 1930s he was living his best, most modern life: friends with artists like Barbara Hepworth and Mark Gertler, while scoring a ballet with sets by the graphic designer McKnight Kauffer. Thus his country retreat was entirely modernist with bright white walls, a flat roof and metal-framed windows, a sun terrace edged with curved railings, accessed by a metal ladder as though the house were a liner. I know all this because the house was painted,

in yet another statement, by Edward Wadsworth, while Paul Nash took a set of photographs when he visited.*

Nash must have stayed at Pen Pits for a while, because he also painted two watercolours there. One is of the pits themselves, showing trees growing out of the sunken holes. He's cropped the image so it consists only of earthworks and tree trunks, and the result looks a bit like his pictures of the trenches in the war.

Bliss would have understood this connection. He too had served on the front and described Pen Pits as being so close that 'in some places the rims of the craters touched, giving the grounds all the appearance of having been shelled by howitzers'. Ten years after he left France, Bliss was still having nightmares about being back in the trenches. Perhaps Pen Pits was a way of turning the holes and gaps of war into something older, less raw and fearful.

Both the site and the house sit outside the village of Penselwood, a name which means the end of Selwood Forest. Although just off the A303, it's a strange, lost place, deep in hollow lanes which curve and twist, their banks dense with ferns and overhanging branches as though this were the furthest west rather than the place where Wiltshire, Dorset and Somerset meet. The village is more of a strung-out collection of houses than a place, its existence marked only by a church and a small triangular green with a decaying oak at its centre.

Bliss's former house is at the end of a long drive with no footpath nearby, so getting any sight of it is a lost cause. Instead I head down the old road. As soon as I leave

* These are preserved in the Tate Gallery Archive.

Penselwood, this becomes a delight, running along the ridge in a way I had not expected from the map. For the first stretch I can see out towards the slopes where the Hardway runs down from Alfred's Tower, but soon I am walking through woodland of neat pines, farmed by the heir of Stourhead, who held on to the more practical part of his inheritance when the decorative bits went over to the National Trust.

I'm looking out for a hill fort, which apparently straddles the road. Even so, I walk into it without realising and have to go back and forth between the map and the land a few times before I am certain. When I find the bank and climb up it, the shape suddenly comes into focus: its deep ditches form a perfect circle with the road running right through the centre. It's a sentry point, controlling traffic in or out of the quarries.

According to the map, the road ends suddenly in the middle of the woods, but in reality it carries on without a second thought, taking me into a strange enclosed valley with a pale meadow in its hollow. When I first approach, this looks more like a silent weed-clogged lake, and I am surprised to find it grass. Drizzle turns to rain and I shelter under a tree to take a phone call about school. Nowhere, however atmospheric or remote, is as far from home as it might be.

The road heads up through dense forestry now, and with the drooping branches of the pines, the ferns underneath drenched and heavy, I feel sentenced to Victorian depression in my damp trudging.

At the stream, the map marks a ford but this is now a bridge. I follow a rough track up the hill, bark and branches compacted into the mud by thick tractor tyres, clippings

spread over churned-up puddles for grip, but it's hard going and the track is so sunken that I can see no sign of the pits. Further up the hill I can finally climb out of the trough of the road, and here they are, deep bowl-shaped inflections in the earth, each one filled with ferns and trees. But I can't find any feeling for them at all, they are simply there.

When I drive back home, I am disappointed. Pen Pits had demanded to be seen, pulling me towards it. Usually when this happens I discover something I need, but today I have found nothing and achieved nothing apart from dragging my mood around with me in the rain. Until, halfway home, I have a realisation. What mattered at Pen Pits was not the earth itself but what had been quarried out of it. Before the millstones came querns, and these mean the work of women.

For thousands of laborious years all grain had to be ground by hand, and this above all was the work which kept women in the home. Once cereals had been domesticated, grinding grain was always their job.

The technology of this developed in three stages. The first and most simple is the saddle quern. This comprises one large rough stone shaped like a shallow basin, which holds the grain while it is pulverised with a much smaller second stone, the rubber. These were used from when the very first grain was cultivated in the Neolithic right up to the Iron Age when they were superseded by the rotary quern. For this, two rough stones are shaped to sit on top of one another with a wooden pole set into the top which is used to turn this stone around over the bottom one. In the end the rotary quern gets bigger and bigger until it is turned by two women, and then animals, then wind power,

becoming no longer domestic but an industrial process which is done away from the home, and so by men.

It's hard to imagine how important the querns were, and the later millstones too, and so how essential and valuable this trade would have been.

The hill fort is not the only structure guarding Pen Pits. At the start of the Middle Ages, three motte-and-bailey castles were built at the edge of the quarries, surveying the stone and its transport from every angle. Milling was the foundation of life itself.

Because of this, quern stones are seen as important symbolic objects and are often found to have been placed in a careful and meaningful way. Fragments of quern stones appear in ditches, in specially dug pits and in the foundations of houses. When Battlesbury was excavated, they found just seven metal objects but 126 fragments of quern. They were practical, but may also have meant transformation, food and plenty, and perhaps even farming itself.

But what they mean above all is women. Quern stones are so associated with women that even archaeologists – never usually keen to state an absolute – shrug their shoulders and say that if there is a quern stone, it must signify a female grave. In the Bible, querns belong to the domain of women; in every contemporary society in which households grind their own grain, this is never done by men. In one Native American society, female puberty is marked by a girl being left in a hut for four days to grind with a quern stone. This is symbolic, the transformation of grain into flour representing her change of status from girl to woman, but it is also a practical test. She proves by her work that she could provide for a family when that time comes.

And grinding grain is hard physical labour. The bones of late Neolithic women show that their arm muscles were stronger than those of elite female rowers today. Milling also takes a long time. With the earliest saddle querns, a woman would have had to work for hours a day to prepare enough flour for her family. The Bible defines a forsaken place as one in which there was no sound of millstones. Women's labour was endless.

Cornmeal, as eaten in the Americas, takes even longer to grind. When mechanised milling arrived in Mexico, the men were against it, worried what their wives would do with the spare time. Perhaps they would leave the house.

Pen Pits is the place where the fixing of women to home is literally carved into the rock. You can build as many fancy white houses over it as you like, but the truth about women's domestication still remains in the shape of the earth beneath.

The Harrow Way, from Halstock to Corscombe and back, and circular walk around Silverlake
Six miles and seven miles

A sense of dissatisfaction remains with me for days. I want to carry on, and the weather has turned into an Indian summer of shining blue skies and sunshine but cool enough that I could walk all day. The problem is that I have a heavy cold and instead sit on the sofa feeling deflated and unhappy, staring at the golden, inviting light through the window.

At the same time I am grateful for the excuse. I want to walk but also do not. The rest of the Harrow Way worries me. This is not just for what it might do to me. Even though I am walking, I am still half-certain that this new path will turn my life over as the Ridgeway once did, and I am scared of what this might involve. But I also know that I have to follow something.

Walking now fills a space, because I am suddenly much less employed. E has reached secondary school: she leaves the house early in the morning and comes back late, getting herself there and back on the bus. There are no packed lunches or school runs any more and even when she is here, I am needed much less. She'd miss me if I

weren't in the house, but she doesn't require me to do anything for her, just be in a room somewhere and exist.

There is another problem too. Along the part I have walked so far, I have been mostly accompanied by men – Veysey-Fitzgerald, Leland, Edward Thomas – and this is not what I am setting out for. One of the reasons I am walking old roads is because I want to go back in time. Or rather times, doubled, the handkerchief folded. I want to go back into my own history, when I strode out without fear, and I am getting there, but I also want to walk back as far as I can manage, to see if I can find the place in which all women walked out and were not afraid, or chained to the grinding and the querns and the household. When they were undomesticated.

I also don't know how much more of the Harrow Way is walkable. Most of the remaining distance is road, a back way, but even so built for cars and speed, not walking. I don't want to be stopped by the police again, the voice of authority telling me I am not supposed to be outside. There can be no grand end to the journey, no final arrival but an assortment of scraps of walking where the road lets me, bookended by drives out and home, piece by small piece. I want to do something dramatic and adventurous, something with a shape, but the road won't let me.

At the same time, I am most afraid of reaching the end. Then what will I do next? And who will I have become?

I start to feel better on a day when rain is forecast to start at lunchtime, so a long walk is impossible. Instead I decide to discover something new where I live, so I set off to walk around the furthest edges of my town. I find my way around the corners of estates I have never seen before, past

concrete and brick, one pavement after another, cars parked and houses shut up for the day. Children cry and hoovers buzz, but all within, invisible. I do find a woodland path, but it runs between the railway and the bypass and then turfs me out into the industrial estate before it had really even begun. After more stone-faced houses and curving cul-de-sacs, I come across a narrow road which turns into a track, leading into fields of bristling weeds and long grass. Being so close to the houses they've turned into a wasteland and all too soon they will be built on too.

Heading home through town I meet a woman I know on the corner of the market place. I haven't seen her for a while. 'You've been walking,' are her first words to me. She knows because I am still recording each section of my walks on Facebook, partly because I like logging how many miles I have done but mainly because I still like setting tranquil photographs of hedgerows and wide views of the vales against the kind of gunfire I have heard that day.

Her passion is women's contributions in both world wars and how this is so often unrecorded, so I start telling her about how women are missing from walking too, and so it is disruptive, rebellious even to walk away from home.

'You need to read *Romany Cottage, Silverlake*,' she says. 'It's perhaps my favourite book ever.' She won't tell me any more than this, other than it's by an author I've never heard of, called Monica Hutchings. The rest I must discover for myself.

She's surprised I've been doing all these journeys alone. 'I'd be too afraid,' she tells me. 'At least in a town someone might hear me if I screamed.' I do know what she means.

There is no more flour to be ground by hand; there are no longer all the jobs of tending and distilling and teaching

which once kept women in the home. The only thing left to keep us domesticated – even though it is something which has been present from the very beginning – is fear. But what are we afraid of? It's not the dark, or strange shapes in the underground or of getting lost and being alone on the hillside. All these things can happen to men too, but they walk out anyway. There are no longer wolves or bears or monsters to threaten us in the forests. What women are afraid of is men and what they might do to a woman who has got it wrong and decided to escape the house, to make a bid for a life on her own terms, to go feral.

This is what men mean when they shout out of vans; when they follow a lone woman at night, just for fun; when they chase down a woman cyclist in the city. Or even when they simply fail to notice that the streets are too dark for women to feel safe, or that they have a free-dom to range which the other half of the population does not. This is what safety work wants to protect women from, and it's the reason why so often they give up and simply don't try to do anything on their own. At the back of their minds they are always worrying about what a man might do.

All this is the final reason why I love the long chalk roads, although it has taken me a long time to realise it. All the instinctual pulls that Belloc understood – the high places, the pull of a known path heading forwards – have extra resonance for me as a woman because they are the things which keep me safe. I can see who is coming and I am seen too. I am on a human-made track rather than being alone in the wilderness. Like the first ancient travel-lers I want the certainty of the road, a sign that other

people have gone before and will come past here again. This is what I need to feel safe, just as they did.

But I cannot say any of this to my friend, not on the street corner in front of the bank, and anyway I am trying to keep the name of the book that she has given me in my head until I am home.

I'm intrigued by the appropriateness of her recommendation at a time when I am looking for women guides, and it becomes even more important when I discover that Silverlake itself sits right alongside one branch of the Harrow Way between Shaftesbury and Yeovil. I'm hesitant to acknowledge this, but it feels like a shove from the universe, pushing me onwards along the path when I don't really want to budge.

A few days later a slightly battered book with a blue hessian cover arrives from the library stacks. When the story begins, Monica Hutchings is just twenty-one and works selling chocolates in a cinema in Yeovil. Walking out, she discovers a small cottage in the countryside beyond the town and ends up renting it. She fits it out frugally and cycles back and forth from the town in all weathers; she meets the farmers and the local shepherd. The subtitle of the work is *An Ordinary Adventure* and that's very much what it is.

The whole thing is a bit fey for my taste, the text like an over-restored gypsy caravan with every part floral and shining and perfect and set in just the right place. I can understand her excitement – I was once full of the joy of living quite alone in the countryside too. But that was more than twenty years ago and I can't throw everything up in the air and go back there. Nor do I want to.

At the same time, I cannot ignore the hints that are being hurled at me, so I take the car and set off to find the next walkable piece of the Harrow Way. On the way there, I will drive as much of the rest of the line as I can, carrying on from where I turned off last time. This doesn't really work: driving takes up both concentration and more importantly vision, so places flash past without being seen. I glimpse a Regency gothic gateway, elongated and sparse with empty windows, waiting for John Piper to paint it. A few fields along, a sign advertises a Roman villa and museum. This is news to me, but I am going too fast to find out any more.

One thing I can see from the car is a signpost a few miles before my destination. In most ways it is an ordinary, old-fashioned fingerpost set in a junction, its blocky lettering showing the directions to Beaminster – 7 miles – and Ever-shot and Halstock. Except it is not standard white but bright fire-engine red, and where a place name would normally be written on its top roundel, this one simply says 'Red Post'. The sign itself has become the most important land-mark here.

This red post is not unique; there are two others in Dorset and one now in Somerset but formerly in Dorset before the boundaries changed, as well as another close to the border between Cornwall and Devon. A couple more in Somerset have white signboards set onto red posts, but these are nonetheless called 'Red Post' too. On top of that there are villages called Red Post in Devon and Dorset which no longer have a post, and a pub called The Red Post on the fringes of Bath. Roads and bridges also bear this name from London to Cornwall and there is a village called Red Post Bridge on the Harrow Way as it approaches Weyhill.

These red posts are odd, but what is even stranger is that no one knows why any of them are red in the first place. They may not even be that old. Signposts were first compulsory on turnpike roads in 1766, but this type of finger post was mostly erected after 1921, which means that they can only be a hundred years old. Yet we still do not know what they mean or how they came to be red.

Two main theories do the rounds. One is that they mark the site of gallows and executions. This is possible: hangings often took place at crossroads and on parish boundaries, and one of the Somerset posts is on a site where executions took place after the Monmouth Rebellion. But that's the only instance where the connection has been proved.

The other is that they were created as way markers for groups of convicts who were being marched to Plymouth to board transportation ships to Botany Bay. Because the prison guards were illiterate, the red posts were used as route markers to guide them on their way. This makes some sense as the posts in Dorset tend to be fourteen miles apart, a reasonable day's march (and hence also often the distance between two hill forts). One post further south also lies close to Botany Bay Farm, where prisoners may have been kept overnight in barns. But none of this explains why there is a Red Post Hill in Dulwich.

In the end there is no answer and there may never be one. What the red posts demonstrate is that some things keep going simply because they already exist. The White Horse at Uffington was scoured every seven years long after everyone had forgotten why it had been made, and the Abbots Bromley Horn Dance happened each September because that is how it had always been. The red posts are maintained and preserved even though their difference

is no longer required and we have no idea why they were first painted red. This is how continuity happens, almost by itself, without anyone ever deciding it has to be so.

At Halstock I pull into a side road by some low brick bungalows. The sky is striped with dark and the wind is up – the remains of a hurricane is heading towards us and I can feel the disturbance in the air. I almost don't get out of the car but it would be ridiculous to come all this way for nothing.

As consolation and encouragement I buy a huge slab of chocolate cake in the Post Office shop and eat it all before I am even out of the village. Turning right at the green, I set off down Common Lane, which soon turns into a track with trees overhanging on both sides. This at least feels ordinary, unlike my otherworldly experience on the Harrow Way before. After the rain, the ground is ridged with mud. The season is shifting, and single squirrels are foraging for winter food. As I go on, the grey clouds begin to lift, leaving patches of sun, but it's still breezy. A clump of oak leaves lands on the path in front of me, edged in fierce orange as though they have been set on fire, but when I look up to see where they have come from, the rest of the tree is still green. It is not quite autumn yet.

The lane rides up and down small hills, one after another, sometimes open, sometimes confined by woodbanks. In the fields, swallows and larks have been replaced by starlings, sitting in flocks on the scratched, stalky fields.

As I come close to the next village, the path sinks deep into the ground to become a holloway. Horsetails line its edge, with lords-and-ladies at eye level on top of the bank, their stark orange berries an intrusion into the green. This

is more than a change of season; I am walking into a different, damper place. I feel as though I am just beginning but too soon there are kerbs on the path and I have arrived at the end, marked by a scattering of houses and a pub with a wagon wheel outside. The name of this place though, Corscombe, is a reminder that I am travelling along what was once a thoroughfare, because it means the valley of the pass road.

With nothing to detain me here, I return by road, one built for petrol engines rather than hooves and feet. The old track runs above me, its trees like a fin along the ridge of the hill while I walk in the lowlands below.

On the way back in the car I try to spot where Monica Hutchings lived, but here the Harrow Way has become a great bruiser of an A-road, and the traffic rushes me past before I can see a single thing.

I've had *Romany Cottage, Silverlake* out of the library for so long that I am not allowed to renew it any more. Guilt makes me sit down and finish it, but within a few pages the story has changed entirely. Now I understand why I was told to read the book. Monica Hutchings does have things to say to me after all.

World War Two has just begun. This isn't a surprise as the cinema newsreels have been talking about Munich since the very start of the book, but now history breaks into the cyclical rounds of Silverlake. Hutchings is acutely alert to how the war enters her world. It seems to rise out of the ground around her, as old army huts she has hardly noticed before are occupied once more. Chocolate is so rationed that she no longer has a job at the cinema, and is directed by the War Office to work in an office in Sherborne, which

means she is there when the old town is heavily bombed in September 1940. Hutchings, out to get lunch, shelters in an archway, but when she sees its stonework trembling like a jelly she throws herself down in the middle of the High Street, which heaves and twists as the bombs fall just thirty yards away. A man close by is badly injured, and she takes him through the rubble to be treated at a chemist's shop. The bombers had been aiming for the Westland aircraft factory in Yeovil, but cloud cover made them miss, and their bombs drop all along the road from Yeovil to Sherborne instead. Some fall in the fields close to Romany Cottage, and the son of her nearest neighbour is killed while tilling the fields on his tractor, along with a small boy who is watching.

War makes Hutchings realise how much she identifies with the countryside itself. Romany Cottage 'represented my country to me. It was my own home and it commanded views of England, the fields around it grew England's food and drink. It was precious to me for all those reasons and so I saved for it and fought for it and braved the elements for it. . .'

Hutchings sounds almost like a female Edward Thomas, letting the soil of England run through her fingers. Yet what she says is not often articulated by women.

I go back. Speeding past in a car is not enough, I need to see her place properly, so I park on the fringes of Sherborne and set off. This takes me into a low valley, with the A30 running along to Yeovil on one side and the railway on the other. Hills rise behind them, the trees and hedges dark on a grey day. I'm walking along the edges of fields, past sag-roofed barns and across a common filled

with dog-walkers until I reach where Hutchings used to live.

In the book, Romany Cottage is two rooms equipped with furniture made from packing cases, barely more than a shack. Now it is called Keeper's Cottage and has become a substantial building, extended several times and looking like a fine place to live a remote life. There's enough original cottage there too – stone-built and with its Victorian wood traceries along the eaves – to make me suspect that Hutchings may have slightly underplayed her home comforts for effect.

I carry on a bit further down the path so that I can loop back to Sherborne by a different way. I cross the railway at Wyke Farm, the home of Hutchings' nearest neighbours, where she got milk and began to learn the rhythms of country life. What I learn here is that one thing she wasn't interested in was architecture. From reading *Romany Cottage*, I had a picture of a typical red-brick square-set farmhouse with a yard. Wyke Farm is far more than this.

The first thing I meet are the barns, which are monumental. One in particular, stone-built and buttressed like a church, is supposed to be a thousand years old, and the longest barn in the country. This whole place once belonged to the Abbots of Sherborne, and the barn would have held their stores for the year.

On the other side of the railway sits the farmhouse, not quite so old but still with stone-mullioned windows and a great oak door, surrounded by thatched barns and outhouses. A moat curves around part of the site, thick with weed, a sign that the place itself goes back long before the house.

This is the England, ancient and rooted into the land,

that people were fighting for in the Second World War; a place of church and agriculture and continuity and, above all, rural. And Wyke Farm was chosen as one image of this idealised national heritage.

When World War Two broke out, no one could predict what its outcome would be, or even that England would survive. Out of this fear, the Recording Britain project was set up. Artists were sent out across England to make images of all the places which might be lost for ever. Over 1,500 pictures were commissioned, by artists including John Piper, Stanley Badwin and Barbara Jones. One, by watercolourist Thomas Hennell, was of the barns at Wyke Farm, and he would have been sketching at the farm while Hutchings lived here. This landscape and what it represented was not just important to her, it was what the whole nation was battling to preserve.

In the end, far more of the buildings and views recorded by the scheme were destroyed by post-war planners than by the Germans. The barns at Wyke Farm were unusual because maps show that bombs did fall nearby as the bombers headed towards Sherborne. In the hedgerow near the farm, a scattering of craters remains, filled with brambles, weeds and saplings, but there is no way of telling whether these are from bombs or quarrying or just there because.

The rest of the walk is in truth not very interesting. It's fine, but it's just a path through Bradford Abbas and then the road back to Sherborne. I miss the great old ways when I am not upon them; I always know when they are not there.

Back at home, I read Hutchings' other books, and there are plenty of them. Although she marries a farmer and has

children, she carries on writing about rural life. She too is very clear about what being an author and being a woman involves, which is that there is no point trying to lock yourself away.

> The vet might ring up with an urgent message and I should never hear it, the baker might forget to leave enough bread, the butcher might accidentally admit a cat, *with* the meat, the postman might wait for ages unheard . . . I might forget to come down and cook the lunch. No it would never do.

She also notes that were she a man her work would be taken completely seriously. Of course it would, but there is also a flip side to this which I have not fully considered until this point. None of the women who have gone out into the countryside have done it at the expense of anyone else. Paul Nash and Eric Ravilious, Edward Thomas, along with the many modern authors, walked away from homes and wives and children, separating themselves in order to produce their work. But women like Hutchings are fitting their writings and their walkings in around lunch and the washing, just as I am. Penelope Betjeman waited until her children were grown and her husband was being looked after by someone else before she set out on her travels. Ella Noyes and her sisters decided that they would only be able to create if they were not beholden to other people. None of them made other people unhappy in the course of writing a book or painting a picture.

It turns out that what the men did was not necessary or essential for their work. Other people – by which I mean women – can see and understand and create in between

breakfast and the baker arriving and the endless demands of the house. This is how I too take my walks, do my writing. Men just like walking away from home, and they don't seem to mind too much who else suffers as a result.

What Hutchings produces in her interrupted times is not sugar-coated either. She isn't afraid to tell people how much she despises hunting and continues in her fury about what is happening to the English countryside and in particular the way it is being eaten up by the army. Which is how she comes to Imber.

As a child at the age of ten, Monica Hutchings lived in Warminster and once walked the ten miles over Salisbury Plain from her house to Imber to visit some of her schoolfriends. Back then it was still a village of thatched cottages, built from cob. Out of curiosity, she returned in 1947 to find the telephone wires hanging ragged and useless, the windows blank, the whole village populated by rabbits instead of people. She must have had a quite determined and intense curiosity because she got there by driving through a barrier which the army had accidentally left open.

The plight of the village clearly struck something deep within her, because three years later she was trespassing once again, only this time accompanied by a cameraman and director. They were making a film called *The New Face of Britain* about what would become of the English countryside after the war. Hutchings brought to the project her concern about how the army were taking over Wiltshire and wanted Imber to stand for all the good productive English soil which had been lost to the uselessness of warfare. She hated war almost as much as she hated

bloodsports, and her sense of belonging in the English countryside produced a surprisingly radical vision of what the land needed to become.

She didn't leave it there either. For the next twenty years, Hutchings was a campaigner for not only Imber but Tyneham too, and she lost none of her trespassing with age. In August 1968, she was one of the leaders of the 'pilgrimage' to Tyneham, designed to draw attention to the continuing plight of the villagers who had been evicted. She walks in and sees places which are complicated, not simple or natural; ones made by people, used and, often, occupied.

One of the other things I learn about Hutchings is that she loves the countryside because she knows it so well. There are hints of this in *Romany Cottage, Silverlake*, where she will cycle down to the Dorset coast in the morning, a fifty-mile round trip, before starting work at the cinema. But this is as nothing compared to the cross-country journeys she describes in her autobiography. Somerset to Hampshire is an easy ride for her, and for a long time she cycles from Warminster to Brighton each weekend to see her parents. When her job changes she starts to do this late at night, arriving there at 2 a.m. on Saturday morning.

What strikes me most about this is her lack of fear. She's not worried for her own welfare. Someone will always take her in and look after her, she is sure, and when she gets a puncture in the middle of the night, this is exactly what happens.

Maybe Hutchings was unusual in having this assumption that the world will provide for her; even so, I feel that losing this is something I want to recognise and then

mourn. And I do not know how women can make our-selves feel at home in the wider world again.

It's only much later on that I discover that I have been navigating alongside Hutchings for much of my travels. One of the books I have been using to work out the routes of the Ridgeway and Harrow Way – Brill and Timperley's *Ancient Trackways of Wessex* – has, when I come back to it again, photographs by Monica Hutchings, who travelled out with the authors many times in search of the old ways. Women have always been part of these landscapes. It's just that, time and time again, we choose to forget them.

A new ridgeway, from Shaftesbury to Hengistbury Head

Thirty-five miles, by car

For my next journey I am cheating in more than one way. To start with I am not walking but driving and stopping at points I want to see. And I am not on the Harrow Way, but following the Ridgeway and then another set of old roads altogether. It's another diversion from the confusion and difficulty of the Harrow Way, and another excuse to defer reaching the end of the road. But I also have a reason: I am off on the trail of one more woman who might give me clues about living and walking on these old landscapes.

I've never tried to walk the Ridgeway where it runs between Shaftesbury and Hambledon Hill, mainly because the books told me it had become the main road, the A350, which twists narrowly from village to village along the valley floor. I believed them until I had to take E to a place where she was going to spend twenty-four hours living as a Viking, and to get to this piece of the past I had to take a different road for the first time. This headed south out of Shaftesbury, towards a high chalk ridge where it carved its way up to the top through twisted-root beech woods until

we emerged out of the trees and into the light. We had reached the spine of the land and could look down on the squared fields and sheep below like a buzzard surfing the rising air. When I studied the map at home, having left E to vegetable tending and a night in a brushwood-roofed hut, I realised that this was where the Ridgeway really ran, taking the highest route as always.

Today I am on that road again, and after a few minutes' driving I am more certain than ever that this is the old, right track.

I'd rather walk than drive but that's not possible. Cars scream past, one after another, down the straight road, and lorries too. A National Trust car park on one side lets me stop and enjoy the view. Today, at last, is the perfect day for seeing. Summer is ending but the world is still green with growth. Chalk stretches out into the vale to touch the lower world of tidy farms and villages.

As I go on, a clump of pines sits at a triangular junction. They catch my eye because I am thinking about drovers and where they might have travelled and stopped — it's much easier to get sheep into a triangular space than a square one — but there's something odd about their grouping so I turn down the side road and pull up, wanting to check what I have seen. I'm not mistaken: the tallest tree is a fake, a decorated phone mast pretending to be a Scots pine with its tall straight trunk and dark branches. Even the bottom of the post has been striped to imitate bark, and only the iron ladder up one side reveals its truth. The uses of high places and pine trees are never-ending it seems.

The next junction is where the Ridgeway turns west, heading down into the vale to become a path again, and I

am following it to the landmarks which mark this junction. Just as happens when it comes down from Salisbury Plain at Warminster, a pair of hill forts guards the path here, watching the traders and the travellers on their way. On one side is Hod Hill, one of the largest forts in Dorset, but even this is small in comparison to its neighbour, Hambledon Hill, which is not so much a hill fort as a conurbation. Two ridges meet up here in the shape of a curvy 'T' and the banks and ditches encircle the largest spur, wriggling round the sides. When I've climbed its steep flanks the space is too big to comprehend from inside. The best thing to do is to look out. Up here I am Queen of the West with three counties laid out in front of me. Height, once again, is power. A man with his black Labrador notices me looking and shows me where I can find the Isle of Wight on one side of the horizon and the hills of the Blackmore Vale in Dorset on the other, a panorama of seventy miles or more.

The sinuous banks of the fort may be eye-catching but they are not the most interesting thing about Hambledon. People had been climbing up this dramatic hill for three thousand years before that was ever built. Less monumental earthworks sit on the other spurs, including the remains of two causewayed enclosures. Because these were eroding away, they've been thoroughly investigated, and what the archaeologists discovered is that five thousand years ago people were not living here, but visiting every so often. And when they did, they came with their cattle and feasted on them.

During their stay, the visitors also traded goods, the most obvious being pottery. While most of the shards found come from local clays, a small proportion contain materials only found on the Lizard Peninsula in Cornwall, 180 miles

west. Intriguingly, they also found traces of a fern which only grows there too, and the suggestion is that its leaves were used to protect the pots in transit. Other, tiny finds suggest even wider connections. Pieces of three hand-axes had been placed in the ditches, each one made from a different stone: from West Wales, from the Lake District and the last from exotic green jadeite from the Alps – and this isn't the only sign of trade with the continent. A grape pip and a tiny piece of grape charcoal also came out of the earth, the earliest trace of this non-native plant ever to have been found in Britain.

In short, the causewayed enclosures on Hambledon Hill are yet another meeting site, the place where people encountered others and for a short while became a community; places where things were exchanged and perhaps animals too. They are Weyhill Fair and Tan Hill and Glastonbury. Given the grape pip, perhaps people got drunk here, just as they did at later fairs. But surely one of the reasons that this took place at Hambledon is that the Ridgeway runs alongside, making meetings possible in the first place.

But what I find most exciting about Hambledon is that it offers a tiny clue into the world I am trying to walk towards. We do not know what the world was like before women were domesticated. There are hints in old myths and legends, of times of goddesses when no patriarchs ruled. But they are shadowy and perhaps we guess at goddesses because that is what we want to find. Who would want to believe that this lot, of nappies and wiping mouths, of food preparation and gathering and storage, of endless circular caring, is inevitable? What I need to know more than anything is that there is a choice.

The excavations here found the bones of people as well as cattle. Like the pottery, some had lived locally but others had come from Cornwall. Analysis shows that their diet was rich in meat rather than grain, so these were not yet people who had settled into full farming. Most interestingly of all, what the bones show is that the women ate more meat than the men, something which never happens in farming societies. This may be one brief glimpse into the world I am looking for, a world where women were at least equal and perhaps revered, a time when being a woman didn't mean being tied to the home and the hearth and the domus. It's a tiny fragment of hope but I will cling on to it.

On the other hand, Hambledon is also one of the few hill forts where we can definitely say that fighting took place, twice. But this isn't a discovery made by archaeologists: on both occasions the battles were reported in newspapers and broadsheets.

The most recent was more of an experiment than a real battle but nonetheless caused the London *Standard* to report: 'Dorset Battle: The Storming of Hambledon Hill.' The army, once again, were practising for war. In September 1910, four divisions of the army and all the cavalry regiments were on manoeuvres, based a bit further south in Blandford Forum, and the game was to seize Hambledon Hill. The Suffolk, Dorset, Gloucester and Green Jacket regiments had to defend their hilltop redoubt against the Devonians, Irish, Suffolks and Staffordshires, who scrambled up the slopes to attack.

'It was like the Highland Brigade storming the trenches at Tel-el-Kebir,' reported the journalist, as if war were some

kind of imperial sport. Four years later, the dreams of gallant charges up hills to rout an enemy and win the game would be trampled for ever into the mud of Flanders.

Two hundred and fifty years earlier, the fighting might not have been so tactical, but it was in earnest, despite the fact that the soldiers defending the hill fort were actually campaigning for peace.

During the Civil War in the 1640s, both Royalist and Commonwealth armies criss-crossed the south-west. Had that been all they were doing, there wouldn't have been a problem, but the troops plundered wealth, goods and animals as they went. By 1645, the local farmers and yeomen had had enough, and formed themselves into a militia. Because their weapons were limited to the agricultural implements they had around them, their groups became known as the Clubmen. Their only aim was to defend themselves. 'If you offer to plunder or take our cattel,' declared one of their banners, 'be assured we will bid you battle.'

The Clubmen often rallied at hill forts and other high places. These held the same advantages as they had always done. The hilltops were safe, and enemies could be seen coming from a distance, but they were also well-known landmarks and at the centre of a network of roads so that everyone had equal access. The initial 'Desires and Resolutions' of the Clubmen were read out at Badbury Rings, south of Hambledon, and then, after a series of encounters with both Royalist and Commonwealth leaders, several thousand Clubmen gathered at the top of Hambledon Hill to make their stand, with Cromwell and his dragoons down below.

At first the ancient defences served the Clubmen well.

Cromwell tried to attack through the gateway of the fort, but was kept at bay, and many of his troops were injured. His next move took them by surprise, attacking up the steep slope of the back of the fort. The Clubmen scattered down the hill – some of them sliding down on their backsides – and into the village of Shroton below, where they were locked into the church overnight and then mostly allowed to disperse. And that was the end of the last battle ever to take place in a prehistoric fortress in this country.

Today, though, I am not following the Ridgeway to the west but going back to the high road on the ridge. This carries on, and given where it is going it's probably just as ancient as the Ridgeway and the Harrow Way too. It speeds me past the edge of Blandford Forum and straight on to Badbury Rings. This was not just a place for the Clubmen to gather but part of a whole chain of ancient forts which, as in so many places, line this road like motorway services and, perhaps, prove how old the road might be.

While technically just another hill fort, Badbury is an odd place. From the ground, or to be more precise, from the National Trust car park with its people and spaniels and serious walkers with poles and Gore-Tex and hats, the place looks too low and flat to be anything at all. It only shows up in the landscape because a grove of trees crowns its top, making it a dark full stop in the pale grass around. When I get nearer, its ditches are deep and at the centre it is raised up in tiers like a wedding cake.

I decide to walk around it first, while the day stays bright and the clouds are small and scudding. On the

map, this whole area is cross-hatched with tracks and paths and drove roads meeting at each field corner. I choose one which takes me along the edge of a small wood. This has been left to turn wild and in here trees are hollowed out with fungus, and rotten branches can fall; the underbrush is not cleared and weeds flourish. But all this takes place in a fenced-off area which the public may not enter for reasons of safety, and the decay is managed by the National Trust, who have set up signs explaining all this to passing ramblers. It's a very southern-counties version of wild.

Close by was a Roman crossroads, whose straight lines could lead you to mines and ports, to Bath and Old Sarum, but its remains can only be seen on the ground when crops are growing, and today it is hidden under the soft velvet of ploughed soil.

Even so, I have questions. Why was an old place like Badbury Rings so important to the Romans that five major roads should cross here? Are the hill forts still then acting as service stations, raven stops, crow lines? Other questions too. Why do we call a road Roman when it runs between one hill fort at Badbury to another at Old Sarum and the maps call it Ackling Dyke? Perhaps it was there all along, even before the Romans found it and gave it a top coat, so taking all the credit.

The Roman invasion itself is yet another argument in favour of ancient roads. When the armies landed on the Richborough shore, their generals had three choices. The soldiers could march cross-country, which is hard work, or the engineers could build roads for them to march on, or they could simply use whatever trackways were already there. We tend, almost unthinkingly, to assume that they

took the second option: that Roman roads were first built across the empty countryside and the army then marched down them. But as military historians point out, constructing a road is a slow process, and in any case can you spare soldiers to do that while you are busy subduing an angry native population? Much easier to use the infrastructure which is already there.

I can't find a causeway into Badbury Rings, so climb up and over the ditches into the wooded centre. This part feels more like a henge or grove than a fort, even though the trees are young. A circle of pines marks the centre and among them a man picks blackberries, in a long hooded black overcoat which reaches to the ground, making him look like a last-remaining priest or monk.

Badbury is yet another place which has persisted. Long before the banks were built, people were coming here, leaving scatters of flints which date back six thousand years. In the Bronze Age, twenty-six barrows were built across the site and when one of these was excavated, it contained a rare stone patterned with images of axes and daggers. The only other place such carvings have been found is on the sarsens of Stonehenge.

The Romans built their temple outside the rings, but the space was not forgotten or unused. King Arthur is supposed to live on here in the shape of a raven. More practically, in the earliest Middle Ages, Badbury was the moot place for the local hundred, an administrative area smaller than the shire but bigger than the parish. Its moot was a kind of local parliament where men, and only men, would gather to take decisions, settle court cases and hear the proclamations of the king. Badbury is a textbook

example of the kind of place that was used for moots: on high ground but close to a major routeway, with good views of the surrounding countryside and often centred around a mound which could be natural or manmade. The uses of a high place and a road are also endless.

But none of this is why I have come here. I'm on the trail of a more recent visitor, the author Mary Butts, to see if she might be my guide. Butts was a modernist writer but at the same time is fascinated by the way history is written onto the chalk landscapes in a way which I understand.

> . . .the short turf & chalk hills which are like nothing else on earth. They sprawl across counties, and our history & the history of man written on them in flint & bronze & leaf & grey stone. A dry country of immense earthworks and monstrous pictures done on the chalk stripped of its grass . . . the history of England open.

She particularly loved Badbury, which became a totemic place in her imaginative life and often appears in her novels, and she also believed that only by walking could a place be known.

At first meeting, I like her a lot. Her diaries are sharp and funny, telling the story of her trying to find her place as a modern woman in London, balancing work and relationships, deciding who she wants to become. Butts was also very aware of what people required of her as a woman and how she so often failed to meet those expectations.

'Men do not like clever women.'

'Why don't you settle down?'

'It has taken me several broken hearts to know what this means – there's more divine life in me than in any man I've known. That's why I lose them.'

And she was fun to have around. Everyone noticed her enormous energy and zest for life, along with her flaming red hair, pale skin and filthy giggle. Apparently she was the perfect person for a party.

When, after several years in a lesbian relationship, she married the poet John Rodker, she found, though, that her exceptional qualities were not enough to keep her from domestication.

My God, I do nine tenths of the work and out of his lordly leisure he is glad to think of me tied to the soil at last.

I have a lot of time for the person I find in the diaries, but mostly I have come to Badbury Rings because of Butts' fiction, which is all about writing women into the countryside. Her heroines often live in an ancient place, which they appreciate for its meaning and past and soul. At best the men don't understand; more often they are trying to destroy the essence of these sites. Butts creates a world where women can belong to the land, to the chalk, and so I want to see what she has seen.

The problem is that today isn't feeling even slightly mystical, what with the other people and the VW Golfs in the car park and the weather, just ordinarily sunny now, clouds racing their shadows over the grass, in and out. She

found transcendence but the wind is cold and today I can only be mundane.

I can at least see into the distance. Despite the trees and the seemingly flat plateau on which it stands, Badbury Rings commands a surprising amount of horizon. A metal plate set into stone at their centre sets out the distance to each point in the panorama around me, as far as Purbeck and the Isle of Wight. My final destination is marked on here too, Hengistbury Head. Thirteen miles, it says. An easy day's walking, but I will be going by car.

The road south takes me into the undefined seaside sprawl of Poole and Bournemouth and Christchurch, each sliding into the other without ever becoming a distinctive place. I'm aiming for St Anthony's Road, Parkstone, which turns out to be a slice of inter-war, red-brick suburbia with wide streets and detached houses. I draw up on an otherwise deserted road; everyone here has parking spaces and garages and most of them are out at work anyway. The only other living being is a dog who trots up to say hello in a way which suggests he doesn't know he's not meant to be out on his own. Fortunately his address is on his collar, so I can take him home.

Once upon a time this wasn't a street at all, but a sprawling garden and grounds which belonged to Salterns House, where Mary Butts grew up. She was the child of an elderly father and his much younger second wife, and loved both the house and garden with a passionate intensity.

She was close to her father, who acted out Greek myths with her on the terrace and talked to her about art, but after he died she was sent away to boarding school, and a year later, in 1904, her mother sold Salterns. Mary never

forgave her. What was even more upsetting was that her mother also auctioned the family's collection of rare prints and paintings by William Blake, who had been a close friend of her great-grandfather. The irony of Mary's fury is that none of them would have gone to her anyway. Although she spent ten years as an only child, once her brother had been born he would, of course, have inherited the whole lot.

The new owners of Salterns sold off the gardens for redevelopment, which was when St Anthony's Road was laid out, the dawning of a new detached suburbia. Now those houses in turn are being refurbished or rebuilt in a kind of seaside modernism assembled from white render, huge windows and clear glass balustrades on the balconies.

I walk up and down the pavement, trying to get my bearings. I'm looking for Salterns House itself, although I am not sure I will find it. Mary Butts herself always implied that, after the sale, the house was pulled down, and I've found no mention of it existing in any book about her. Yet when I looked on old maps and aerial photographs, the right-shaped building still seemed to stand in the same place it had always done. So I go back and forth until I find the turning, a tiny lane overhung with beech trees. Halfway along, under an arch of yew, is the sign: Salterns House. The house, like its neighbours, is plastered white, with a 1930s modern extension, railings around its flat roof like a liner, probably built with the profit from selling the gardens.

Salterns surprises me by being there, but also because it is so far from Badbury Rings. Butts' heroines have estates which have belonged to their families for generations, and the ancient earthworks form part of this inheritance too; woman and land and history are all one. But in this, Butts

is rewriting her own life as she wished it had been, a world in which the Rings were hers, childhood homes were never sold and women were not disinherited.

Somehow she managed to persuade people that this fiction was also her own story. I was almost convinced too, but in reality her father bought Salterns less than thirty years before Mary was born, so there were no ancestral ties here. The windows did look out at the sea and their garden and fields, but also over the old saltworks, other houses and the pottery kilns and the slums surrounding them. There are no ancient rings for miles.

I'm poring over Mary Butts and walking her roads because I really want her to be a guide. She is a self-willed modernist yet one immersed in a landscape which holds a profound sense of the past, another topophile like me. But the closer I look, the more she and her works become not the answer but a whole new problem.

Butts was an intelligent and opinionated woman who found it hard to fit into a world which was neither as modern nor as forgiving as she would have liked it to be. As part of the generation profoundly affected by the First World War, she felt that any meaning and direction had evaporated as a result of the senseless carnage.

All standards seemed gone, all values discredited, or at least stood on their heads. Anything was possible, but safer to bank on the worst coming to the worst . . . A generation properly disenchanted.

This is borne out by the shape of her life. During the war she worked hard as a children's social worker in East

London, then for a precursor of the National Council for Civil Liberties, but after the war ended she found it hard to keep the same sense of purpose. While she did apply herself to her writing, she was often distracted, by love affairs, by the occult theories of Aleister Crowley (although she later repudiated both the man and his thinking), and most of all by drink, opium and heroin. Her short stories and novels were admired by fellow writers such as Ford Madox Ford, E. M. Forster and Ezra Pound, and published in the most prestigious periodicals of the day. She was friends with figures such as Jean Cocteau and Peggy Guggenheim, but she wasn't universally liked: Virginia Woolf called her Scary Mary.

One of the things I find hard to get past is the way she treated her daughter. Camilla was born in 1920 during Mary's brief marriage to John Rodker. Within a year Mary had been distracted by both a new destructive relationship and her fascination with Crowley, so she left the one-year-old with a friend and set off to Europe. Camilla stayed there for the next five years, then spent another two in lodgings and schools in France until John Rodker finally went to visit her and demanded that she should be looked after properly, in England. So Camilla went to live with Mary's aunt, Ada Briggs, and was raised by her from then on.

There's a huge amount of internalised sexism and domestication in my dislike here. I want Butts to prioritise her child, demanding that, as a woman, she must perform the expected role of selfless mother. I ought to be turning this narrative around, asking why it took John Rodker eight years to notice his daughter, but I can't get over the fact that it is Camilla who has become the casualty while the adults fail to suffer at all.

Mary Butts is flying from the domestic, but not like a man walking away from home. Knowing that it will absorb her entirely, she has to leave it behind for good, never turning back, throwing the baby out with the bathwater. And so she cannot tell me how to live. I want to occupy the domestic *and* the sublime, to live a life in which I do not abandon the family altogether, but also, just sometimes, do what I myself want. Domestic but not domesticated.

Of course, when I read about John Rodker's life, his lack of regard for his children – his first daughter spent ten out of her first eleven years in care – is never mentioned.

Camilla Rodker survived her childhood well enough in the care of her aunts to write a preface for her mother's posthumous autobiography, but, in a very English way, uses it to suggest that she doesn't agree with a great deal of what her mother has written. Butts despised her aunts as Bournemouth provincial, but for Camilla they were the best family she had known.

Another problem lies in Butts' vision of the world. Not everyone is permitted to settle in her mythical southern England, and her heroines are often battling against outsiders who cannot understand. In *Armed with Madness*, the threat comes from Clarence, who is both American and Black, while in *The Death of Felicity Tavener*, the enemy is Nicholas Kralin, a Russian Bolshevik Jew who wants to cover the unsullied land with suburban villas, cinemas, car parks and shops; in other words Bournemouth. Her implicit message is that the estate owners are the only true custodians of the landscape. The racism is overt: only those who are native and white can belong to the countryside. Everyone else is an intruder.

But dismissing Butts and her books doesn't make this problem go away. Questions of race, class and exclusion are embedded into every view in the English landscape. As a woman, I can feel threatened and afraid when I go out walking but even so, being white and middle-class and English, on many levels I am tolerated. For anyone who is not white, the rural is far less welcoming.

People of colour are half as likely to visit the country-side, because it is a white place and they would feel too visible, and unwelcome too. Only one per cent of visitors to the National Parks come from Black and minoritised ethnic groups.*

An organisation called Black Girls Hike has been set up to show women of colour that being in the countryside can be a positive experience, but also to provide company, because walking out alone could be just too difficult for them. This isn't an overreaction. When the group were featured on the BBC's *Countryfile*, viewers complained, apparently outraged by the simple fact that the group existed. One of the complaints was on the grounds that 'trees aren't racist'.

To understand this better, I really wanted to find a book in which a woman of colour walked out upon the chalk but these are still being written. A few things come close. Anita Sethi has done this alone in the Pennines, but in the south the nearest thing – and it misses by a country mile – is *The Enigma of Arrival* in which V. S. Naipaul writes a barely fictionalised story about his experience living just south of Stonehenge. But this is very much the story of a man taking his ego for a walk and not seeing much else,

* This is improving, but only slightly.

only this time from the perspective of colonialism. Elsewhere, botanist Claire Ratinon writes about how excluded she feels when people describe some plants as 'native'. After all, neither wheat nor oats nor barley come from Britain but they are essential to our lives, not incomers to be resented.

What I find most arresting are the photographs of Ingrid Pollard, an artist whose works directly explore what it is to be alien and 'other' within the traditional English countryside. In a set of pictures called *Pastoral Interlude*, she takes large format self-portraits in which she is a lone Black female in the rural landscape, but sets them against captions which undercut our expectations. An image of her, camera in hand, on a dry-stone wall is accompanied by text which wonders whether the Black experience can only be lived in an urban setting. She makes the reference to Wordsworth's poems which is expected of every visitor to the Lake District, but to very different effect. Her loneliness is from being the only Black face in a sea of white. For Pollard, the countryside cannot be a site of simple relaxation or pleasure; her walks are mixed with unease, even dread.

Pollard reminds us that the landscape of the Lake District is not wild or natural, however much we are taught to see it as such. Rather it has been created not only from layers of history and occupation but also through the works of poets and walkers. The result is an artefact, which has been made, curated and written about by white people.

It is essential that we understand this because the countryside is such an essential element in what it means to be English or British. By 1950, four out of five people lived

in cities, but even so the national self-image is of green rolling hills dotted with villages and market towns, a deep southern England. When we tell people they don't belong in those landscapes, we exclude them from the nation itself.

Getting stared at and being made to feel uncomfortable isn't the only barrier that people of colour face in the country-side. History is also used to make them feel unwelcome. Immigrants don't belong here, this argument says, because their roots have not been in the soil for generations past. Native plants are such a problematic idea because they all too easily suggest that there are native people too. Mary Butts' heroines belong to Dorset not just because they own chunks of it, but also because they are, they believe, the dir-ect descendants of those who built the Rings.

Unfortunately, these ideas are still very present today, and still using ancient monuments to make their point. On the Ridgeway near the Uffington White Horse is a Neolithic long barrow called Wayland's Smithy. The monument itself is so old that no one can ever say what it means; the name came along much later because Wayland was a figure from Norse legend, the blacksmith to the gods. Local folklore had it that if you left a horse outside the barrow overnight, with a penny for payment, it would be shod when you returned in the morning.

Despite its irrelevance to the actual monument, the Norse name has caused the barrow to be adopted by a far-right group called Woden's Folk, who have been holding masked and torchlit ceremonies up at the site, as well as carving swastikas into trees.

Woden's Folk are a white supremacist group who want

to launch an English resistance to multiculturalism and various other modern ills, but what makes them different is that they take their energy from the countryside and the past rather than the city: 'as you take back the streets of England, so shall we take back these Ancient and Holy sites around rural England.'

It's easy to dismiss them as right-wing lunacy mongers, not least because their leader, Wulf Ingessunu, is in actual fact a pensioner from East Sussex called Geoffrey Dunn and most of their revelations are derived (I kid you not) from the television show *Robin of Sherwood*. But their ideas are part of a wider and sometimes more articulate movement which has been called eco-fascism, an ideology which combines veganism and a hatred of single-use plastic with racism, Norse and Celtic mythology and a reverence for Hitler. A core belief is that people – by which they mean white people – need to take better care of the lands of their forefathers and the best way of doing that is to get rid of immigrants.

This may seem laughably extreme, but their ideas are starting to slide into the mainstream. Jacob Rees-Mogg made a short video about Getting Brexit Done, filmed at the stone circle of Stanton Drew in Somerset. To be fair, this is in his constituency, but so are plenty of businesses and factories which are going to be more affected by a change in trade regulations than a field full of stones. Except that wasn't his point. Rees-Mogg was sending a subliminal version of the message that eco-fascists are saying out loud: *This land is ours, not yours and these stones prove it*. His intended audience was entirely white.

The truth is of course far more complicated than these people would like to pretend. No single chain of ancestors

reaches from Stanton Drew to Jacob Rees-Mogg, or from Stonehenge to modern Britain. As the Amesbury Archer demonstrates, many people who built monuments and whom we then dug out of the earth were immigrants rather than belonging to this soil. Genetic evidence is also beginning to show that metalworking and the Bronze Age culture which accompanied it was brought in by a whole wave of people from Europe like the Archer who replaced the existing population. They weren't even the first. The earliest Britons who gathered at Star Carr or Blick Mead were black and brown, carrying no genes for pale skin or blonde hair. We are all immigrants on this island; either everyone belongs here or not one of us does. These landscapes are no one's birthright and it is wrong to pretend otherwise.

One thing we could do is tell better tales about our origins. The first myth of Britain, as told by Geoffrey of Monmouth and chroniclers before him, was that the nation was founded by immigrants. Brutus of Troy had been exiled from Italy and wandered around Europe until he finally landed in Totnes, calling the land he had found Albion. He and his men killed all the giants, throwing the last remaining one off the cliff at Plymouth Hoe, and then built London, although Brutus named it Troia Nova, or New Troy.

This tale was taken as fact right up until Elizabethan times, and was so well known that the chronicles of English history became known as Bruts. And it is still marked on the land. Sunk into the pavement of the main street in Totnes is a small granite boulder, the Brutus Stone, marking the spot where Britain's founder first stepped onto its soil.

Geoffrey of Monmouth may be a fabulist, but the story he tells is better and more true than the idea that there

were ever native Britons. King Brutus is the origin myth we really need.

Its essential truth is demonstrated by my final destination. Hengistbury Head, along the coast east from Salterns, is a place where people came and went across the seas far back into prehistory.

No old ways remain in this endless spreading half-city, so I have to rely on satnav to take me past the shopping precincts and ribbon developments and double-track overpasses. Eventually it sends me down one last turn and Christchurch peters out in a final flurry of brick bunga-lows whose picture windows don't face the sea. I pass a golf course which marks the end of aspirations; from here on the place is sandy, unimproved scrubland. The large empty car park is populated by a flock of shiny starlings, waiting for their moment to wheel over the sea at dusk and in the meantime perhaps steal someone's sandwich. I watch them strut while a rain shower passes over, big drops battering the windscreen, dark lines sharp over the sea.

The weather passes and I get out into the cleaned air. There's little to see on the ground, just gorse and scrappy seaside bushes and a footpath heading through sand to a gentle hill. The rise is Hengistbury Head itself, a geologi-cal oddity of hard stone which leaves the headland sticking out into the sea, uneroded. When I climb to the top and look inland, the view is less Bournemouth than working village in East Anglia, the edge of the water lined by wooden huts and a bigger building of tarred planks, while small boats shift from side to side on the sheltered calm of the inlet and cows graze the meadows behind.

Three thousand years ago the view would have been at

least as busy because Hengistbury was a thriving market of international trade, one of the major ports in England, and this safe harbour would have been filled with boats. Behind me, a set of banks and ditches cross the land. As with a hill fort, these could be defensive, but it's also thought they might be marking a protected zone, a kind of freeport where seafarers and merchants could exchange their exotic foreign cargo for the goods that England had to offer.

We know that goods travelled over the sea to and from Europe because the finds are there to tell us. A hoard of metalwork pulled out of a Spanish estuary contained spears cast in England as well as brooches from Italy. Mediterranean glass has been found in the Orkneys, while an anchor buried at a hill fort near Poole has its nearest parallel in Pompeii, and ancient Greek writers knew that tin came from Cornwall. At Hengistbury Head itself were continental posts and coins, bronze cups, raw glass of purple and yellow from the east which would be made into bangles and beads, and the seeds of dried figs. The dogs and slaves which the chroniclers say were exported from here have left no trace.

Load after load arrived by ship. Long before the Romans came to Britain, their goods had already landed on its shores. Over 100 kg of amphora fragments have been found at Hengistbury Head, huge pottery urns which would have held wine from Italy and olive oil from Spain, a massive maritime trade during the Bronze and early Iron Age. There's evidence too that this exchange began much earlier. Underwater finds off the Isle of Wight suggest that, 6,000 years before this in the Mesolithic, grain was already being brought to England from the continent.

Brought by human beings who have been travelling since the very start of history.

Boats are obviously the key to this traffic and a surprising number of prehistoric craft have been found. We don't make as much fuss about them as perhaps we should, even though many have been found in Britain and the oldest are some 4,000 years old. Which is extraordinary. The earliest were single logs, hollowed out, but by the Bronze Age they were constructed from planks sewn together with a kind of yew string. A boat like this was found in Dover in 1992 and it's thought to be the oldest seagoing vessel in the world.

These boats could have crossed to France and beyond, but they were not easy to land, and required a safe harbour to load and unload, sheltered from wind and waves. This is why Hengistbury Head, with its mirror-flat inlet behind, was so important. All along the coast from Plymouth to Dover, safe harbours like this would have offered shelter to trading ships.

This place is why the old road I followed today carries on south to the water's edge. The ancient tracks were scored into the ground by trade and travel and always have been. People moved and things moved with them, and to do this they needed boats which could cross the sea and paths to follow across the land. But these routes carried people too, coming to see what this new land was like and sometimes, like the Amesbury Archer, deciding to stay in it. Of course these travellers and traders and immigrants had roads.

Heading back, I can still make no sense of this seaside conurbation so I let the phone and its calculations take me

home. Alongside a dual carriageway somewhere, I see a sign for the Hurn Proving Ground. I am too alert by now to the ways the military hide themselves in plain sight, so what catches my attention is the word 'QinetiQ'. This is a cypher for the army, a new name for what was once their research and technology division and a company which is still mostly owned by the Ministry of Defence. These rough heathlands between the fields and the sea are another good place to put activities you don't want other people to see.

In theory the Proving Ground is used for all manner of positive activities, like training operatives to defuse mines, but when I get home I watch videos of it being traversed by a strange autonomous robot on tracks, designed to deliver supplies to frontline solders without putting any extra personnel at risk. It turns and navigates on its own, while carrying a payload of something unidentifiable wrapped in a large black binbag. It can take NATO pallets, says the video, and apparently it also 'reduces cognitive load'. I am all for this, in fact I would quite like my own cognitive load reduced somehow, but find myself wondering whether this robot might also deliver bombs as well as provisions. I don't know if I am too cynical or whether it would be naive not to think this. It turns out I am not cynical enough: it takes me less than five minutes to discover that it can be fitted with a remote-control machine gun as well.

The Harrow Way and Ridgeway together, loop around Beaminster
Nine miles

I still haven't worked out how to finish the Harrow Way. The rest of the journey would be road rather than track and I am torn between wanting to walk all of it or none at all. The latter idea nearly wins, simply because it is easy, and safer.

Except there is one place I want to see. On the map it doesn't look like any kind of landmark: an anonymous and unnamed junction on a high, empty hill. This, though, is the place where the Harrow Way and the Ridgeway meet again, forty miles after their last encounter, joining forces for the final twenty miles towards the sea.

I work out a loop of walking which would take me there, and which I could do in a day. The roads curve in an arc about the town of Beaminster – pronounced, because this is deep England and nothing is as it is spelled, Bemster. I could park there, walk up to the junction and then travel the path for as long as I could manage before turning back to the car. How I finished after that would be a problem for another time.

★

When I finally have time and set out, I take the fast way through Yeovil, mostly because I have realised how bad I am at following old roads in a car, but the days are also getting shorter and I want to spend what daylight I have on walking.

In Beaminster, the day is flat and grey, with clouds settled on top of the far hills. The centre of the town turns out to be a tangle of way-marked paths, with the Wessex Ridgeway, the Jubilee Trail and the Hardy Way all crossing in the town. The Jubilee Trail commemorates the sixtieth anniversary of the Ramblers Association, while the Hardy Way wanders around Dorset linking up locations from Thomas Hardy's life along with the settings of his novels. On the map, these are all marked with the same green dotted lines, so it takes me a while to work out that I need to follow the Hardy Way uphill to the ridgeways.

This takes me to the edge of town and then into woods. It turns out that Thomas Hardy has not been looking after his path very well as there are no finger posts nor any indication that the way exists, and I end up checking the map every few hundred yards, following a stream up through birch woods. My footsteps surprise a huge ginger cat, horrified to see a human trespassing in its territory. Perhaps it too is hoping to escape its domestication.

Emerging into a field, the path becomes visible as a faint mark in the long grass, a reassurance that others have travelled this way before me. In the woods it showed as a thin line filled with dead leaves, like a Richard Long artwork of a walk taken. Long understands that footpaths show us the way all the time, even when they do not have signs or maps or markings on the stiles. The other signs I

see in the field are recent cow pats. I am not happy, but the field is empty.

Beyond this, the way turns into an older track, trodden into a shelf of flat land with hedges on either side. I'm relieved to find it, but oh it is wet. A rill filled with rain runs down one edge, but this has drained nothing and the track is thick with mud and pockmarked with puddles. All too soon this established road ends, disappearing into a private drive, and I am sent up a path which climbs the hillside. By this point I am cursing Thomas Hardy and his Way out loud. Someone has cut back the vegetation, but branches and nettle stems and brambles carpet the ground, although none of this is flat like a carpet but lumpy and boobytrapped with tussocks and holes and I never know where to put my next step. My foot slides on a wet branch. I fall over and for the next two hours have a wet arse.

From here, it gets worse. I have come into some primordial landscape of thin trees, mare's tail – a plant which genuinely hasn't bothered evolving since the dinosaurs were on earth – and bog. The whole slope is a sodden puddle but covered in a thin layer of moss and tiny leaves so the surface looks like a field instead of water. I never know whether the next piece of ground will hold me until I put my foot down. Half the time, despite the fact that it looks solid, I end up deep in watery mud up to the ankles of my walking boots. If I stand still, I sink further, but when I try to haul my foot up, the mud holds on, only giving up with a final twist and a sucking noise like a dodgy drain. I am trying to follow the path in the hope that this runs along the firmer ground, but it doesn't. Instead I have to test one possible route after another, turning back and trying again when I reach each dead end of bog.

Up the hill sits a digger with a man in it. I assume he is having his tea break as the machine isn't moving. At first I had registered him as a potential threat – we are quite alone up here and the prehistoric ooze makes the whole landscape seem malevolent. But after twenty minutes of hauling myself through mud and only getting a few metres up the hill, I am starting to calculate that if I fall and twist my ankle, he will at least be able to help me.

What I am learning on this walk is how important it is to have a safe, visible path in order to get anywhere. Without a track to follow, you can end up in a bog, or worse. In rain and winters of the far past, almost every way forward would have been difficult. Following a watershed, as the ancient tracks do, does more than just avoid rivers, it keeps the path free from water. When Belloc walks the Harrow Way in Kent and Sussex, he observes that, whenever it can, the old path runs on a line a few paces below the south side of the hill, the place where it would dry out most quickly.

When I finally emerge onto a firmer trackway, I realise that there is no one in the digger at all, just a high-vis jacket slung over the seat. But this no longer matters because I am on solid ground, a ledge of roadway running east to west along the side of the hill. I turn left, east, to get to the place where the Ridgeway and Harrow Way meet, but after three fields of walking I meet a posse of cows standing at the stile. I have already had more than enough for one day, and when I look closely these are not cows but young bullocks. I turn back and retrace my steps until the path spits me out onto the closely wooded road instead.

The hill is steep, climbing and climbing through the

trees until I emerge into the grey open space of Beaminster Down. This is, in short, a dump. In Hardy's time, and before, it could have been an almost-romantic blasted heath, but now it's dull, made up of ploughed fields, low hedges and a howling wind which comes at me as soon as I am close to the crest of the hill. A bare, unlovely land. I turn back on myself to get to the point where – as far as I can tell and as much as these things can ever be proved – the two old roads join. The only markers are a road sign and posters for a ploughing match and beer festival. I want there to be a milestone or a megalith or anything which might mark the spot, but there is nothing and perhaps I am the only person in England who cares.

As soon as I turn west onto the twinned paths, I start to feel better, if only because I can put one foot in front of the other with ease. I can also tell that this is a proper pathway, running along the ridge with purpose, and the relief feels good. The road is empty, too; few cars pass me on the grey tarmac, next to the fading hedges and the dark cloud. Autumn is coming, blowing in from the sea.

Other tracks cross this one now and then; I see pale clusters of ivy flowers in the hedgerows and bare hawthorn twigs. The path goes on and on, unchanging. This is the further joy of a known track: it stops me from having to think about bogs and routes and cows, minimising cognitive load. All I need to do is keep walking. Even though I am facing into the bitter wind, I don't mind. I prefer the ways of the ancients to any route plotted by fans of Thomas Hardy. Although Hardy did know this place. He noted the 'diversions' on offer at Sea Mark Fair, yet another livestock fair which was held on fields right up here in August, but you'd never know this now.

Not just the fair but any trace of its site has vanished entirely.

Eventually I reach the very last piece of trackway on the Harrow Way. Common Water Lane is a piece of the old path which climbs a steep hill, while the road now goes through in a concreted tunnel. After this lies only metalled road, all the way to Axmouth and the sea, and I do not know how I will go further.

This part is wooded, deep-cut into the hillside, its surface rocky and lumpy. I stumble over where it has been worn into channels by water, and then realise that this was once tarmac too, now unmended and eroded away. The trees hem me in, giving only a few glimpses across the fields to the haze where the sea should be. I walk on and on until, almost at the end, it resolves into the perfect lane, wide and hawthorn hedged as it rolls through the landscape. Even the sky has opened up, the clouds lifting and splitting to reveal stripes of blue in the distance. The fields have become green again and sheep survey me through the fence, newly fleeced and washed white by the rain.

Where this track meets the road again is the point where I need to turn back. I head down Owl Lane and then along the lower road, back to Beaminster and my car. Once again, I hear someone slowing down next to me and the policeman winds down his window to ask if I am alright. This time I open the door and get in. He says it's a dangerous road and I don't mind not walking it, at least not much, because I am cold and tired and I have no attachment to this ribbon of ordinary tarmac. At the same time, this car ride is a reminder of the forces outside my control. Women should not be walking alone, roads are no longer for people. In short, I am still not meant to be here, however hard I try.

The Harrow Way, home to Yeovil
Thirty-two miles, by bike

Winter closes itself in and I have to stop walking despite the fact that the Harrow Way remains unfinished. I am not sure where it ever began, though, so perhaps the end does not matter either. That's what I tell myself, although the truth is that I am still afraid of what I might find. Or perhaps worse, that there might be nothing there at all.

Then, as spring rises, the entire world is shaken and rearranged by the virus. Now we are all forcibly domesticated, shut into our homes for twenty-three hours a day, housebound and restless. Everyone wants to walk away from home. I see them wherever I go, alone or in family groups, getting out of the house onto strangely empty roads.

My urge to break out is stronger than ever, and walking cannot satisfy it. In my government-allotted time for exercise it's not possible to get far enough away if I walk: on pavements, past houses, sighting green as only a distant edge. I am saved by cycling, which can take me out for miles, into lanes heaving with cow parsley as another new spring emerges, the hawthorn branches again weighted down with dollops of blossom. The land is fresh and remade, green dotted with white, the fields full of lambs and crows.

Lockdown simplifies my life, depositing me entirely in the present where I speed downhill unbothered by cars or lorries or anything at all. I cycle along a lane at eye level with a kite, passing cats hunting in fresh wild fields, the air full of the sour honey smell of spring. I am going somewhere.

The back lanes I cycle on are new and beautiful to me, but at the same time they have returned to their old ways. Empty, safe, unvisited, they have become again the roads on which Belloc and Thomas and Ella Noyes walked out, used by riders and walkers and cyclists but very few cars. After a couple of months, hens and ducks peck at the verges, just as they used to. None of this will last, I know this, but for now the chance to visit the same land they walked in is pure pleasure.

I am surprised at how fast I can travel too. On my favourite route I freewheel down one long hill near the end, all the way to the turning for the Roman road. My phone tells me afterwards that I have been doing thirty miles an hour, faster than any car on these twisty lanes. It turns out that I am not afraid of danger or risks when I am outside. It's just men that scare me. And cows.

Despite the fact that we are all trapped at home by the virus, the burden of the work falls threefold on women. The home, after all, is our domain. The radio and papers report this as though it is a surprise, but it is not news to any woman I know. This is what I cycle away from so fast, putting as much distance as I can between myself and my endless tasks. Getting away from home is the only way I can relax.

I go further and further each time. My legs get stronger

and I learn a different version of the countryside near where I live. I order a new bicycle even though it will take months to come. Although Longleat is closed to visitors and cars, the grounds are open to anyone with a bike, because two National Cycle Routes run through them. As someone with a bike, I cruise around the estate under the blue skies as though I own the place, down the long drive in front of the house and past the ancient trees which dot the meadows. I cycle close by the hill fort lurking in the grounds, its slopes and banks covered in woods, and pass hippos grazing in their fields, freed for the moment from the constant surveillance of visitors. Best of all is when I come in from the far gate up the hill, past rhododendrons and specimen trees until suddenly the whole estate is displayed – the house, the stable block and the gardens beyond – as though all belongs to me and has been set out for my pleasure alone.

This solitude and sense of belonging will not be mine for long, but I now know what I will do when a kind of normality returns. I will fix the Harrow Way by cycling it, from where I live to the very end by the sea. It's downhill all the way, and I will not need to cross many rivers as I go.

Finally, in September, the time comes. E is back at school and my new bike has arrived. The night before I am nervous, sleeping badly, with a proper fear in my stomach. I don't want to go, but I have said out loud that I will do it, and so I have to, even though forty-eight kilometres seems like a long way to travel without a car in just one day.

The first part I know well from my lockdown exploring, and today I cruise through it in glorious sunshine, low and autumnal, which lasts all the way through Longleat.

The cream stone of the house glows in the morning light, the iron gates at the end of the drive cast a crisp shadow as I pass through. Then an uphill to Maiden Bradley, which I have been dreading but isn't as bad as I feared, and from there to Kilmington, where I will join the Harrow Way.

This stretch is a narrow back lane, and it is full of birds. Pheasants rocket out of the hedgerow to fly in front of me, but slowly, so I have to worry about what would happen if a bird got caught in my front wheel. Then I start to see soft, pale partridges too, and finally quail, eight of them together taking a dust bath at the edge of the road. These are so stupid that they take a long time to work me out and only fly away when I try to take their picture.

Too many game birds. Like Monica Hutchings, I don't like hunting, but I have other objections to what I am seeing too. Pheasants are the symbol of upper-class land ownership, a way of ramming home who is in charge. If you are shooting on your estate then it's not safe for anyone else to walk over it, exactly as in the army training areas. It's a territorial act, like a dog pissing on a lamppost.

It turns out that there are so many birds here because this stretch of land is home to the Brixton sporting club. This is nothing to do with South London in geography, and sociologically it's even further removed. I strongly suspect that everyone here is white. The club hosts a shoot with three drives, one of which is called Abyssinia. You can pay to come and shoot, but it's booked up for years in advance. Finding out more takes me into a whole other, unimagined world of men. Of course it's mostly men. Women are rarely mentioned in anything I read, apart from one outraged shooter who resents, after the amount he has paid for half a

day's 'sport', having to cough up extra for his wife's lunch. My suspicion is that the people involved have enough self-awareness to realise it's best if they are not identifiable, but when they are snapped, they all wear tweed and green gilets and flat caps.

What's for sale here is a temporary entrance to an older world, one with servants and gamekeepers who know their place, and where lunch somehow appears without any noticeable effort or thought. A world where women are sidelined and men are very much in control of the land. Our glorious English past.

I've always thought of pheasants as being the only immigrants to this country that the upper classes are prepared to accept, because their bright red eye markings and striped feathers speak so clearly of an exotic origin, but it turns out that they may have been in the country for a long time, perhaps brought by the Romans. In fact it's the unobtrusive beige partridges – so understated and apparently so English – who are the real newcomers, only introduced in the eighteenth century.

They don't survive well here even now, so most of the birds in this country are not only imported but factory farmed as well. The eggs come over from Spain and chicks are reared in great sheds near the shoots, as packed in as cheap chickens, with 90 per cent of the partridges shot in this country bred this way. Driving birds towards a gun is already not much like a sport; rearing half-tame ones ready to be slaughtered for some rich man's entertainment makes it far worse. I don't think I could despise these people any more if I tried. Nothing about what happens here is either wild or natural.

★

Industrialised slaughter isn't the only presence on the road; there are traces of a more basic nature too. I speed past a fluffy corpse on the tarmac, a white and brown rosette of feathers. By the time I see the second one, and the third, each with a pair of long legs sticking out, I realise that these are most likely the inedible remains of owlets. I don't stop to look too closely. A vast, sleek buzzard cruises down the lane ahead of me, gliding on the still air until he turns to go over a gate and into a copse of trees. I want him to be getting fat on incomer partridge rather than baby owls, but it's a faint hope.

A right turn, then I am heading into the woods and downhill, past the edge of Stourhead, Alfred's Tower and Jack's Castle, much faster this time, screaming past them at a speed which almost frightens me, getting through an hour's walking in what feels like five minutes. I am going so fast that I get lost on the same bit of road as I did in the car, although this is much harder work on a bicycle as I push myself all the way up a steep hill only to discover the effort was a wasted mistake.

Eventually I find my way and am heading again down Cattle Hill. I pass the ancient John Piper gothic gates, which I now know once led into a constructed landscape as elaborate as Stourhead but which, unremembered, has vanished entirely.

A year has gone by and the Roman villa is no longer merely a sign but fully built, and its slope-roofed upper storey, bright with lime render, looks out over the road. At the gateway, where the diggers are still working, stands a clump of pines, a place to rest which no one needs any more.

From this point onwards I am less sure of the way, so I

call on assistance, in the form of bike-nav. I've down-loaded my route onto my phone and in theory this will give me directions as I go, so I don't have to stop, get off the bike and look at the map. It's useful but also annoy-ing. Somehow I have chosen, or been given, a male voice who speaks to me in a superior form of Radio 4 English which suggests that he is continually questioning my choices. I might be able to put up with this if he actually knew where we were going, but quite often he does not. Mr Phone is particularly keen on shouting 'Turn right!', sometimes when he means go straight ahead, and some-times for no reason at all, like some kind of navigational Tourette's, leaving me standing in a road which is clearly heading forward only, looking at someone's drive and thinking, *Surely he does not mean me to turn right into that.* And he doesn't.

Mr Phone is using military technology to help me find my way. Just as analogue maps were first produced by the army, GPS and navigational systems were originally designed so that soldiers could be certain of where they were and, perhaps more importantly now, guns and mis-siles could be targeted with greater accuracy. Each time the supercilious man in my back pocket issues an instruc-tion, my phone has performed a complicated calculation which could once only have been done with a military supercomputer.

The army always loves to be high: every battle and every strategy has a vertical dimension. Or perhaps, as Belloc suggests, it is one of the great original instincts and the army has simply taken it over. The satellites which tell me where I am are simply the final iteration of this longing. They are not simply indicating directions but all-seeing

too, crow-visioned, revealing far more than could ever be seen from a single hilltop.

The stretch of landscape I am passing through now is low and flat, like crossing a valley. Back in the past I could probably have taken one of many ways across it but now I have to swerve left because only one route will take me and my bicycle across the A303 instead of depositing me into its relentless double-track flow. I end up on the other side of the traffic next to Cadbury Castle, a ditch-ringed hill which sits on its own south of the main road, like a lump of earth turned out of a jelly mould. In some ways, Cadbury is the original hill fort, the one from which all ideas of what these forts might be sprang. That's because it has long been known as the place which may have been Camelot, and its hill is where Arthur sleeps until his country needs him again. This is what the locals told Leland when he visited here in the sixteenth century, and the legend lingers on.

Cadbury is also a typical hill fort in that it's been a notable place for a very long time. As well as the giant Iron Age fortifications, remains have been found here going right back to the Neolithic thousands of years before. It persisted afterwards too. Once the Romans came, the hill fort didn't fall out of use, instead they built at least one temple up here. This happens in other forts too, all across the south of England, and it might be a clue about why these high, ditched places existed in the first place.

One of the things which bothers me about hill forts is how exposed and unpleasantly windy they can be. They can seem quite pleasant in the summer, but in a wet

November, living in one would have been like standing on the deck of a ship at sea, rain-lashed, cold and unnecessary.

In later history, people did moan about being up these hills. Ella Noyes, when she visits the excavations at Old Sarum, mentions how much the clerks of the cathedral hated being on the exposed hill fort, complaining that they could hardly hear each other sing over the noise of the wind, and it gave them rheumatism.

Even in the Iron Age people had a choice. Hill forts were not the only place to live; there were plenty of other settlements in far more sheltered and salubrious locations down in the valleys. So why live up the top of a hill?

Religion can often make people do uncomfortable things, like the early monks who chose to live in the desert, or on exposed rocky islands on the fringes of Britain. And it's easy to see that in a hill fort, you might feel closer to the gods. In which case these over-determined banks and ditches may not be for defence but to keep the profane out and the sacred within.

There are particular clues on Cadbury as well which suggest some kind of ritual importance. Monica Hutchings, whose Romany Cottage was just an hour away by bike, reports that at dawn on the summer solstice, the first rays of the sun shine into Queen Anne's Well on the summit of Cadbury, something which is unlikely to happen by accident.

I don't have time to climb the fort today and find its wells, there's too much cycling still to be done. Once out of the village I can see the long ridge of land down which the original travellers on the Harrow Way would have come, but it's less easy to find where that path goes now. I am on

a road which curves between the hills, and this keeps bringing me to trackways which I think might be the old road, but then they disappear, squared off by eighteenth-century field enclosures or petering out into nothing. I am starting to think that I have plotted this route wrong, out of my own imaginings rather than any facts, until I come to a crossroads. Here two holloways meet, deep and ancient. Trees grow out of the high banks, arching over the road and no one else is travelling here, not now. The old-fashioned finger post points me to Holway, enough of a clue to cheer me.

The road goes on, down and forward. The sun has disappeared and the sky has flattened to grey. I'm not cold, but I'm not warm either and the fun is wearing off. My legs are worn out and my brain has had four hours to think about everything from the practical implications of feminism in the built environment to what I want to do when I get home and now it has decided to dig up odd events from thirty years ago for me to examine all over again.

I arrive up a hill in Sandford Orcas where a clump of pines signals a triangle of land with a pub. I would like to stop and rest here like a drover, but it's only early afternoon and I have still got a way to go. I don't care any more whether this track is the Harrow Way or not, I just want to get on and if I stop I will never start again. Finally, after mile after mile of shady sunken lanes, villages strung along with each one no more than a few houses and a pub and sometimes a pine tree, I emerge. From the top of the ridge I can see for miles, not quite to the sea but perhaps all the way home. Yeovil is below, tucked under the edge of the slope, and the hills stretch out in front of me, showing me the way forward.

That's next time; for now I am stopping. The station is on this side of town and I have time to find refreshment, even though the only place turns out to be a Starbucks in a collection of out-of-town shopping sheds. While this isn't glamorous or particularly satisfying, it has coffee, a toilet, and an outside seat where I can keep an eye on my bike, so it is good enough. From here, it's an easy five minutes to the train home. This eats up the whole day's riding in half an hour. Even so I am pleased. This is how I will finish the Harrow Way.

Except that is not how things worked out. I had a day planned for the second half of the ride, and the weather was set fair, but the week before I was floored by stress migraines, the first I had ever had, as intense and sudden as a blast of thunder. Their pure, distilled pain sent me to bed with the curtains drawn against the last of the summer light, trapped in my own head, unable to speak or understand until the painkillers began to work.

The first one came on during a difficult phone call, the agony so sudden that I had to hand the phone over to T so that he could make my excuses. It was the result of something which had been brewing during lockdown.

Over the last few months, I'd understood where all the women had been leading me. Now I understood that I did not have to remain at home, to be domesticated. We all had as much right to the countryside as any man.

What I had found now was another side of this injustice, a piece of practical sexism designed to keep girls from getting out of the house. It turned out that almost everything provided for teenagers in public parks was mostly used by boys and the needs of girls were never even

thought of. This wasn't just about skate parks and football pitches and what girls might want to do, it had bigger implications too. Girls were being designed out of the public realm, and the message that the infrastructure gave them was that they belonged at home.

I didn't want to be the only one who was feral, I wanted to set other women free too. And perhaps if girls were encouraged to get out of the house when they were teenagers, they might discover how good it is to walk out into even wider open spaces, as I had done.

At first, my questioning was only directed locally, at my council, who had built a skate park and a fenced football pitch and a BMX track – all dominated by boys – but then told me that they didn't see sex or gender as an issue in this. (I suggested that this attitude might be the source of the problem. That didn't go down well either.)

These arguments were what had given me the headaches. No logical arguments about fairness or justice or equality law seemed to get through to them. I felt furious and hobbled and impotent and the frustration built up in my head until it boiled over in this phone call and made me feel as though I was having a stroke.

The agony, I would discover later, was the birthing pain of Make Space for Girls. But I didn't know that then. In fact I now see these conversations with the council as a boon; their resistance turned my incoherent fury into a campaign. Had they said yes, and just built some swings and some seating, I would have moved on and gone on to do something else. So now I thank them and the headaches for galvanising us into action. Back then, though, all I had was pain and I did not fully understand why.

The biggest problem was that the headaches kept

happening. I didn't dare drive for fear one would strike while I was in the car, leaving me unable to do anything but breathe and swear until the drugs kicked in. Cycling was worse. It triggered them before I was even a hundred yards from the house.

At the time I felt these headaches as a rupture, an intrusion which kept me apart from the Harrow Way. My brain had rebelled, set itself against the whole project of getting away from home. But why so late in the day? Perhaps I was afraid of having nowhere left to go. If I never finished the Harrow Way, I wouldn't have to decide where to head next.

That's what I thought then. Now I know it was telling me where to set my course for next. A destination beyond the end of the road.

Eventually the headaches improve and I can go out for walks, then I start driving and finally go out on the bike. But I still don't know how to finish. The roads at the end look fast and unyielding and I think I will have to drive. Time is ticking and yet I still dither.

Until I have no choice. One day remains before a new lockdown begins, and it has dawned clear and bright, so I will have to do what I can with what's left of the Harrow Way.

The days are getting shorter and there is less time to mess about, so I am back on the A303, speeding down to Dorset. I'll join the old road where I left it at the end of last year.

It seems I have read the maps wrong, because the lane is quiet and empty. I regret not walking here or cycling. The road is enticing, running along the southern edge of

the ridge, exactly as an old road should. I pull into a grav-elled lay-by to one side, and in front of me is the Marshwood Vale, enclosed by an arc of hills and at its furthest edge meeting the sea, a bright blue horizon, calm and glittering in the sunlight.

Behind me is Pilsdon Pen, the second highest hill in Dorset, an abrupt, shouldered peak, shaped like the hull of a ship. Its sides are covered in gorse and fading bracken as well as grass, a patchwork of rough browns and smooth green, a heath not a meadow. And at its summit is of course a hill fort.

From the top, the view is even more clear and perfect. The air has the stillness of a morning in late spring as the heat is building, only this is November, the day before Guy Fawkes Night; no time for the sun to be shining from a cloudless sky. This whole autumn has been warm, too warm, and down in the vale the fields are still lush with pasture and the trees have hardly begun to lose their leaves. The land is rolling ahead of me, rising and falling in smooth curves, heading for the end of my journey.

The top of Pilsdon Pen isn't that spacious, and it doesn't take me long to walk round the edge. I'm not quite on my own; another couple are circumnavigating the banks too, while a small flock of sheep graze the central compound. Their bellies are already rounded with next year's lambs and they skitter away if I get too close.

Over the weekend, when we saw people for the last time before lockdown set in once more, one friend decided we needed champagne, and the excuse would be to toast Samhain, the Celtic turning of the year. I wasn't looking for a reason, but then she said, 'It's the conception of the New Year.' The bellies of the sheep remind me of

that thought. Somewhere, invisible to me and as yet unbidden and unknown, the next thing I will do is already preparing itself. Perhaps it won't matter when the Harrow Way comes to an end; whatever is going to happen to me is already brewing, regardless.

The coming lockdown and the shining November weather are the sort of strange events which mean that the English speak to one another, so when I meet the couple on the banks, we talk. It's Pete's birthday – I wish him happy birthday – and so he and Ann have come out for the day. Next they'll go down into the vale for a pub lunch, and then up to the next hill fort at Coney's Castle, nearer the sea. I say that I am off to Lambert's Castle next, and they point it out to me, a wooded ridge off to the west.

They live over that way too, in Devon, and Pete has set himself the challenge of walking all the hills he can see on the horizon from their home. But it turns out he has a long connection to Pilsdon Pen.

'I came up here every summer when I was younger to work on the excavations here.' They laid their sleeping bags on the hard boards of the village hall down in Bettiscombe and walked over each evening to Birdsmoorgate to drink at the Rose and Crown.

'It was one of the formative experiences of my life,' he says, looking out at the far hills.

'That's why we come up here on special days,' says Ann.

I wish them a good lunch and a happy rest of the day. When I look up the archaeology later, it turns out that the digs started in the 1960s.

One of the more remarkable finds from that dig was a fragment of a crucible, with tiny beads of gold adhering to

its edge. Someone up here was making very precious and magical things indeed. Perhaps that's the right thing to do in a sacred space.

Lambert's Castle is a few miles away, a couple of hours' walk or a very short drive. When I pass through Birdsmoorgate, the Rose and Crown has disappeared, turned into a private house. Not enough people travel this way any more, and an inn on the road now has little purpose.

The car park is full of cars and fallen leaves and people in gilets with their dogs, but somehow they are all absorbed by the landscape and the woods because the hill fort, when I get there, is empty.

The information board at the entrance tells me not only that this is a hill fort, but that there used to be a fair held up here right up until the 1950s. Of course there was.

Unlike Pilsdon Pen, which is like a distillation of a hill fort, a single peak surrounded by banks from which you can see to every point of the compass, Lambert's Castle is harder to understand. The flat space is huge, with woods and the road – the Ridgeway and Harrow Way combined – running along to the north. Only one part of the summit is marked out by a single stretch of bank and ditch running across. They remind me of the earthworks at Hengistbury Head, defining an area as sacred, as safe or for trade rather than being any kind of defence. In fact the whole fort feels as though it would be useless under attack; at every edge the banks on the hillside below me are only sketched in, more symbolic than useful.

The fair up here only ended in 1953 when the National Trust took over the ownership. Livestock were bought and sold, of course, and there was cudgelling and wrestling and

other diversions, but on the second day there was also horse racing along a course laid out around the other end of the hilltop, outside the fort itself. Local tradition said that the races had begun when Roman cavalry were stationed near here. Nowadays the hill fort is a prime site for illegal raves. People are always gathering, somehow.

As the walk draws to an end I've been thinking, on and off, about why I have been making this journey, and gradually I have been coming to some conclusions. The view from up here is a reminder that although I am travelling to new places, seeing different valleys from high places, I am also travelling backwards. Wherever I go, I am finding places which are familiar as well as new discoveries.

I grew up on an edge. There's a double meaning to this, because my childhood wasn't entirely happy: my parents were ill-suited and my mother found family life difficult in many ways.

But this is also the literal truth. Up until the age of eight, I lived in a place descriptively called Edgehill where the tough russet geology of the Cotswolds comes to a sudden end in a slope as steep and dramatic as any chalk scarp. It was a place of both history and warfare as well: a battle was fought here during the Civil War, while I was taken to school each day on a road which ran past the ammunition dumps and chain-link fencing of an army base. There had once been hill figures here too, just below our house but now overgrown with weeds and trees and time. The only difference was that these lost gods of Tysoe would have been red rather than chalky white.

All my walking has been doing is spreading out the landmarks of my childhood across the face of southern

England, so that I can discover them all over again. I'm not only looking for the beauty and history, but also the tension of the missiles and the bullets under their modern barrows, skinned in green grass. My own countryside is made up of hidden threats as well as the long views from the hills. I'm always trying to go back.

This may be true, but I'm not sure it changes anything, or helps. This knowledge won't give Penelope Betjeman and Helen Thomas their wild lives back. It can't reconcile me to the beeping of the dishwasher or walking through fields of cows, nor to Stourhead and shooting and confinement. It might explain why I set out in the first place but that is only the beginning, not what I have found. And it certainly won't stop male writers from walking out and pontificating about the unspoiled landscape without ever considering the drudgery that enables them to be there.

So my personal history wasn't an explanation. At least that's what I thought until I was looking again at watersheds, and clicked on a map because it had Kineton on it, the village in the vale below the ridge of the lost gods where I grew up, and where we went to the old-fashioned grocers where a man in an apron took things from the high wooden shelves. The website told me that Edgehill, my childhood home, was the national watershed, the place at which waters divide to go east and west and south.

I have a dizzying feeling of looking down into a swirl of coincidence, as though I have not been driving any part of this, but the fact had set out to find me. I have found something buried. All our pasts are buried, not just the ancient ones but our own personal histories too.

We are all topophiles of our own lives, living in a land-scape covered in markings, if only we know how to interpret them.

And so in all these paths, in all these findings-out, I had not known it but for all of my journeys, I had been trying to go home even when I thought I was walking away from it.

The last stretch of the road takes me down dark lanes, overhung with trees and ferns. I think I am lost until sud-denly there are two sharp turns and I emerge out of the woods by a cottage. This is Axmouth, and when I cross the bridge this will be Seaton. Whatever way round, it is the end.

Axmouth and Seaton sit at either side of the estuary of the Axe. Now there is little to see apart from muddy flats, some leisure craft and a few houses, but Axmouth is where both the Ridgeway and Harrow Way end. Back in the past there had to be a reason for all this arriving and there was. This whole valley would have been a vast inlet, deep and sheltered, making it the safest harbour and the biggest port in the west. It's possible that boats could have gone three miles or more upriver to unload their cargoes of glass and wine and oil, as happened at Hengistbury Head, and these upper stretches are guarded by another pair of hill forts at Hawkesdown and Musbury.

The Romans, when they arrived, were not afraid of crossing rivers so their great Fosse Way ended not at Axmouth but at Seaton, on the other side of the estuary. This is where the town stands today, a small Georgian port and resort with gift shops and ice-cream stalls and a giant gold lion standing on the porch of what must have been

an inn but is now a stationer's shop and Citizens Advice Bureau.

No trace is left of shipping or trade. Seaton's decline came in the fourteenth or fifteenth century when a bar of shingle grew across the mouth of the estuary, making it hard for ships to enter and, worse, causing the deep water behind it to silt up. Over the years its trade declined and no one ever really asks why the roads had been so determined to come here.

They were not the only things which ended at the estuary. During the Second World War, every town on the south coast had a beach which bristled with concrete obstacles and gun emplacements on the hills behind. Seaton was more defended than most because the town was the terminus of another of the army's Stop Lines. Although it was thought that the major part of any German invasions would come into Kent, it was possible that diversionary forces would be sent further west. So a Stop Line was built running from Highbridge on the Severn estuary to Seaton, following the routes of the rivers Parrett and Axe, as well as railways and canals. It's now commemorated by a 75-mile-long cycle and walking route, the Stop Line Way. This barrier is as well preserved as the Wansdyke, observed by more than a hundred and fifty pillboxes and its route still littered with all kinds of concrete devices: blocks and stops for tanks, angled posts to stop them climbing up slopes, cubes and obstacles for their tracks. Perhaps I will cycle it one day.

I'm not too sure what to do with myself, so I walk up and down the main street. The museum has been shut since March, and half the shops are closed too. I buy a slab of chocolate brownie and stand on the promenade.

The beach is full of people. A group of women have gathered together after a sea swim; others are here because it is their last chance to be somewhere for a month, or perhaps more. They are sitting on the benches and the shingle, staring out to sea, wondering what is going to happen next.

Acknowledgements

Despite having one person's name on the spine, books are very much collaborative projects and I am indebted to many people who have helped and advised along the way, and I hope I have remembered them all here.

The Hard Way would not exist without the enthusiastic and knowledgeable team at Unbound, in particular Aliya Gulamani and Marissa Constantinou, who have steered the book from first proposal to finished text with charm, humour and good will at every stage. Also huge thanks to Emily Faccini for turning my inartistic scribbles on Google Maps into such a beautiful record of my travels.

The book was also helped into existence by many people, including Andrew Ziminski and Guy Shrubsole, as the only person who knew about Margaret Nash's early life, along with Laura White at Tenderfoot and Jon Woolcott at the Clearing who published some pieces of work in progress.

I am also very grateful to every single person who supported the crowdfunding process with pledges, post sharing and publicity – it would not be here without you.

Finally, the biggest debt of all is to T and E, because in all of my complaining, restlessness and walking away from home, they were always the place to which I wanted to return.

Bibliography

This is less of a conventional bibliography and more of a guide to the territory. I've included books and articles where I would recommend them, where I have quoted from them or where they answer the question 'how did you know that?'. Many other books have given me ideas and background knowledge, as have a myriad of articles on the internet, but this list has to stop somewhere.

Some are difficult to pin down – many books are old and have almost disappeared, others have been reprinted many times; some are available online, others not. In each case, the reference is to the first edition, to give an idea of when it was written. Those marked with a ‡ exist in several editions, those marked with a ★ I found online (but your experience may vary).

The sections for each chapter also include the sources of any quotations.

On roads

Anderson, J. R. L. and Godwin, Fay, *The Oldest Road: The Ridgeway*, Wildwood House, 1975.

Bishop, Mike, *The Secret History of the Roman Roads of Britain*, Pen & Sword Military, Barnsley, 2014.

Cochrane, C., *The Lost Roads of Wessex,* David & Charles, London, 1969.

Hippisley Cox, R., *The Green Roads of England,* Methuen, London, 1914.

Langlands, Alexander, *The Ancient Ways of Wessex,* Oxbow, Oxford, 2019.

MacFarlane, Robert, *The Old Ways,* Hamish Hamilton, London, 2012.

Moran, Joe, *On Roads: A Hidden History,* Profile, London, 2009.

Margary, Ivan Donald, *Roman Roads in Britain,* John Baker, London 1967.[‡]

Taylor, Christopher, *Roads & Tracks of Britain,* Dent, London, 1979.

Timperley, H. W. and Brill, Edith, *Ancient Trackways of Wessex,* Phoenix House, 1965.[‡]

On women and walking

Andrews, Kerri, *Wanderers: A History of Women Walking*, Reaktion, London, 2020.

Hewitt, Rachel, *In Her Nature*, Chatto & Windus, London, 2023.

Reddy, Jini, *Wanderland*, Bloomsbury, London, 2020.

Solnit, Rebecca, *Wanderlust: A History of Walking,* Verso, London, 2001.

On the history of the landscape

Cope, Julian, *The Modern Antiquarian,* Thorsons, London, 1998.

Hauser, Kitty, *Bloody Old Britain: O.G.S. Crawford and the Archaeology of Modern Life*, Granta, London, 2008.

—, *Shadow Sites: Photography, Archaeology and the British Landscape 1927–1955*, Oxford University Press, Oxford, 2007.

Hoskins, W. G., *The Making of the English Landscape,* Hodder & Stoughton, London, 1955.‡

Matless, David, *Landscape and Englishness,* Reaktion, London, 1998.

Rackham, Oliver, *The History of the Countryside,* Dent, London, 1986.‡

Shrubsole, Guy, *Who Owns England?*, HarperCollins, London, 2019.

Stout, Adam, *Creating Prehistory: Druids, Ley Hunters and Archaeologists in Pre-war Britain*, Blackwell, Oxford, 2008.

Avebury to Gore Cross

p. 10 'Our roads indeed. . .' *Spectator*, 22 February 1913.

p. 20 'The other day we happened. . .' Leigh Hunt, *On the graces and anxieties of pig-driving*, 1828.★

p. 28 'Wild or unhumanised nature. . .' W. H. Auden, Introduction to *Slick But Not Streamlined*, a US edition of John Betjeman's poetry published in 1948, quoted in Kitty Hauser, *Shadow Sites.*

Bell, Martin, *Making One's Way in the World: The footprints and trackways of prehistoric people*, Oxbow, Oxford, 2020.

Bonser, K. J., *The Drovers*, Macmillan, London, 1970.

Carpenter, Edward and Winton, Helen, 'Marden Henge and Environs', *English Heritage report*, 2011.★

Cunnington, Maud, 'Knap Hill Camp', *Wiltshire Archaeological and Natural History Magazine*, 1912.

Field, David, J. Martin, Louise and Winton, H., 'The Hatfield Earthworks', *Marden, English Heritage report*, 2009.★

Grundy, B., 'The Ancient Highways and Tracks of Wiltshire, Berkshire and Hampshire, and the Saxon Battlefields of Wiltshire', *Archaeological Journal*, 75:1, 1918.★

Hubbard, Arthur John, *Neolithic Dewponds and Cattle-ways,* Longmans, Green & Co., London, 1904.

Leary, Jim, 'Journeys and Juxtapositions. Marden Henge and the View from the Vale', in Gibson, A., *Enclosing the Neolithic. Recent studies in Britain and Europe,* Archaeopress, Oxford, 2012.★

Vera-Gray, Fiona and Kelly, Liz, 'Contested gendered space: public sexual harassment and women's safety work', *International Journal of Comparative and Applied Criminal Justice,* 44, 2020.

Westlake, Susan, 'East Kennet Long Barrow, Wiltshire', *English Heritage report,* 2005.★

A loop around Barbury Castle

p. 29 'A great many must be walking. . .' Edward Thomas, *The Icknield Way,* Constable, London, 1913. ‡

p. 35 'A broad green track runs. . .' Richard Jefferies, *Wild Life in a Southern Country,* Smith, Elder & Co., London, 1879.★

p. 36 'Moving up the sweet short turf. . .' Richard Jefferies, *The Story of My Heart: An Autobiography,* Longmans, London, 1883.★

p. 37 'The friendship of a hill. . .' Alfred Williams, 'Liddington Hill', *Collected Poems,* Erskine Macdonald, London, 1929.

p. 41 'For there were to come dark days. . .' Helen Thomas, *As It Was,* Heinemann, London, 1926.‡

English Heritage, *Liddington Castle: Archaeological earthwork survey,* 2001.★

Hey, David, 'Kinder Scout and the legend of the Mass Trespass', *Agricultural History Review,* 59.

Historic England, *Nine Thousand Miles of Concrete: A review of Second World War temporary airfields in England*, 2016.

McQueen, Mike, 'Barbury Castle Environs', *English Heritage report*, 2009.★

Serres, Michel, with Bruno Latour, *Conversations on Science, Culture and Time*, University of Michigan Press, Ann Arbor, 1995.

Thomas, Edward, *The South Country,* Dent, London, 1909.‡

Thomas, Helen, *Under Storm's Wing*, Paladin, London, 2012.

Wilson, Jean Moorcroft, *Edward Thomas: from Adlestrop to Arras: A Biography*, Bloomsbury, London, 2014.

St Joan a Gore Cross to Westbury White Horse

p. 57 'Yet the Ministry of Defence. . .' Guy Shrubsole, 'Defence of the Realm: The Ministry of Defence's Land Holdings', *Who Owns England?*, 14 August 2016, www.whoownsengland.org/2016/08/14/mod-land/

p. 68 'Living like this with Eric and Edward. . .' Tirzah Garwood, *Long Live Great Bardfield*, Persephone, London, 2016.

p. 71 '. . .what you want, sweetheart. . .' Paul Nash, *Outline: An Autobiography*, Faber & Faber, London, 1949.‡

p. 72 'If you trod on or "fouled". . .' *Ibid.*

p. 73 'We all lunch together. . .' Letter from Paul Nash to Gordon Bottomley, 16 July 1918, in Claude Colleer Abbott and Anthony Bertram (eds.), *Poet and Painter: Being the Correspondence Between Gordon Bottomley and Paul Nash*, Oxford University Press, Oxford, 1955.

p. 73 'She devoted her whole life. . .' Lance Sieveking, *Eye of the Beholder*, Hulton, London, 1957.

p. 74 'Myfanwy described herself as a town person. . .' Interview in British Library Sound Archive.

Binyon, Helen, *Eric Ravilious: Memoir of an Artist*, Lutterworth Press, London, 1983.

Cardinal, Roger, *The Landscape Vision of Paul Nash*, Reaktion, London, 1999.

Causey, Andrew, *Paul Nash: Landscape and the Life of Objects*, Lund Humphries, London, 2013.

Crawford, Lotte, *Tirzah Garwood*, Eiderdown Books, Bath, 2023.

Friend, Andy, *Ravilious & Co: The Pattern of Friendship*, Thames & Hudson, London, 2017.

Gough, Paul, *Brothers in Arms: John and Paul Nash*, Sansom & Co., Bristol, 2014.

Hiscock, Karin, *Axis and Authentic Abstraction in 1930s England,* PhD thesis, University of York, 2005.

James, N. D. G., *Plain Soldiering: A History of the Armed Forces on Salisbury Plain*, Hobnob Press, Gloucester, 1987.

Jenkins, David Fraser, *John Piper: The Forties,* Philip Wilson, London, 2000.

King, James, *Interior Landscapes: A life of Paul Nash,* Wiedenfeld & Nicolson, London, 1987.

Shrubsole, Guy, *The Work of the Committee for Social Investigation and Reform, c.1913–1921*, unpublished thesis.★

Smiles, Sam, *British Art: Ancient Landscapes,* Salisbury Museum, Salisbury, 2017.

Spalding, Frances, *John Piper, Myfanwy Piper: Lives in Art,* OUP, Oxford, 2009.

Wantage and Avebury

p. 86 'Ever since I left India. . .' Penelope Chetwode, *Kulu: End of the Habitable World*, John Murray, London, 1972.

p. 89 'Foul Harwell. . .' Professor Herbert Skinner, who helped set up the Atomic Energy Research Agency in 1946.

From 'Village for a Thousand Years', *Harwell Village*, www.village4a1000years.com/the-book/

p. 94 'Th' used to reckon. . .' Peter Gurney, *Shepherd Lore*, Wiltshire Rural Life Society, 1985.

p. 95 'At first the finder. . .' Maud Cunnington, *An Introduction to the Archaeology of Wiltshire*, Charles Henry Woodward, Devizes, 1949.

De Angelis, April, 'Troubling Gender on Stage and with the Critics', *Theatre Journal*, 62, 2010.

Butterworth, Jez, *Jerusalem*, Nick Hern Books, London, 2009.

Green, Candida Lycett, *John Betjeman Letters Volume One 1926 to 1951*, Methuen, York, 1994.

—, *The Dangerous Edge of Things: A Village Childhood*, Doubleday, London, 2005.

Green, Imogen Lycett, *Grandmother's Footsteps: A Journey in Search of Penelope Betjeman*, Macmillan, London, 1994.

Hillier, Bevis, *Young Betjeman*, John Murray, London, 1988.

—, *John Betjeman: New Fame, New Love*, John Murray, 2002.

Malim, Tim, 'Grim's Ditch, Wansdyke and the Ancient Highways of England: Linear Monuments and Political Control', *The Proceedings of The Clifton Antiquarian Club*, 9, 2010.★

Newman, Paul, *Lost Gods of Albion: The Chalk Hill Figures of Britain*, Wrens Park, Barton under Needwood, 2000.

Pollard, Joshua, 'The Uffington White Horse Geoglyph as Sun-horse', *Antiquity*, 91, 2017.

Schwyzer, Philip, 'The Scouring of the White Horse', *Representations*, 65, 1999.

Wilson, A. N., *Betjeman*, Hutchinson, London, 2006.

Gore Cross to Battlesbury

Crutchley, Simon, *Salisbury Plain Training Area: Survey Report,* English Heritage, 2000.★

Legg, Rodney, *Tyneham,* Dorset Publishing Company, Dorset, 1992.

Rowley, Trevor, *A History of The English Countryside in the Twentieth Century,* Hambledon Continuum, London, 2006.

Wright, Patrick, *The Village that Died for England,* Cape, London, 1995.

Westbury to London Waterloo

p. 109 'There is no head or tail to this story. . .' Mary Butts, 'Brightness Falls', *Collected Stories,* McPherson, New York, 2014.

p. 124 'We craved these things. . .' Hilaire Belloc, *The Old Road,* Constable, London, 1904.

Bright, Derek, *The Pilgrim's Way,* The History Press, Stroud, 2011.

Mowl, Timothy, *Historic Gardens of Wiltshire,* Tempus, Stroud, 2004.

Wilson, A.N., *Hilaire Belloc,* Hamish Hamilton, London, 1984.

Winchester via Weyhill

p. 130 'For my part I don't see. . .' Thomas Hardy, *The Mayor of Casterbridge,* Elder & Co, London, 1886.★

Anderson, Kay, 'A Walk on the Wild Side: A Critical Geography of Domestication', *Progress in Human Geography,* 21, 1997.

Bickle, Penny, 'Thinking Gender Differently: New Approaches to Identity Difference in the Central European Neolithic', *Cambridge Archaeological Journal*, 2019.

Elliott, B., Knight, B. and Little, A., 'Antler Frontlets', In: Milner, N., Conneller, C. and Taylor, B. (eds.) *Star Carr Volume 2: Studies in Technology, Subsistence and Environment*, White Rose University Press, York, 2018.

Hanson, Caspar Worm et al., *Gender Roles and Agricultural History: The Neolithic Inheritance*, Journal of Economic History, August 2015.★

Hutton, Ronald, *Pagan Britain,* Yale University Press, New Haven, 2013.

Leeson, Peter T. et al., 'Wife Sales', *Review of Behavioural Economics*, 2014.★

Lerner, Gerda, *The Creation of Patriarchy,* Oxford University Press, Oxford, 1986.

Raper, Anthony C., *The Ancient and Famous Weyhill Fair,* Weydon Press, Andover, 2017.

Scott, James C., *Against the Grain: A Deep History of the Earliest States*, Yale University Press, New Haven, 2018.

Warminster to Sutton Veny

p. 141 'Under the rising clouds of smoke. . .' Mortimer Wheeler, *Maiden Castle*, Dorset, 1943.

p. 145 'When Faricius, Abbot of Abingdon. . .' Oliver Rackham, *The History of the Countryside,* Wiedenfeld & Nicolson, London, 1986. ‡

p. 147 'These white roads travelling endlessly. . .' Ella Noyes, *Salisbury Plain: Its Stones, Cathedral, City, Villages and Folk,* Dent, London, 1913.★

p. 154 '. . .the cavalry exercises are even. . .' *Ibid.*

Bosanquet, Nicholas, *Our Land at War: Britain's First World War Sites,* Spellmont, Stroud, 2014.

Ellis, Chris and Powell, Andrew B., *An Iron Age Settlement outside Battlesbury Hillfort, Warminster and Sites along the Southern Range Road,* Wessex Archaeology Report, 2008.★

Field, David and McOmish, Dave, *The Making of Prehistoric Wiltshire,* Amberley, Stroud, 2017.

Russell, Miles, 'Mythmakers of Maiden Castle', *Oxford Journal of Archaeology,* 2019.★

Noyes, Ella and Dora, *The Casentino and its Story,* Dutton, London, 1905.

Serjeantson, Dale and Morris, James, 'Ravens and Crows in Iron Age and Roman Britain', *Oxford Journal of Archaeology,* January 2011.★

Wheeler, Mortimer, *The Excavation of Maiden Castle, Dorset,* Oxford University Press, Oxford, 1935.

Newton Tony to Amesbury

p. 159 'of which I did not go above a hundred. . .' Celia Fiennes, *The Journeys of Celia Fiennes.* She wrote the book in 1702 but it was only published in full in 1888.★‡

p. 162 'boyled in ye Sea water. . .' *Ibid.*

p. 162 'Thence to Woolfe. . .' *Ibid.*

Barber, Martyn, 'Stonehenge Aerodrome and the Stonehenge Landscape', English Heritage, 2014.★

—, *'Restoring' Stonehenge 1881–1939,* English Heritage, 2014.

Bowden, Mark, 'Vespasian's Camp, Amesbury, Wiltshire: analytical earthwork survey', Historic England, 2016.★

Christopher, David, *Mean Fields: New Age Travellers, the English Countryside and Thatcherism,* PhD thesis, London School of Economics, May 2003.★

Clarke, Bob, 'Wiltshire's World War I Airfield Landscape: a Focus on the Landscape of Aircrew Training', *The Wiltshire Archaeology and Natural History Magazine*, III, 2018.★

Chippendale, Christopher, *Stonehenge Complete*, Thames & Hudson, London, 2012.

Craig. O. E. et al., 'Feeding Stonehenge: cuisine and consumption at the Late Neolithic site of Durrington Walls', *Antiquity*, 89.

Fort, Tom, *A303: Highway to the Sun*, Simon & Schuster, London, 2012.

Darvill, Timothy and Wainwright, Geoffrey, Stonehenge Excavations, 2008, *The Antiquaries Journal*, 89, 2009.★

Geoffrey of Monmouth, *The History of the Kings of Britain*, Penguin, London, 1966.

Hewitt, Rachel, *Map Of A Nation: A Biography of the Ordnance Survey*, Granta, London, 2010.

Lawson, Andrew J., *Chalkland: an archaeology of Stonehenge and its region*, Hobnob Press, Salisbury 2007.

Madgwick et al., 'Multi-isotope analysis reveals that feasts in the Stonehenge environs and across Wessex drew people and animals from throughout Britain', *Science Advances*, 2019.★

Parker Pearson, Mike, *Stonehenge,* Simon & Schuster, London, 2012.

Shillito, Lisa-Marie, 'Building Stonehenge? An alternative interpretation of lipid residues in Neolithic Grooved Ware from Durrington Walls', *Antiquity*, July 2019.

White Sheet Hill to Redlynch

p. 179 'How womankind. . .' Henry David Thoreau, 'Walking', *Atlantic Monthly*, 1862.★

p. 183 'Hedgehogs are creatures. . .' Veysey-Fitzgerald also recorded his walk in the now-defunct *Out of Doors*

magazine, which is why I am able to quote a seventy-year-old radio programme.

p. 187 'Farmers will tell you. . .' Edward Thomas, *The Icknield Way*, Constable, London, 1913.

p. 191 'The colour of the water. . .' John Leland, in John Chandler (ed.), *John Leland's Itinerary: Travels in Tudor England, Gloucester*, Sutton, 1993

p. 192 'Then I saw a grey-hound. . .' *Ibid.*

Anon, *Lives of the Antiquaries,* Clarendon Press, Oxford, 1772.

Bliss, Arthur, *As I remember,* Faber & Faber, London, 1970.

Brayshay, Mark (ed.), *Topographical Writers in South-West England*, University of Exeter Press, Exeter, 1996.

Casson, Janet, 'Women in Control?: Ownership and Control of Land by Women in Nineteenth Century England', Economic History Society, 2018.

Crawford, O. G. S., *Archaeology in the Field*, Phoenix House, London, 1953.★

Hockensmith, Charles D., *The Millstone Industry*, McFarland, London, 2009.

McDonagh, *Elite Women and the Agricultural Landscape, 1700–1830*, Routledge, London, 2018.

Watts, Susan, 'The Symbolism of Querns and Millstones', *AmS-Skrifter* 24, 2014.

Halstock to Corscombe and Silverlake

p. 209 'represented my country to me. . .' Monica Hutchings, *Romany Cottage, Silverlake*, Hodder & Stoughton, London, 1946.

p. 211 '. . .the barns at Wyke Farm. . .' *Recording Britain, 1946–8.* A selection of the pictures were published in

these four volumes, and the full archive is at the Victoria & Albert Museum.

p. 212 'The vet might ring up. . .' Monica Hutchings, *The Walnut Tree*, Hodder & Stoughton, London, 1951.

Barrett, John C., Freeman P. W. M. and Woodward, Ann, 'Cadbury Castle', *English Heritage Archaeological Report*, 2000.

Hutchings, Monica, *Special Smile*, Hodder & Stoughton, London, 1951.

Palmer, Arthur (ed.), *Recording Britain,* Four volumes, Oxford University Press, Oxford 1946–8.

Saunders, Gill, *Recording Britain,* V&A Publishing, London 2011.

Shaftesbury to Hengistbury Head

p. 225 '. . .the short turf & chalk hills. . .' Mary Butts, in Nathalie Blondel (ed.), *The Journals of Mary Butts*, Yale University Press, London, 2002.

p. 226 'Men do not like. . .' *Ibid.*

p. 226 'My God, I do. . .' *Ibid.*

p. 229 'All standards seemed gone. . .' *Ibid.*

p. 232 'Only one per cent of visitors. . .' Natural England, *The Mosaic Model*, 2015.

p. 235 'as you take back the streets. . .' Hayley Dixon, 'Neo-Nazis at the National Trust: How far-right groups are trying to "take back" ancient sites', *Daily Telegraph*, 9 August 2019.

Barclay, Gordon J., and Brophy, Kenneth, '"A veritable chauvinism of prehistory": nationalist prehistories and the "British" late Neolithic mythos', *Archaeological Journal*, 2020.*

Bradley, Peter et al., 'Maritime Havens in Earlier Prehistoric Britain', *Proceedings of the Prehistoric Society*, February 2019.

Butts, Mary, *Ashe of Rings*, Three Mountains Press, Paris, 1925.

—, *Death of Felicity Taverner*, Wishart & Co., London, 1932.

—, *The Crystal Cabinet: My childhood at Salterns*, Methuen, London, 1937.

—, *Complete Stories*, McPherson & Co., New York, 2014.

Clark, Peter (ed.), *The Dover Bronze Age Boat*, English Heritage, London, 2000.

Cunliffe, Barry, *Hengistbury Head*, Elek, London, 1978.

Dunkley, Mark, 'Travelling by water: A chronology of prehistoric boat archaeology/mobility in England', in Jim Leary (ed.) *Past Mobilities*, Routledge, London, 2014.

Jones, Martin, *Feast: Why Humans Share Food*, Oxford University Press, Oxford, 2007.

Mercer, Roger and Healy, Frances, 'Hambledon Hill', *English Heritage Archaeological Report*, 2008.

Naipaul, V. S., *The Enigma of Arrival*, Vintage, London, 1988.

Neil, S., Evans, J., Montgomery, J. and Scarre, C., 'Isotopic evidence for landscape use and the role of causewayed enclosures during the earlier Neolithic in southern Britain', *Proceedings of the Prehistoric Society*, 84, 2018.★

Pollard, Ingrid, 'Pastoral Interlude, 1988', Ingrid Pollard Photography, www.ingridpollard.com/pastoral-interlude.html

Wilkes, Eileen, *Iron Age Maritime Notes on the English Channel Coast*, PhD thesis, Bournemouth University, 2004.★

Unbound is the world's first crowdfunding publisher, established in 2011.

We believe that wonderful things can happen when you clear a path for people who share a passion. That's why we've built a platform that brings together readers and authors to crowdfund books they believe in – and give fresh ideas that don't fit the traditional mould the chance they deserve.

This book is in your hands because readers made it possible. Everyone who pledged their support is listed below. Join them by visiting unbound.com and supporting a book today.

Bryce Adams
Judith Aldersey-Williams
Kelly Joanne Allen
Shelley Anderson
Teresa Ansell
Veronica Armstrong
Sabrina Artus
Fleur Ashworth
Ellie Atkins
Joe Attwood
Laura B

Jennifer 'Thames walker' Bagshaw
Nicola Bailey
Sharon Bailey
Eileen Ball
Natalia Banach
Anna Barker
Deborah Barker
Pepper Barney
Emma Bayliss
Kythé Beaumont

Pamela Beaupré

John Beckley

Victoria Belcher

Emily Bell

Jo Bell

Sally Bence

Elizabeth Bentley

Jacqui Best

Karen Beynon

Amy J. Biel

Sally Blandford

Marga Blankestijn

Katherine Blossom

Roger Blunden

Mina Blythe

Tessa Boase

Alison Bolitho

Ann Booth-Clibborn

Matt Borne

Amy Bottomley

Joanna Susan Bowe

Maureen Boyle

Victoria Bracey

Anna Bradshaw

Stewart Brady

Chris Brasted

Martin Bright

Juliet Brooks

Pauline Brooks

Deborah Brower

Georgina Brown

Gillian Browning

John Bulpitt

Andrea Burden

Sarah Burgess

Karen Burnett

Aimee Burnham

Alison Bybee

Jennie Caminada

Elizabeth Card

Michelle Carter

Mary Caws

Lindsay Chard

Thalia Charles

Paul Cheney

Don Church

Donna M. Clark

Ken Clark

Lindsay Clarke

Chris Clegg

Lara Clements

Jim Colbert

Tonia Collett

Gina R. Collia

Patricia Collin

Sally Collins

Vanessa Compagnoni

Belinda Coney

Beverley Cook

David Cooke, Julia Sheppard

Fi Cooper

Marsha Cowen Hosfeld

Glyn Coy

Sarah Crofts

Yvonne Crone

Nancy Crosby

Jasper Cross, Deborah Soper

Georgina Rosanna Crowe

Tessa Crucefix

Courtney Culverhouse

Damesnet

Danica Rocks! XxX

Elizabeth Darling

Laura Darmstadt

Pauline Davey

Cathy Davies

Jane Davies

Laura Davis

Sian Davis

Bill Deakin

Celia Deakin

Jo deBank

Linda Deeley

David Denny

Heather Desserud

Angela Dettling

Liz Dexter

Emma Dickens

Jacqueline digitalis

Anna Dillon

Samantha Dodd

Jan Douglas

AnneMarie Dranchak

Isabel Drummond

Robin & Kate Duckering

Tom Duckering

Monica Dunkley

Carolyn Dwyer

Isobel Eaton

Antonia Echefu

Tim Edbrooke

Glenys Edwards

Jane Eldridge

Marti Eller

Elisabeth England

Gage Evans

Christopher Everest

Tina Fabray

Kate Fahy

Amanda Falkson

Charlie
Farquharson-Roberts

Anna Farrell

Alexandra Fearon

David Finch

Ellen Finch

Leila Finn

Simon Fitch

Molly Flatt

Tracy Flowers

Becky Ford

Helen Forman

Colin Forrest-Charde

Jonny Fox

Sarah Freeman

Sarah Friend

Teryll Galley

Helen Gatehouse

Sarah Gaventa

Natalie Geerinck, Michelle O'Donnell

Lynn R S Genevieve

Amanda Gibbons

Julie Giles

Bea Gill

Rina Gill

Richard Gillin

Joan Gillison

Jessica Gioia

Claire Glen

Jacob Gloor

Maria Godebska

David Gosling

Jennifer Gourley

Tamsin Grainger

Gemma Greenhalgh

David Greig

Anna Griffiths

Diana Jean Griffiths Osborn

Julie Groom

Louise Groome

Jen Grosz

Geoffrey Gudgion

Aliya Gulamani

Kate Haddock

Gretel Hallett, Debra Gregory-Jones

Sarah Hamblin

Rachel Handley

Corrin Hanlin

Elizabeth Hanson

Katharine Harding

Stephanie Harding

Andrea Harman

Maritsa Harrington, Emily Denham

Michael Harrington, Emily Denham

Robbie Harris

Neil Harrison

Toni Harrison

Tom Hart

Helen Hawken

Alison Hawkins

Rachel Hazelwood

Clare Hein

Jennifer Hein

Jim Henderson

Jude Henderson

Zoe Hendon

Sophie Henson

Lucy Henzell-Thomas

Cecilia Hewett

Hannah Hiles

Jeremy Hill

Daniel Hillman

Catherine Hills

Pete Hindle

Beth Hiscock

Anne Hodgkins

Kathryn Hodgson

Amelia Hodsdon

Michaela Hoeher

Marten Hoekstra

Josie Holford

Sophie Holroyd

Jules Horn

Michael Horsham

Judy Horton

Jackie Howard-Birt

Neil Howlett

Ayo Hughes

Richard Hughes

Sarah Hughes

Julia Hunt

Julian Hyde

Clare Jackson

Estelle Jackson

Mike James

Karen Jantzi

Lisa Jennings

Jesse & Helen

Susannah Jewsbury

Rachel Johnson

Zoë Johnson

Helena Jones

Sarah Jones

Suzi Jones

Tamara Jones

Tom Jones

Mary Jordan-Smith

jrd

Christine Kaltoft

Krystallia Kamvasinou

Gerry Kaspers

Frances Keeton

Kirstie Kelly

Tricia Kelly

Helen Kelsall

Fiona Kelsey

Shannon Kelso

Candace Kendall

Elizabeth Kenneally

Ros Kennedy

Sue Kennelly

Ann Kingsbury

June Kingsbury

Jackie Kirkham

John Kittridge

Laura Krstovska

Tara Kunert

Gill Laker

Laura Lamb

Jennifer Langley

Clare Langstone

James Larcombe

Sarah Lawes

Nigel Lax

Antonia Layard

Joanna Layton

Caroline Leatherdale

Fern Leathers

Karen Lee

Michael Lee

Kirsty Lepage

Frances Liardet

Taryn Lindhorst
Jayne Lindsay
Joy Ling
David Link
Nikki
Livingstone-Rothwell
Andrew Local
Julia Lockheart
Emma LP
Brigitte Colleen Luckett
Nina Lucking
Audrey Ludwig
Jen Lunn
Angela Lytle
George MacDonald
Kate Macdonald
Dylan Mace
Sarah Macfarlane
Richenda Macgregor
Liz Mackevicius
Susan Mackie
Karen Mackrill
E MacLennan Kingsley
Erin Maher
Emma Major
Catt** Makin
Keith Mantell
Marsha Mars
Sara Marshall
Sarah Marshall
Sharon Martin
Jan Martin, Sarah Robinson

Ruth Norman Mason
Stephanie Massie
Jen Mather
Grace Maxwell
Simon May
Linda Maynard
Laura Mazza
Yvonne Carol McCombie
Victoria Sharratt
McConnell
Rosemary McCormick
Helen McLachlan
Anthea McWilliams
Sally Mears
Sher Meekings
Kristina Meschi
Deborah Metters
Sophie Meyer
Tim Middleton
Caroline Millar
Auriol Miller
Naomi Miller
Toby Miller
Kirsty Millican
Maria Mol
Linda Monckton, Meadbh
Bruce
Maarten Monckton,
Meadbh Bruce
Richard Montagu
Michelle Moore
Kate Moreton

Rebecca Morland
Lauren Mulville
Claire N
Carlo Navato
Klil H. Neori
Barbara Neve
Jill Nicholls
Kay Norman
Grainne O'Donnell
Rachel O'Meara
Rachel O'Reilly
Catriona Oliphant
Lisa Ollerhead
Karen B Olney
Janne Olsen
Angela Osborne
Monica Osorio Malfitano
Paula Page
Tashya Page
Joy Palfery
Liz Panton
Christina Papadaki
Gwen Papp
Nick Parfitt
Duncan Parker
Angela Pater
Heather Patey
Stanislaw and Stefania
Pazucha
Lou Perry
Karen F. Pierce
Jean Leek Ping

Helen Plowman
Fiona Plunkett
Philip Podmore
Lynsey Pollard
Kirsty Powell
Tracy Powell
Rebecca Prentice
Helen Price, Maggie Jones
Sue Pritchard
Katharine Quarmby
Hannah Quay
Susi Quinn
Hazel Rallison
Bryony Ramsden
Sue Rathmell
Romy Rawlings
Helen Raynor
Tom Revington
Holly Richardson
Isobel Rickard
Rachel Ritchie
C H Roberts
Esther Roberts
Holly Roberts
Ingrid Rock
Lynne Rogers
Bryony Rogerson
Kat Rose
Jenny Rosenthal
Tracy Roxbury
Daniel Ruff
Amelia Rusbar

Dawn Russell
Gill Rutter
Anna Sabine
Jesús Martín Sánchez
Lucy Saunders
Ajax Scott
Gemma Scott
Kate Scott
Maylin Scott
Emma Scutt
Georgina Sear
Dick Selwood
Seven Fables Dulverton
Helen Shalders
Faye Sharpe
Stephanie Sheehan
Deirdre Shepherd
Candy Sheridan
Guy Shrubsole
Emma Siertsema
Henrietta Simpson
Juliet Sluce
Fran Sluman
Cathy Smith
Michael Smith
Nigel Smith
Victor Smith
Marina Sofia
Antje Sommer
Alison Souter
Monique Speksnyder
Louise Spencely

Laura Stafford
Charlotte Stark
Nic Stevenson
Danu Stratton-Kent
Jules Streete
Janet Strugnell
Stacey Styles
Lesley Styles, Chantal Brooks
Anne Summerfield
Christopher Sweetman
Ellie Swinhoe-Evans
Helen Tabeshfar
Nicola Tanner
Stephanie Tarnofsky
Paula L. Tarrant
Sally Tate
Emma Taylor
Jen Taylor
Alison Teagle
Sarah Thelwall
Helen Thompson
Liz Thompson
Toni Thompson
Anne Thomsett
Lara Thornton
Marian Thorpe
Ruth Till
Grace Timmins
Adam Tinworth
Katrina Tipton
Betty Tisel

Todsy
Bella Tomlinson
Clare Topping
Tracey
Eleanor Trenfield
Joe Tristram
Allison Turner
Jo Turner
Mel Turner
Allison Tyler
Robert Upton
Malinka van der Gaauw
Molly Varga Smith
Craig Vaughton
Clare Venables
Violet Venables Ziminski
Diana Wackerbarth
Mark Waddington
NIcky Wade
Sally Wadsworth
Helen Wakeham
Geoff Walker
Peter Walker
Carol Waller
Gabrielle Wallington
Jo Walton
Joanne Wardale

Jenny Warner
Ingrid Wassenaar
Ruth Waterton
Jackie Watson
Jackie Watts
Andy Way
Mary Weaver
E Webb
Elizabeth Weitzman
Sarah Wells
Nicole Welsh
Andrew Wheatley
Paul Whitewick
Patricia Wightman
Chad Wilkinson
Rachel Wilkinson
Lois Williams
Shz Williamson
Denise Wilton
Katy Wiseman
Evan Wood
Elizabeth Woodcraft
Jon Woolcott
Georgina Wright
Xiang Yi Zhang
Susan Zasikowski
April Zoll Close

A Note on the Type

The text of this book is set in Bembo MT Pro. Created by Monotype in 1928–1929, Bembo is a member of the old style of serif fonts that date back to 1465. Its regular, roman style is based on a design cut around 1495 by Francesco Griffo for Venetian printer Aldus Manutius, sometimes generically called the 'Aldine roman'. Bembo is named for Manutius's first publication with it, a small 1496 book by the poet and cleric Pietro Bembo.

Monotype created Bembo during a period of renewed interest in the printing of the Italian Renaissance. It continues to enjoy popularity as an attractive, legible book typeface.